∞ SPLENDID SLIPPERS ∞

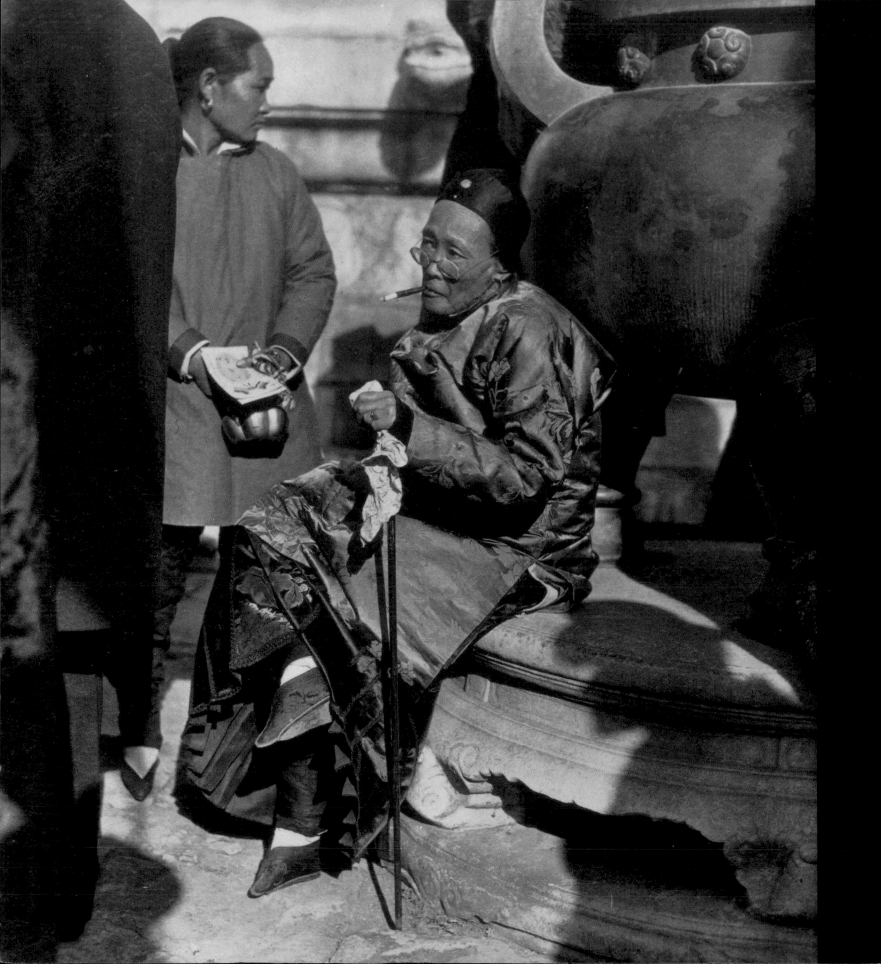

SPLENDID SLIPPERS

A Thousand Years Of An Erotic Tradition

Beverley Jackson

TEN SPEED PRESS
Berkeley, California

10 TEN SPEED PRESS

PO Box 7123
Berkeley, California 94707

Ten Speed titles are distributed in Canada by Publisher's Group West, in the United Kingdom and Europe by Airlift Books, in South Africa by Real Books, in New Zealand by Tandem Press, and in Southeast Asia by Berkeley Books.

◎◎ *Frontespiece:* Two classes, two generations, both with bound feet: A wealthy matriarch sits and smokes while her maid stands nearby carrying her mistress's handwarmer. (From the Sidney D. Gamble Foundation for China Studies)

◎◎ *Opposite Table of Contents:* (From the author's collection)

Cover photo and additional photography styled by Veronica Randall
Cover photo and additional photography by Larry Kunkel
Cover design, text design and composition by Brad Greene
Printed in Hong Kong

Library of Congress Cataloging-in-Publication Data

Jackson, Beverley.
 Splendid slippers / by Beverley Jackson.
 p. cm.
 Includes bibliographical references and index.
 ISBN 0-89815-957-I (pbk.) ISBN 0-58008-256-4 (cloth.)
 I. Footbinding--China--History. 2. Foot--Social aspects--China.
 3. Women--China--Social conditions. 4. Feminine beauty
 (Aesthetics)--China--History. I. Title.
 GT498.F66J37 1997 97-22585
 CIP

Second Printing, 2000

For Taylor

∾

ACKNOWLEDGMENTS

For a strawberry-blonde American who doesn't speak or read Chinese to write a book on Chinese footbinding took much help from many wonderful people—from old friends and new ones I made while working on my project. My greatest thanks go to my editor and guardian angel, Veronica Randall, who understood my book better than I did myself and who made it soar far beyond my wildest hopes; to Larry Kunkel for exquisite photography; to Brad Greene for a stunning interior design; to Jackie Wan who taught me how to organize my thoughts and words; to Dolores Wong, who opened not only doors but hearts and eyes, my own included, helping me tirelessly through long years of research, and to Delbert Wong for his patience with us both; to Dolores and Immanuel Hsu, very special friends for whom no question was ever too trivial.

❖ ❖ ❖

And to the following, each of you knows what contribution you made and I shall never forget—

❖ ❖ ❖

Bickey and John Alexander; Steve Allen; John Ang; Martin Blakeway; Steve Boyiajian; Ray Bradbury; Terri and Hugh Carpenter; Marie and Robert Carty; Marilyn Chandler; Mme. Carole Chicket; Peggy Dent; Carol Duan; Anita and Yasu Eguchi; Gail Fisher; Rose Fong; Kay Glenn; Catherine Gamble Curran; Steve Gilbar; Parry Gripp; Jessica Harrison-Hall; Pat Hsiung; Genevive Hsu; Virginia Castagnola Hunter; Joan Jacks; Jian Xue-zhu; Dr. Donald A. Johnson; Marcelle Kaddell; Dr. Lee Kavaljian; Dorothy Ko; Mrs. Loy Kwok; Munson A. Kwok; Gerard Levy; Dr. Raymond Lum; Fidelia Manug; Sister Ignatia McNally; Alfred Moir; Dr. Martha Mottram; Leslie Neidleman; Peter Nelson; Beatrice Owen; Victoria Randall; Glenn Roberts; Baroness Philippine De Rothschild; Sophie Su and Phillip Ruston; Shelly and Max Ruston; Mary Sheldon; Dr. A. Jess Shenson; Dr. Ben Shenson; Yang Shaorong; the Sisters of Providence; Judy Sutcliffe; Hui Hsu Sturman; Susan Tai; Hania Tallmadge; Donald G. Toy; Douglas Whyte; Jane Withers; Sister Ann Colette Wolf, S.P.; Gordon R. Wright; J. Junnaa Wroblewski; Dilling Yang; Dr. Henry Yang; Charlie A. Zee; Zhong Li Shi; Athena Zonar; and Jane Zonka.

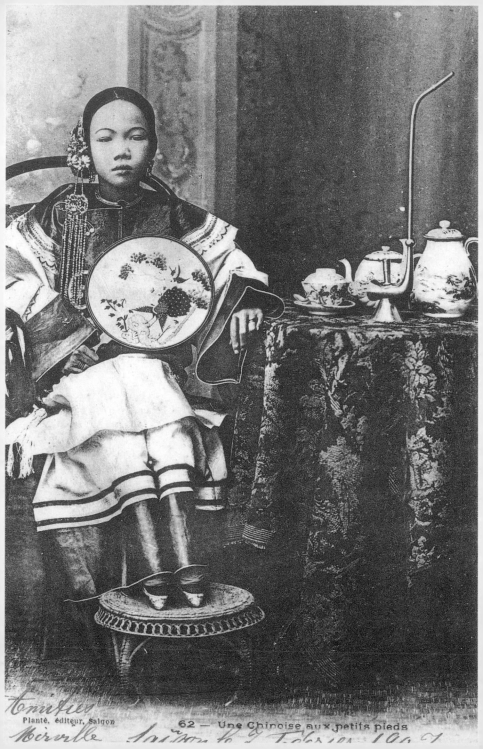

62 — Une Chinoise aux petits pieds

CONTENTS

AUTHOR'S NOTE

My original intention was for all Chinese words to be spelled according to the modern Pinyin system, but this was not always practical (or pretty). I have used Pinyin for places, events, or characters in a present-day context. When I have placed such references in a historical context, I have used the older, and to some, more familiar, Wade-Giles system. Because so many of my references predate Pinyin, untangling the old spellings from the new was often difficult, if not impossible, and I apologize for any inconsistencies and inaccuracies.

HISTORICAL DATES

Shang Dynasty	c.1766-1122 B.C.
Zhou Dynasty	c.1122-256 B.C.
Warring States	403-221 B.C.
Qin Dynasty	221-206 B.C.
Han Dynasty	206 B.C.-A.D. 220
Three Kingdoms, Western Jin, and Southern and Northern Dynasties	220-589
Sui Dynasty	589-618
Tang Dynasty	618-907
Five Dynasties and Ten Kingdoms	907-960
Song Dynasty	960-1279
Yuan Dynasty (Mongol)	1279-1368
Ming	1368-1644
Qing Dynasty (Manchu)	1644-1911
Republic of China (Nationalist)	1911-1949
People's Republic of China (Communist)	1949-present

PREFACE

It was 1938 when my mother took me from Los Angeles to San Francisco on the train for the World's Fair. At the end of an exhilarating, exhausting day, we walked from the St. Francis Hotel, across Union Square, and approached the Grant Avenue Gate—the entrance to Chinatown. It was early evening and the neon signs were already flickering to life above streets that seemed curiously narrow after the broad boulevards of the Fair.

We stopped for supper at a chop suey parlor, lured by the tantalizingly unfamiliar and irresistible aromas that spilled out into an alley. In those days one didn't dine on Chinese cuisine, one ate in smoky little restaurants with rows of half-enclosed booths and dusty red lanterns hanging from the ceiling, tassels blowing in the breeze of the ubiquitous electric fan stationed near the kitchen door.

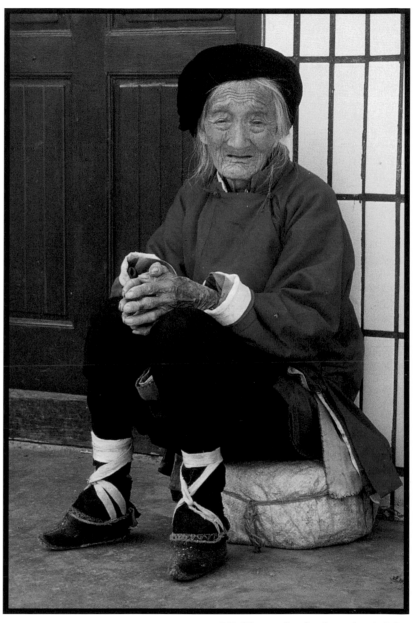

◎◎ Photo taken by the author in May 1997, in Yunnan Province.

After dinner we went for a long walk along Grant Avenue, peering in the windows of the long, skinny shops, piled to the ceilings with exotic goods, and smelling of moth crystals and burning joss sticks. Just before my first Chinatown adventure came to a close, my mother bought me a doll. I didn't particularly want her. She was a stiff old lady in severe blue and black attire,

1

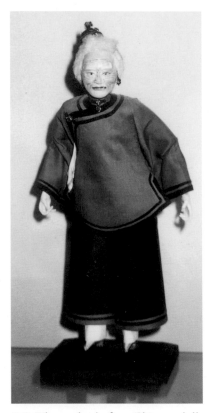

◎◎ The author's first Chinese doll, c. 1938.

with her arms set at a strange angle, as if she were getting reading to do a shallow dive off the side of a pool. And she stood precariously on the tiniest little feet I'd ever seen. It was many years before I thought about the tiny feet of that unloved doll hidden away somewhere in a closet.

Almost forty years later, in 1975, I had a long wait at the railway station in Beijing, as my visa into the city couldn't be located. I worked my way through the throngs of people to find a small patch of unclaimed ground where I could collapse on my bags. Moving cautiously through the sprawling families all dressed in blue Mao suits, half hidden by bundles of possessions, I became aware of elderly women dressed in black and blue with tiny feet—like my doll. Throughout the trip I was to glimpse them walking in the Forbidden City and on the back streets in Shanghai and Tientsin, often supported by healthy young girls with normal feet.

In later years, whenever I lectured about antique Chinese clothing and the lost world in which they were worn, the question and answer period proved most interesting. What people really wanted to hear about was *not* costumes. They wanted to know about bound feet, and, I realized, so did I. Casual reading led to several years of serious research.

The inevitable and immediate Western reaction to the thousand-year-old custom of footbinding is "It must be the men's fault." This is hardly surprising since the image of pre-1949 Chinese women we have from Western films and literature is of the down-trodden subservient daughter, wife, or daughter-in-law. So while this may have been a natural conclusion to come to at one time, it is far too simple for today—and the truth is much more fascinating.

Splendid Slippers is an aesthetic exploration of that truth. It is an attempt to gently and respectfully lift the edge of a great curtain that hangs across the vast sweep of history and culture that is China. My choice of title is a conscious one: As a lover and collector of textiles, this passion was initially sparked by my appreciation for the shoes themselves. This kindled my curiosity about footbinding which, in turn, ignited my interest in its historical and cultural origins.

It is never easy to analyze the inner workings of another culture. We in the West have problems analyzing our own culture. We have problems analyzing our

own lives! Where else in the world do so many people pay so many hundreds of dollars an hour to have someone help them with the process? Yet we feel adequately informed to pass judgment on a culture that is totally foreign to us.

One of the most frustrating and puzzling aspects of studying Chinese foot-binding is the relative scarcity of research being done on such an intriguing subject. This is compounded by a reluctance on the part of many people to even discuss it. The great historian and sinologist John King Fairbank wrote: "Strangely, social historians of China, both men and women, have hardly yet acknowledged its existence. It is the least studied aspect of Chinese society. The fascinating complexity of marriage arrangements and the general inequality meted out to women have been brilliantly explored, but not footbinding. Its avoidance perhaps represents the occupational quirk of sinologists, a secondary patriotism or sinophilia that may lead to otherwise hard-headed scholars to want to say no evil of the object of their researches. Nevertheless, a social evil that becomes institutionalized though shameful to recall must still be faced." (From *China: A New History* by John King Fairbank. Harvard University Press, Cambridge, MA, 1992.)

I am not able to tell you that Confucian philosophy and male domination are responsible for one thousand years of Chinese women binding their feet. After all, it was not men who performed the actual binding and perpetuated the custom. It was mothers and grandmothers who did this. For a sociopolitical/anthopological/ psychological discussion, I can only refer you to the writings of ancient scholars, or to such contemporary scholars as Patricia Ebrey and Dorothy Ko. This subject is certainly worthy of serious examination, and after reading them you can make your own decision.

My own conclusion comes down to a sort of Chinese version of: Which came first, the chicken or the egg? *Splendid Slippers* does not try to explain the Chinese psyche or resolve Chinese gender issues for the past ten centuries. My mission has been to share my experiences, discoveries, and reflections, which continue to this day. My hope is that it will inspire the reader to further study.

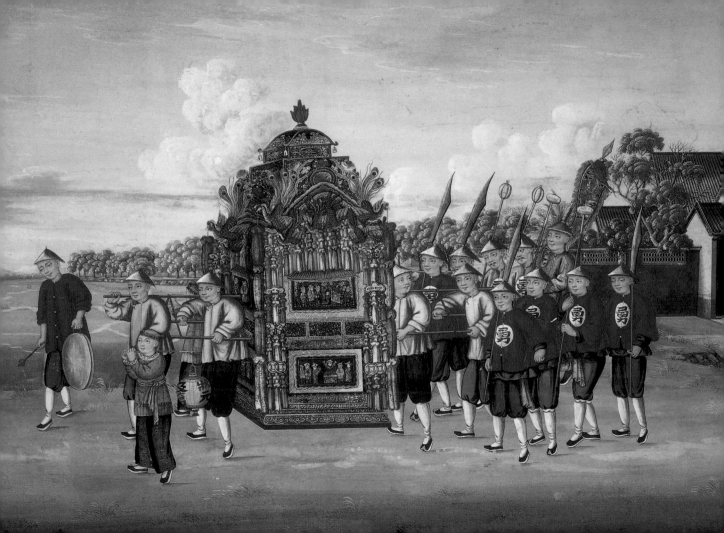

CHAPTER I

THE TREASURE WAS HER TINY FEET

T he colorful procession moved slowly through the swirling, choking dust from the Gobi desert as it approached the massive walls of Peking. The bearers kept pace with the lumbering camel caravans from the north bearing gold, sables, and hawks; from the west with jade and fine rugs; from the south with sapphires, amber, and porcelains. Mongols with great hats of fur and colorful thick robes scurried past on their small shaggy ponies, astride their bright red leather saddles, their colorful patterned leather boots barely clearing the ground. Wagons heaped with tribute rice lurched and shuddered through the yellow Gobi dust.

All who passed the bridal cortege paused to stare at the crimson and gold lacquered palanquin carried by eight sweating coolies at the end of the procession, hoping to catch a glimpse of the precious treasure hidden within. There was no way to know that the lone passenger longed for just a glimpse of the noisy world beyond the tightly drawn curtains. For the coolies carried neither jade, nor sable furs, nor amber—but a frightened young girl, called Phoenix Treasure, who had been sent by her family from the only home she had ever known to the far-off capital to marry a man she had never seen.

Tradition bound her to stay hidden from view, dressed in her sumptuous bridal robes of scarlet silk with wondrous embroideries of gold. The wedding crown of splendid blue kingfisher feathers, adorned with jeweled butterflies and

◉◉ *Opposite:* Detail of a wedding procession, 18th century, gouache on paper. (From a private collection, Larry Kunkel Photography)

Opposite: Pair of silk, almond-colored shoes embroidered with accurately rendered birds (a kingfisher on the left, a mallard duck on the right) in a pond of fanciful blue lotus. Length 3½ inches. (From the author's collection, Larry Kunkel Photography)

flowers, quivered and trembled with every movement and was heavy and hot upon her head. Her face was covered by a swaying curtain of pearls that chattered softly with the motion of the chair like a whispered reminder that she was coming ever closer to her new life with every step the coolies took.

Phoenix Treasure looked down at her tiny, perfect, three-inch lotus feet encased in their beautiful crimson wedding slippers. She felt anxiety, excitement, and fear at what lay ahead just as she had felt that day, long ago, when she watched the footbinder enter the front gate of the family compound and heard her mother chanting prayers before Kuan Yin, the goddess of mercy. She had been running and playing with her brothers amidst the rocks from Lake Tai that filled her family's garden. If only she'd kept running—running through the gardens and past the spirit screen[1] that protected the entrance from straight-flying demons, running through the streets and into the hills. If only she could have kept running on her normal six-year-old feet—away and forever. She stopped for a look at the old woman with the red painted wooden stool and mysterious tools—the woman who would change her life forever. But she could not run away from tradition on that day any more than she could on this one. The tradition that bound her to each stage in her life was the same that bound her feet into tiny, lotus bud-shaped curiosities.

For it was not Treasure's lovely face and silky black hair that had resulted in her impending marriage. Nor was it her happy laughing disposition or her lovely slim body that brought her to be wed to the eldest son of an important Peking citizen. It was those painful, misshapen, three-inch feet secreted inside the beautiful red shoes that had made her the choice. The matchmaker had not gone to her future husband's home with a picture of her, the kind those Western men captured inside a big black box and magically turned into a paper image. Instead, the matchmaker had carried a tiny pair of shoes the girl had made and embroidered herself, with a statement of her father's wealth and a description of the dowry that would accompany her. Treasure's future mother-in-law had not queried the matchmaker about the girl's disposition. She had simply examined the shoes to see how small they were. Very small shoes meant the girl could endure great

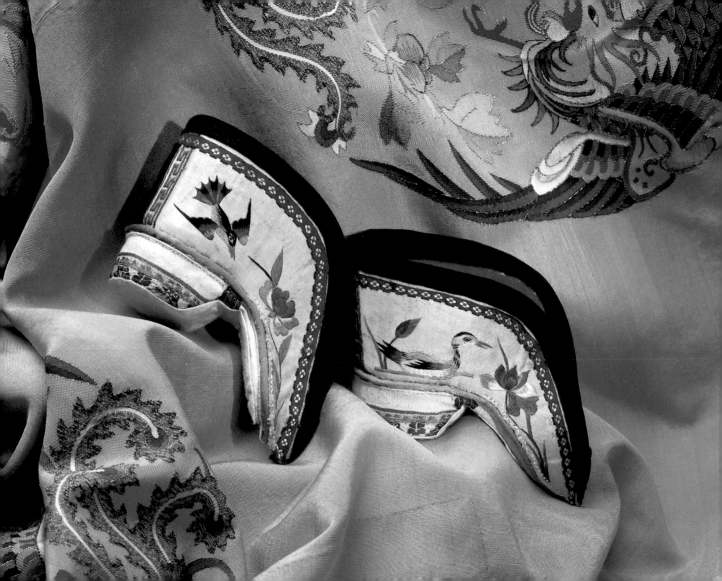

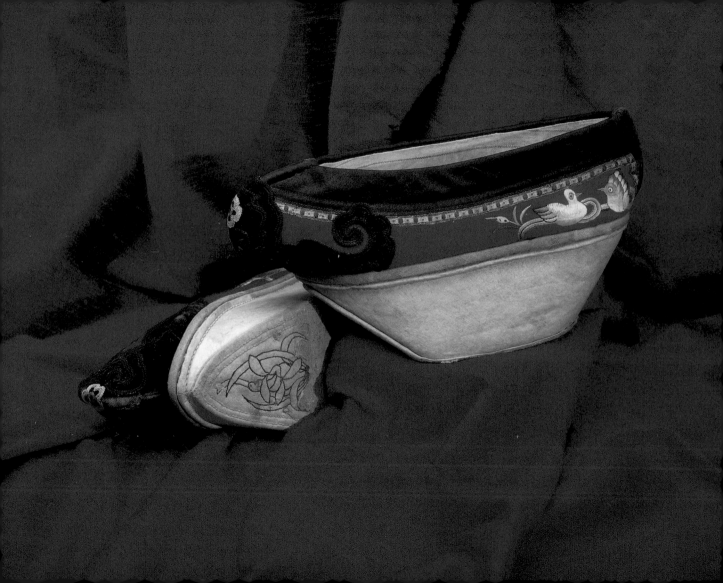

pain and would follow orders well. Fine embroidery was another example of one who accepts discipline.

Inside the sedan chair, the dark, humid air mingled with the bride's musk and orange peel perfume and grew ever more stifling. The procession plodded on, passing through the South Gate in the city's outer wall beneath the ninety-nine-foot high watchtower[2] with vermilion pillars and roof of shining tile. It continued down Ch'ien-men Street, designed by Kublai Khan in 1267. Golden dust swirled like dervishes around the weary bearers. Overhead, silken dragons and butterflies of every color snapped and strained at the ends of their long kite strings. What an exciting moment it should have been, experiencing life inside the walls of the legendary city.

Cocooned within the muffled darkness of the chair, Phoenix Treasure saw none of this. But she could hear sounds that were comfortingly familiar—the brassy, insistent rhythm of caravan bells suspended from brightly enameled donkey harnesses were easily distinguished from the tinkling ping of the tiny bells carried by the fan peddler; the dried fruit and nut vendor sang out lustily to be heard over the clanging gong of the candy peddler, the ringing *huan t'ou*[3] of the barber, and the resonant thudding of the charcoal seller's snakeskin drum. The hollow clacking of hinged bamboo sticks announced the passing of a foot fixer (chiropodist). It was all she could do to keep from flinging back the curtains and begging him to change her feet back to their normal size—and thereby change the course of her life.

The coolies picked up their pace, and an experienced traveler would have sensed that the end of the journey was near. The procession turned at T'ien an men, within sight of the massive gold-tiled roofs of the Forbidden City, and trotted past walls within walls into a maze of *hutongs*[4].

Suddenly, all motion stopped, and the sedan chair was lowered to the ground so abruptly that its weary passenger slid off her perch. Outside, great activity welcomed the arrival of the exhausted cavalcade. From behind the high walls of the compound that was to be Treasure's new home came servants and family—not to greet the bride, but to accept the silks and jewels that were her dowry.

∽ *Opposite:* Pair of embroidered silk with velvet appliqué Manchu shoes. Note the unusual stem stitch embroidery at the front of the platform soles. Length 9 inches, bottom of sole; length 3¾ inches, bottom of platform. (From the author's collection, Larry Kunkel Photography)

And most importantly, they sought the examples of the beautiful little lotus slippers she had made for her wedding trousseau. Her greatest embroidery skills and keenest imagination had gone into their creation, as she knew they would be put on display for all the relatives and friends to view and judge. But their judgment held no fears for her. She was confident that her lotus bud-shaped feet of the perfect three-inch size, with the exquisite shoes she had made to cover them, would bring admiration, and in later years, considerable power.

❖ ❖ ❖

For centuries, this scenario was played out in varying degrees of splendor all over China, from remote parts of Mongolia to the Bay of Hong Kong, from Shanghai to villages along the upper Mekong Valley. Horoscopes were compared, fortune tellers consulted, matches arranged, and young girls with bound feet were sent forth on the most auspicious date of the year.

In most cases, a simple red sedan chair would arrive from the groom's village to fetch the bride carried by the groom's friends in a happy procession with waving banners and lanterns. Fireworks, gongs, drums, and other musical instruments often accompanied the sometimes drunken cavalcade along the route between villages. On this very special day, a bride could rest the minuscule feet that, on every other day of her life, might have to wade through flooded rice paddies, climb steep mountain paths, or cross hard-packed, sun-baked fields. The humble village girl had one advantage over her wealthy urban counterpart—at the end of her journey she shook pink plum blossom petals out of her hair and robes rather than the yellow choking dust off the desert and the gritty black soot from a million charcoal fires. When she stepped down from the sedan chair to enter her new home, her wedding slippers never touched the ground, for a cloth was laid out for the bride to tread upon. Once she had alighted, she tottered on tiny bound feet down this pathway to the rest of her life.

This is not a storybook tale limited to a select social strata of Chinese girls. This is the story of millions of young women, and a custom that began at least a thousand years ago, following the collapse of the Tang Dynasty, during the period known as the Five Dynasties and the Ten Kingdoms. And it was

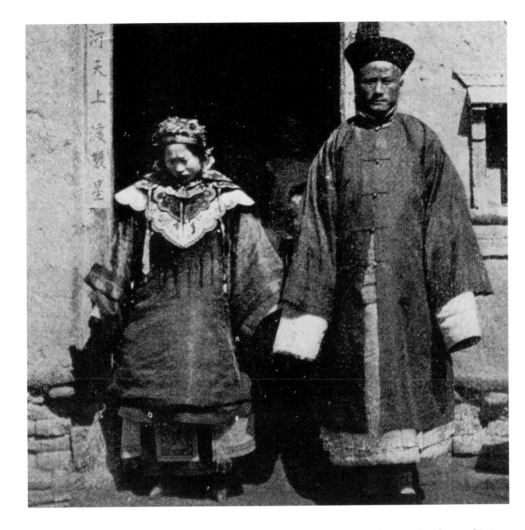

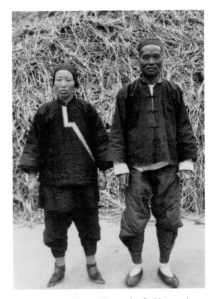

∾∾ *Above:* The village chef, Chin-ts'un, and his wife. (From *The Carl Whiting Bishop Papers,* Freer Gallery of Art and Arthur M. Sackler Gallery Archives, Smithsonian Institute; image #391-52).
∾∾ *Left:* A bride and groom after a winter wedding. (From *Village Life in China* by Arthur A. Smith. New York: Fleming H. Revell Co., 1899)

not completely abandoned until the Communists, under the leadership of Mao Zedong, proclaimed the People's Republic of China in 1949.

◇ ◇ ◇

The practice of footbinding began in the royal palaces in the mid-10th century, and it remained a custom of royalty, the nobility, and the very rich until the beginning of the 17th century. Imitation is human, so it is not surprising for a custom that began with the aristocracy to work its way down the social scale. By the end of the 17th century we are not speaking of small numbers of privileged women binding their feet. We are speaking of millions of Chinese women of all socioeconomic backgrounds.

☙☙ *Above:* Poor women in Tientsin, 1930. (From the Sidney D. Gamble Foundation for China Studies)

☙☙ *Opposite:* Pair of very rare wooden-soled, bad weather shoes made of heavily lacquered, parchment-type paper. The soles are attached with tiny handmade nails and carved with ridges in the middle for better traction. Length 3½ inches. (From the author's collection, Larry Kunkel Photography)

The origins of footbinding remain mysterious—comprising equal parts historical evidence, local tradition, and scholarly conjecture. The generally accepted theory credits Prince Li Yu who ruled one of the Ten Kingdoms in southern China. It is said that Prince Li Yu had a favorite concubine, Precious Thing, who was a superb dancer. Not only did she dance on a platform shaped like a lotus, but she toe-danced inside a six-foot-high lotus flower made of gold, and decorated with pearls, precious jewels, and silken tassels. This famous beauty was known for wearing silk socks over which she wound long, narrow bands of silk to make her dancing more seductive.

Thus, the origins of the strange Chinese custom of footbinding appears to be an early variation of ballet, known today as dancing *en pointe*. However, modern ballerinas settle for squeezing into pink satin shoes with hard flat toes to balance on, while ancient Chinese dancers resorted to a permanent condition of disfigurement in order to execute their exotic choreography.

It is not easy for anyone today to fully understand the ancient Chinese custom of footbinding. How could so many generations of mothers perpetuate this painful disfigurement of their daughters' feet? How could the daughters accept the custom? The key factors that come up in history after history are marriage and tradition. The worst thing that could happen to a Chinese woman of the past was to be deemed unmarriageable. Even 19th century Western missionaries had to permit footbinding in their orphanages or they would never have found husbands for the Han girls in their care.

Status also played a crucial role in the history of Chinese footbinding. If you accept the theory of a prince lusting for the beautiful dancer with tiny feet, it is not unreasonable to imagine that other women in the imperial household would be envious of her and choose to bind their own feet with silk in hopes of finding such a position for themselves. Gradually, the royal craze became an accepted custom taken up by the lesser nobility and on down the social ladder to the merchant classes and the peasantry—each aspiring to achieve higher standing through smaller feet.

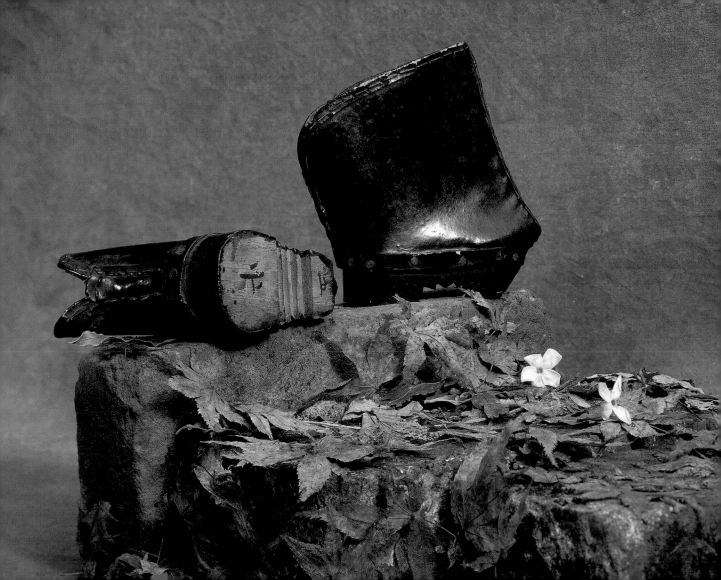

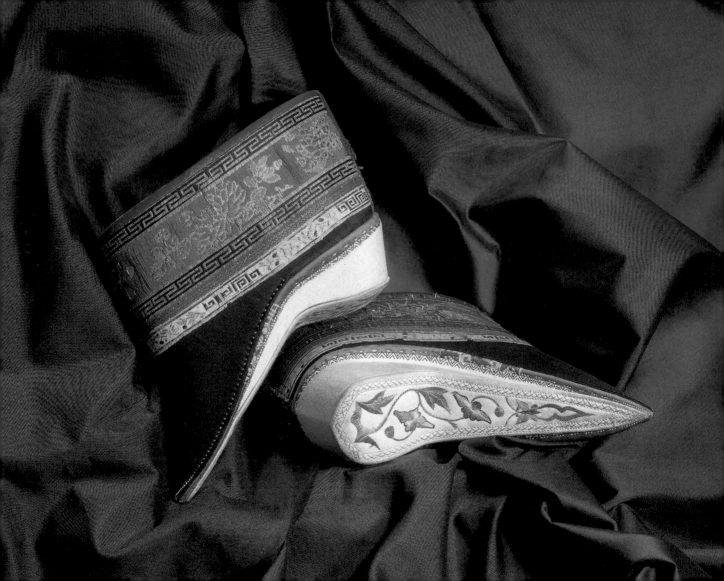

Left: Paper burial effigies representing the deceased's servants are burned in order to assure continued service to their master in the next life. Note the two female figures on the left wear lotus shoes. (From the Sidney D. Gamble Foundation for China Studies)

Opposite: Pair of black silk shoes with blue brocade ribbon and padded lining for cold weather. Note the exceptional embroidery on the soles. Length 5½ inches. (From the author's collection, Larry Kunkel Photography)

For poor people, an additional impetus may have been the enduring belief that material things exist in the next world. To this day, the Chinese send their dead off with the best replicas of material luxuries they can afford. Paper and bamboo money, houses, clothes, cars, and yachts, are burned to accompany the departed. Thus, a poor girl with an aristocrat's feet would have a chance at a better position in the afterlife if her feet were bound.

Male domination of women was obviously a major factor as well. A woman who was kept physically restricted was, presumably, less likely to be mentally independent. Her very helplessness conveyed an elevated status to her husband and his family. Anyone who could afford a "helpless" wife must be a successful man, regardless of his actual social or economic reality.

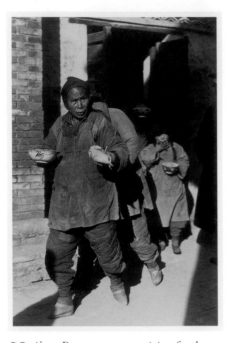

⊚⊚ *Above:* Poor women receiving food from a mission charity, Chou Chang, 1930. (From the Sidney D. Gamble Foundation for China Studies)
⊚⊚ *Opposite:* Women who worked on fishing boats did not bind their feet, Foochow, 1930. (From the Sidney D. Gamble Foundation for China Studies)

Adele Fielde, who lived in the Shantou area for ten years in the early 1800s, wrote a book called *Pagoda Shadows,* in which she described the state of affairs. "Near the coast, even in the farmsteads and among the most indigent, every woman has bound feet," she said. "It is not a voucher for respectability, for the vilest are often bound-footed. Neither is it a sign of wealth, for in those places where the custom prevails, the poorest follow it. Inferior wives, unless they come as bond maids [slaves] into the household, are usually bound-footed women. Taking all China together, probably nine-tenths of the women have bound feet." (Fielde 1890)

Fielde observed that a woman would be laughed at and despised if her feet were like a man's. And if her feet were not bound, she would be as strong as her husband and could not so easily be kept in subjugation by confinement or beatings. Summing up the situation, she said, "Religion is not the only sentiment which has its martyrs."

The tenets of Confucianism leant themselves quite profoundly to footbinding. It is known that Confucius himself endured a very unhappy early marriage, which possibly shaped his thinking on the subject of women. "A woman should never be heard outside her own home," he proclaimed to his followers, paving the way for a life behind walls for the women of China. In fact, this philosphy has been blamed for China becoming a country behind walls. The Great Wall kept out foreigners for centuries. City walls kept out enemies. Compound walls kept out nonfamily members and established a way of life that kept women virtually captive all their lives.

Learned scholars, both Chinese and Western, basically have agreed that women's rights were taken away from them by the Confucian dictum of "Thrice Following" from the *Book of Rites.* In simple terms, Thrice Following stated that the woman must obey her father and elder brothers in her youth, her husband after marriage, and her son after the death of her husband. Her feet did not have to be bound to keep a Chinese woman at home, but it certainly fit into the overall picture of Confucian ideals—confinement and subjugation.

Chu Hsi, a great Confucian scholar of the Song Dynasty (960-1279), supposedly introduced the custom of footbinding in Fujian Province as a means of

spreading Chinese culture and teaching the separation of men and women. Lin Yutang, a contemporary scholar and author, has done extensive research on Chu Hsi and his theories, and has come to quite a different conclusion. "If it [footbinding] had been regarded only as a symbol of the suppression of women, mothers would not have been so enthusiastic in binding the feet of their young daughters. Actually footbinding was sexual in its nature throughout. Its origin was undoubtedly in the courts of licentious kings, its popularity with men based on the worship of women's feet and shoes as a love fetish, and on the feminine gait which naturally followed. And its popularity with women was based on their desire to curry men's favor." (Lin Yutang 1935)

Already the masters of Inner Mongolia, Manchuria, and Korea, in 1644 the Manchus came from the north and conquered China. They tried to abolish footbinding in China from the very beginning of the Qing Dynasty (1644-1911) by threatening severe penalties. But traditions do not die easily with the Chinese, and the Manchu rulers eventually gave up strict enforcement. They did bar all women with bound feet from the imperial harem for their entire reign. This was done not as an ethical protest against footbinding, but rather to maintain the purity of the Manchu imperial line of succession. Contempororary scholar Dorothy Ko has interpreted the Manchu policy on footbinding as a political statement by offering the brutal custom as a justification of Manchu superiority and domination over the Chinese. Nevertheless, court gossip from this period is laced with whispers of the occasional glimpse of a lotus foot peeking out from under the imperial yellow quilts of an emperor's bed. The girls were usually beautiful Chinese prostitutes smuggled in by the court eunuchs.

Intermarriage between Chinese and Manchus was also strictly forbidden. Because of the rigorously enforced laws, the Manchus kept their separate identity throughout their reign. There was no assimilation until the end of the dynasty, and then only to a minor degree.

In addition to the Manchus, there were other groups of women in China who did not bind their feet. The hard-working Hakka women in the hot climate of

the south were one group who did not. Because many of the men in this area of China emigrated to other countries to find work, this left the women to farm the land and big, natural feet definitely suited their circumstances better. The women of the Tanka community in Guangdong lived their whole lives on boats and never bound their feet. And in certain areas where the wet, sandy soil was worked for breeding fish rather than growing rice, bound feet were not suitable, and the women did not bind there either.

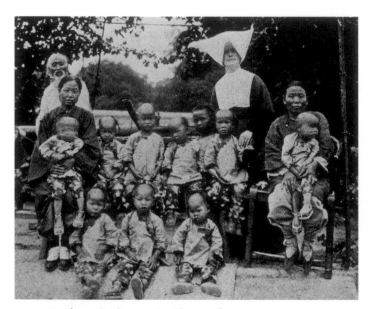

⊚⊚ *Above:* Orphanage in Chentingfu. (From *Observations in the Orient by a Maryknoller* by the Very Rev. James A. Walsh. Catholic Foreign Mission Society of America, New York, 1919) ⊚⊚ *Opposite:* The Manchu woman on the left has normal feet clad in flat slippers; the Han lady on the right wears tiny, pointed lotus shoes. (From the author's collection)

There was one group of women, also in the south, who did bind their feet, and these were the women of the Chinese Jewish community founded in 1163 in Kaifeng Fu. There was a great deal of intermarriage between the Jewish colonists and the Chinese. Many native customs were adopted, including the custom of footbinding.

Today, when one speaks of the Chinese, the reference is most likely to the Han Chinese, as they represent more than 94 percent of China's total population. But China is a multi-ethnic nation, encompassing some fifty-five minority peoples, each of which has certain basics that distinguish their culture from the others—language, religion, social customs, cuisine, clothing, etc. The women of some of these minority peoples did not bind. The Koreans are figured into this list of fifty-five, by the way. There were certain incidences of footbinding in Korea at one time, but it did not last long, nor did it expand beyond a very small group of women. Basically, then, it was the Han women who bound their feet for almost a thousand years.

What Westerners have asked for centuries is, "Why and how could this painful procedure continue through so many generations?"

It was tradition. It was fashion. The men wanted it. Without bound feet, a Han Chinese girl might not get a good husband. In the 17th century, an author known as Liu-hsien offered a list of seven reasons for footbinding:

First: If a girl's feet are not bound, people say she is not like a woman but like a man and they laugh at her, call her names, and her parents are ashamed of her.

18

Second: Girls are like flowers, like the willow. It is very important that their feet be bound short so that they will walk beautifully, with mincing steps, swaying gracefully, thus showing they are persons of respectability. People praise them. If not bound short, they say the mother has not trained her daughter carefully. She goes from house to house with noisy steps and is called names. Therefore careful persons bind short.

Third: One of good family does not wish to marry a woman with long feet. She is commiserated because her feet are not perfect. If betrothed, and the size of

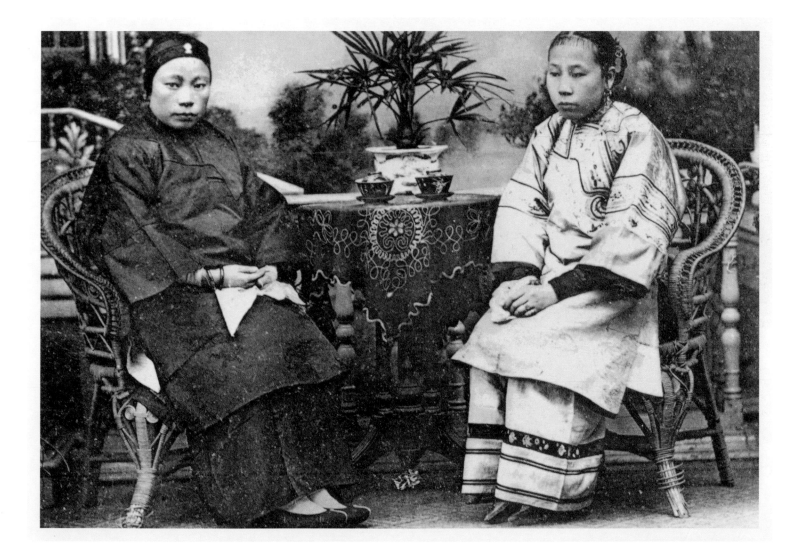

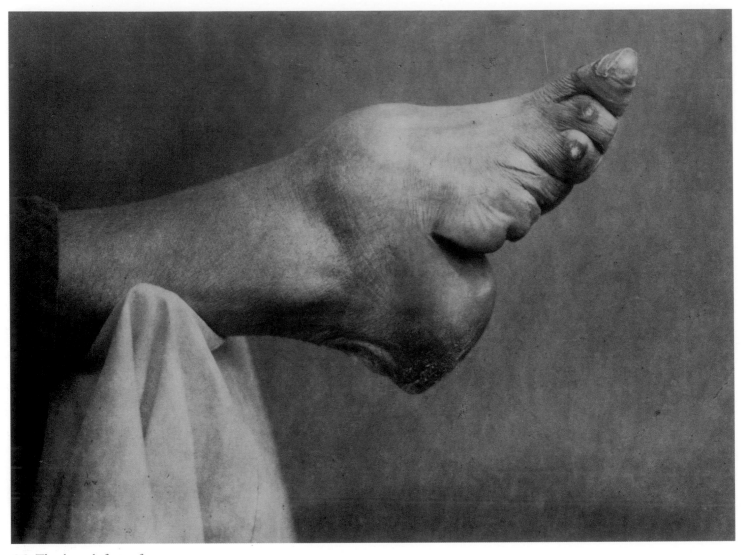

🌀 The bound foot of a woman.
Note the calloused heel and toes.
(From the Peabody & Essex Museum,
Salem, MA)

her feet is not discovered until after her marriage, her husband and her mother-in-law are displeased, her sisters-in-law laugh at her and she herself is sad.

Fourth: The large-footed has to do rough work, does not sit in a sedan chair when she goes out, walks in the street barefooted, has no red clothes, does not eat the best food. She is wetted by the rain, tanned by the sun, blown upon by the wind. If unwilling to do all the rough work of the house, she is called gormandizing and lazy. To escape all this, her parents bind her feet.

20

Fifth: There are those with unbound feet who do no heavy work, wear gay clothing, ride in a sedan chair, call others to wait upon them. Although so fine, they are low and mean. If a girl's feet are unbound, she cannot be distinguished from one of these.

Sixth: Girls are like gold, like gems. They ought to stay in their own house. If their feet are not bound, they go here and there with unfitting associates. They have no good name. They are the defective gems that are rejected.

Seventh: Parents are covetous. They think small feet are pleasing and will command a high price for a bride. (From *Strange Stories from a Chinese Studio* by P'u Sung-hing [commonly known as Liu-hsien] translated by Herbert A. Giles, 1880)

History leaves us a choice of origins for the beginnings of footbinding. But it is an often quoted couplet from an unknown source that comes to mind today:

"I don't know when this custom began

But it must have been started by a man."

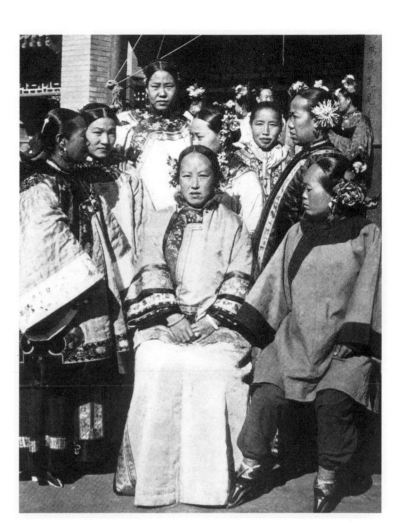

◎◎ The unbound feet of this Manchu matron are hidden beneath her robe. The bound feet of the Han women are proudly displayed in lotus shoes. (From *The Chinese* by John Stuart Thomson. Bobbs-Merrill Co., Indianapolis, IN, 1909)

END NOTES

1. Because it was believed that evil or demon spirits flew in a straight line, spirit screens were erected in Chinese gardens to deflect them from their flight paths, thus diverting them from homes or other buildings.

2. Because it was thought that good or benevolent spirits flew at an altitude of one hundred feet, this necessitated building construction to a maximum height of ninety-nine feet to ensure their safe clearance over the rooftops.

3. An iron, fork-like instrument that is struck with a small metal rod or mallet.

4. Narrow, meandering streets, often ending in a cul de sac.

THE THREE-INCH GOLDEN LILY

ntil Phoenix Treasure was six years old, she played freely with her beloved older brothers in the lush gardens within the high walls of her father's compound. Her days were spent watching the wild creatures who visited, the birds and mice and squirrels, chasing insects and butterflies, catching fish out of the ornamental pond, and playing with the boys. She was happy to ignore the scoldings from her *amah* (nanny) who would have preferred her to be more like her elder sister, Golden Peony. Treasure often felt sad for Peony who could not join in their raucus games for her feet were bound into tiny, bandaged bundles so small that Treasure marvelled at her sister's ability to stand at all. Instead, Peony spent her days indoors bent over the exquisite embroidery that would one day adorn the items in her trousseau.

On a crisp autumn morning, Treasure's amah summoned her in from the garden.

"This is a great day for you little Treasure. The binding of your feet begins at last."

"But I don't want to! How shall I walk and run and play if my feet are crushed until they are no bigger than squashed crickets?"

"Don't be foolish, child. They will look like precious lotus buds, like delicate lily blooms. Besides, if your mother allows your feet to grow any more, they'll be as big as palm-leaf fans and very ugly. And then who will want to marry you?"

◎◎ *Opposite:* Late 19th century gilded wooden footbinding stool. Cotton bandages were wound around the roller and pulled as the foot was bound while resting on the stool. A Northern-style shoe, length 4¾ inches, sits in the foreground; in the background hangs a sleeveband embroidered with peonies in the Peking knot stitch. (From the author's collection, Larry Kunkel Photography)

With that, Phoenix Treasure was marched to her mother's room where a small shrine to Kuan Yin, the goddess of mercy, held burning incense and a pair of the tiniest scarlet slippers Treasure had ever seen. She began to struggle, trying to squirm out of her amah's grasp.

"Please don't do this to me," she wailed. "It will be so painful, and I'll never be able to play with my brothers again!"

Then she heard her mother's voice, "I must do this, my Treasure, only because I love you. If I do not do this for you, you will never forgive me later—later when you are old and have no husband and no children to look after you. It is time to forget about childish games and think of your future. Someday, my little Phoenix, you will be grateful to me."

◇ ◇ ◇

For well over a thousand years, Chinese men and women pursued the ideal known as *san zun jin lian,* the three-inch golden lily, or golden lotus, as it is also called. The driving force behind this desire was complex: it had to do with marriage; it had to do with sex; it had to do with status; it had to do with beauty; it had to do with duty. Whatever the rationale, the fact is that by the time the practice was abandoned, millions of Chinese women had endured the unimaginable pain of the footbinding process, and in doing so, had sacrificed forever their ability to move about freely and normally.

As with so many other aspects of the Chinese culture, the custom of footbinding was a highly structured endeavor that was rich with tradition. Through the centuries, very precise methods of binding were established and passed on from generation to generation by the female members of the family. Simple variations would occur from region to region, village to village—even from footbinder to footbinder. Still, it is quite possible to make certain generalizations, and to describe the general process most accurately.

First, it is helpful to understand just what a well-bound foot—the golden lily or golden lotus—was supposed to look like. The key attribute of the perfectly bound foot, of course, was length. Three inches, or even less, was the ideal, and only a foot this size earned the title of Golden Lily. Then the perfectly bound foot must

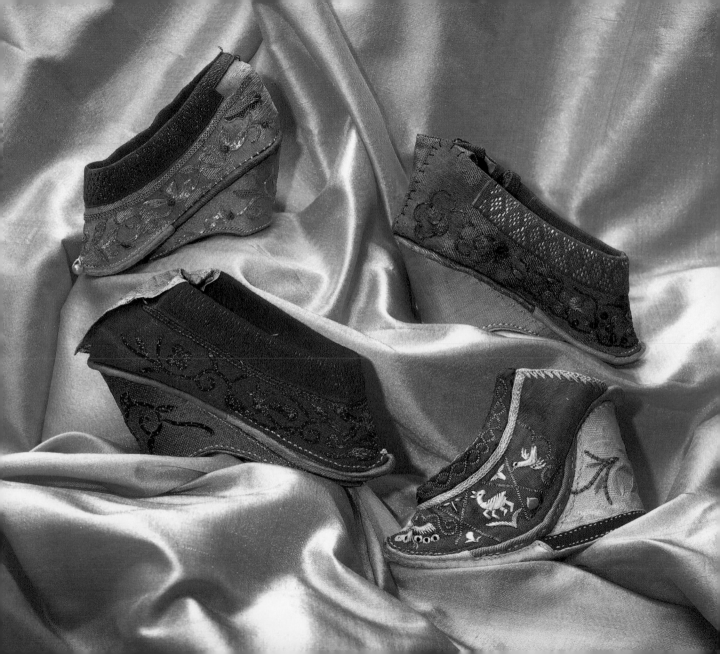

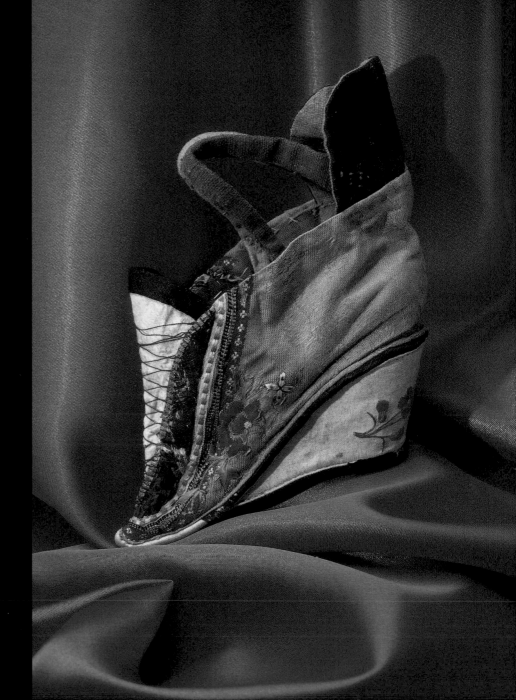

Northern-style pale blue cotton shoe. A sturdy example with a very high heel, which makes a large foot look smaller, shows obvious wear. Length 4 inches. (From the author's collection, Larry Kunkel Photography)

be shaped like the bud of a lotus flower—full and round at the heel and coming to a thin point at the front. Sadly, the only way to achieve the proper length and shape required actually breaking the arch of the foot and permanently bending all the toes except the big toe beneath the foot. The brutality of this procedure never fails to shock people when I describe the process of the actual binding of the foot, but it is a fact, and you can be sure that it was excruciatingly painful.

Contrary to general belief, footbinding was not begun in infancy. A girl's foot had to be quite well developed before it could be worked with properly to achieve the desired shape and size. The more fully developed the arch of the foot was, the better it could be broken to achieve the desired cleft in the foot between the front part of the foot and the heel. This cleft was the third requirement for a perfectly bound foot. The footbinders had a specific test for the cleft in a bound foot. They would take a Chinese silver dollar and fit it perpendicularly into the cleft, which was ideally two or three inches deep. If the coin fit tightly, this phase of binding was considered a success. (The cleft was sometimes used in rather unexpected ways, as will be discussed in Chapter 7.)

Finally, a perfectly bound foot must appear to be an extension of the leg, rather than an appendage set at an angle to it. In order to achieve this effect, the bones of the instep had to be made to bulge and form an arch resembling a crescent moon.

The Preliminaries

The usual age for beginning the binding of a girl's foot was between five and seven years, although customs varied somewhat in different areas of China. It could be done as early as age two or be attempted up to age twelve or thirteen. However, six years was the ideal age, as then the foot is still composed primarily of pre-bone cartilage which is predominantly water, and is therefore more easily molded. (Berg 1995)

The binding of a little girl's foot was generally begun in the autumn. The cold of winter would later help numb the feet during the critical first months. The twenty-fourth day of the eighth lunar month was the most usual time to

begin. Since the Chinese associate certain deities with almost every event in their lives, it is not surprising that they attribute using this date to the birthday of an obscure goddess called the Little-footed Miss instead of to the weather. It was also believed that the foot was softer on this particular day, thus making it easier to bind. (Yuan 1947)

Another lucky day for commencing binding was the nineteenth day of the second lunar month, the birthday of Kuan Yin, the goddess of mercy. Kuan Yin

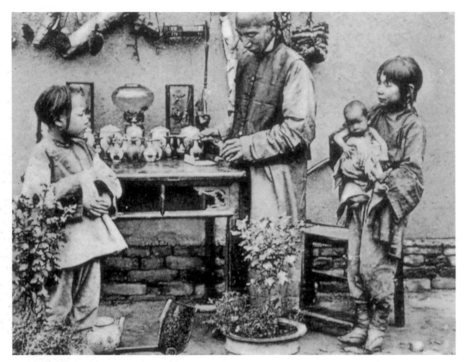

is the divine intercessor of the Buddhist faith, and is considered more an instinct of the heart than a goddess. Her name translates to "She Who Looketh Down and Hears the Cries of the World." There is irony in the choice of Kuan Yin's birthday in connection with footbinding, for there were certainly cries to be heard from the little girls whose feet were bound, but little mercy from the footbinder! And yet, Kuan Yin is looked upon as the protector of children. It is also interesting that in India, where she is also revered, Kuan Yin's name is Padma-pani, which translates to "Born of the Lotus."

Sometimes holidays and festival dates were chosen for the beginning of binding. In some regions of China, the corn and hemp festival in the seventh lunar month was frequently selected. The theory behind this was that the foot being bound might achieve the slimness of the stalk of corn or hemp.

Propitious days to commence binding were researched very carefully. In the cities, astrologers and fortune tellers were sought and consulted. However, it was the diviner with his occult books and special intuition whom village mothers consulted when dates had to be chosen for any important event, including the initiation of binding. In fact, it was customary to confer with a diviner before

@@ *Above:* Poor children buying medicine from an intinerant apothocary. (From the author's collection) @@ *Opposite:* This little girl's feet are not much smaller than the woman seated beside her. (From the Sisters of Providence, St. Mary's-in-the-Woods, IN)

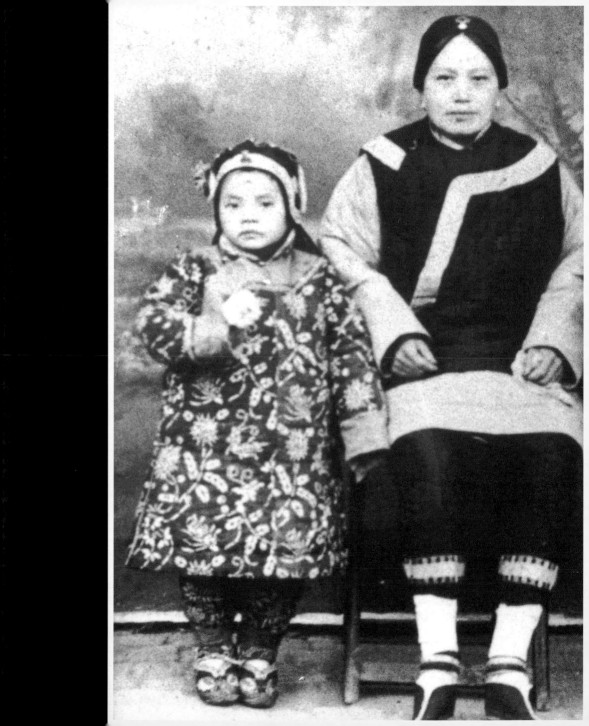

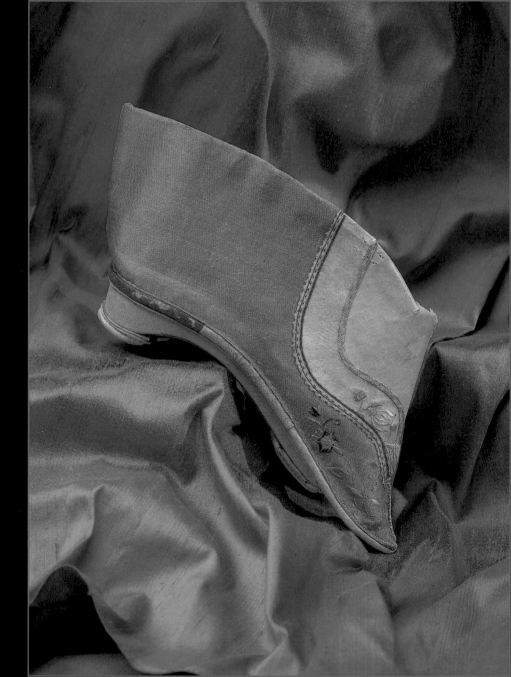

Northern-style salmon satin shoe. A more delicate example made and worn by a woman of leisure as the soles show virtually no wear. Length 5¼ inches. (From the author's collection, Larry Kunkel Photography)

embarking on any activity, major or minor: weddings, of course, but also when to plant the fields, an auspicious date for doing business, or even when to make patterns and cut out clothes.

If the girl's father was opposed to binding, the date to begin would have been scheduled for a time when he would be away from home. When a day was decided upon, it often became a social event for the female relatives of the girl and for her mother's friends. The guests would frequently travel great distances, in uncomfortable sedan chairs, in springless, man-powered, wheelbarrow-type carts, or in horse or donkey-drawn Peking carts, to attend an ordeal they had all, no doubt, experienced themselves.

In preparation for this major event, the mother of the girl would have made a very special pair of shoes. These shoes would be a mere one and a half to two and a half inches long, made of the best fabric the family could afford, and very finely embroidered. They were red, as a rule, since red is the good luck color worn by Chinese women for weddings, birthdays, and all other important occasions.

The night before the binding commenced, the mother would take the elfin shoes to the altars of the goddess Kuan Yin and/or the Little-footed Miss. Incense and many candles would be burning upon the altar, with offerings of fruits and special dumplings already in place. The mother would place the tiny altar shoes before a statue of the beloved Kuan Yin or the Little-footed Miss and pray that the binding would produce exquisitely tiny feet for her daughter. Dishes of red bean dumplings would also be placed on the altar, and at this time, the mother would feed her daughter some of these dumplings. Eating these particular dumplings was thought to help the foot achieve a softness and size similar to the dumplings themselves.

The word "dumpling" has always had a close association with bound feet. The Chinese language is replete with puns based on words that sound alike but have different meanings and are written differently. In Chinese, "dumplings" are

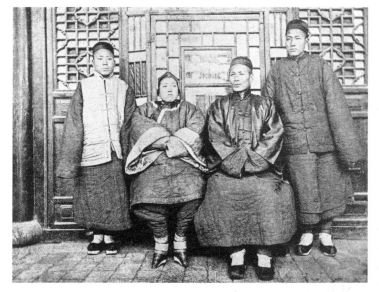

ᏸᏅ This is not the mother-in-law a six-year-old bride would want to bind her feet. (From *Chinese Characteristics* by Arthur H. Smith. Fleming H. Revell, Co., New York, 1894)

called *jiao ce (chiao ts'e)*, but *jiao* also means "foot," which makes for a great play on words. While "red dumpling feet" implied pink, healthy, well-shaped little feet, and were something to be coveted, to tell a girl that she had "rice dumpling" feet was a great insult. This was an unfavorable description of poorly bound feet. In a similar vein, since a golden lily was the ideal, a larger bound foot might be called a silver lily, or worse yet, an iron lily.

When it came time to begin the actual binding, there were special women skilled in binding who could be brought in to do the job, or an elder woman relative or friend known to have experience and good technique would be called upon. The mother usually did not do it because it was thought she could very well succumb to her little girl's cries of pain. However, published reports from missionaries and Western doctors negate this theory. Chinese mothers could be quite brutal with their own daughters. The worst possible situation a little girl could find herself in was to have her mother-in-law do the binding. And since girls were often married off while they were still children, this was not an uncommon fate.

Soaking the Feet

Before beginning the actual binding, the child's foot would be soaked in warm to hot water to soften the skin. Various ingredients might be added to the water, such as ground almonds, mulberry root, white balsam, tannin, frankincense, urine, and an endless number of herbs and roots. Families handed down their own secret soaking recipes from one generation to the next.

The most exotic concoction I have read about was a broth made from boiled monkey bones. Monkey bone broth had to be used cautiously according to the manual, or it could soften the bones of the feet so greatly that the girl would not be able to walk. Should this happen, it was necessary to switch to a foot bath of purple copper powder and raw alum to strengthen the little foot bones again.

Warm animal blood was another pre-binding bath. In certain areas of Shanxi Province, particularly in Datong, an area renowned for especially minuscule feet, a terrifying procedure of foot softening was practiced. After the altar ceremony,

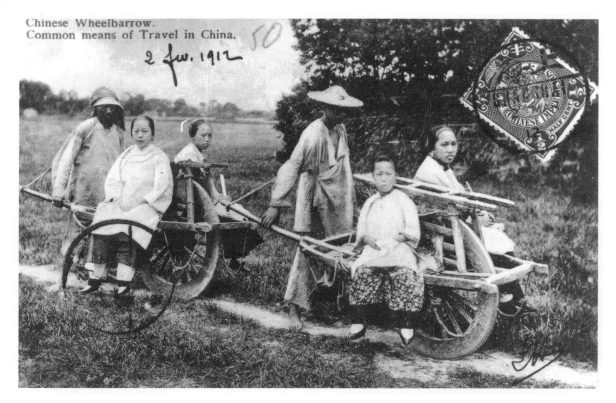

Chinese Wheelbarrow.
Common means of Travel in China.

2 fw. 1912

∾∾ A young girl's first footbinding ordeal became a festive event for female friends and relatives, who often traveled long distances in uncomfortable, wheelbarrow-type carts to attend. (From the author's collection)

a lamb's stomach was cut open, and both of the child's feet were inserted into it. The pathetic lamb was not yet dead, so its cries must surely have been a forewarning to the girl of what lay ahead for her. The feet would be left inside the lamb for about two hours, then quickly bound without washing. In Jiangxi Province, a live hen would sometimes be used in the same manner.

In areas where normal soaking was practiced, a good soaking was followed with a thorough drying, and then all the dead flesh rubbed off. Part of the creation of a smaller foot involved the loss of flesh that would ultimately rot away.

The toenails were the next target. It was necessary that they be clipped very short, as the four smaller toes were to be bound under the foot and crushed against the sole. Toenails digging into the foot could lead to serious infections.

After toenail clipping came a foot massage, with a liberal sprinkling of alum between the toes. Alum is used throughout the world as an astringent because it contracts body tissue and checks secretions and capillary bleeding. The alum

was particularly needed to offset perspiration. A lifetime problem for women with bound feet, perspiration caused itching and infections as well as unpleasant odors.

Binding the Feet

At this point, the binding began. The footbinder would use bandages made of white or dark blue cotton, approximately two inches wide and ten feet long. The dark blue was preferred in poorer areas as it wouldn't show the soil so easily. With bandage in hand, the footbinder would press the four smaller toes under towards the sole of the foot. Then, after placing the bandage against the instep, would wrap it over the small toes, holding them against the sole. The big toe was left exposed and bent slightly upwards and back towards the front of the leg.

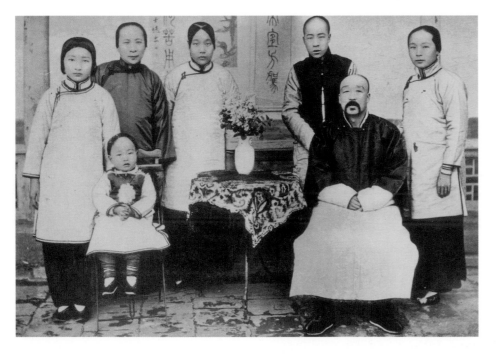

From the inside of the foot, the bandage was pulled up and around the bottom of the big toe, then pulled down, over, and around the instep. Next, the bandage went up and around the ankle, then back down to the instep. From the inner side of the foot, the bandage was then wound back around the heel, beginning the process of pulling the heel towards the front of the foot. The heel would ultimately take on a flattened, saucerlike appearance when binding was concluded, and while walking, the weight of the body would go to the heel. The binder would continue working the bandage in this order, using a figure-eight movement, instep to heel. Generally, the bandage was wrapped around the front part of the foot twice and around the heel three times.

Some footbinders soaked the bandages in hot water before using them, so that when they dried, the shrinking of the cloth bound the foot more tightly. In

northern China, a popular method for tightening the bindings involved insert-ing strips of bamboo into the bindings. In other areas, strips of leather were used along with the cotton bandages. Seeking to further shorten the foot by causing the skin to rot away, some binders inserted bits of sharp material such as glass, porcelain, or metal into the bindings. This would cause open wounds and speed the decaying of skin.

The footbinder frequently took a needle and heavy thread and sewed the bandages together at various points to keep them from unraveling and, more importantly, to keep the little girl from loosening them. Needless to say, the temptation to loosen the bindings had to be overwhelming.

A small pair of shoes made earlier by the mother would now be put on, and next came the worst part of the whole operation—the child had to stand up and take the first agonizing steps on her newly bound feet. She was forced to walk back and forth to avoid mortification setting in immediately.

The feet would be bathed and rebound frequently from now on. The period between rebindings varied according to the footbinder's own preferred method. It might be every day or two, or once a week. Progressively smaller shoes were used as the feet were gradually bound more tightly. It generally took about two years to complete the process resulting in a tiny foot that was properly shaped to look like an unopened lotus flower bud—the three-inch golden lily or golden lotus.

The lotus is a large pink, white, or yellow multi-petaled flower of the water lily family. Used as a religious symbol in Buddhism, Taoism, and Hinduism, it is most common to find statues of Buddha rising out of a lotus blossom. Buddha saw humanity in the form of lotus flowers—some immersed in the mud, some rising out of the mud and finally blossoming. Buddhist heaven is thought to consist of thirty-three levels, with Buddha himself sitting on a lotus blossom at the very top. The Chinese lunar calendar has a flower fairy and a flower anniversary for each of its moons. The Lotus Lady holds court in the sixth moon which falls midway between the summer solstice and the beginning of autumn. The twenty-fourth day of the sixth moon is the actual lotus blos-som birthday, and it does not go without celebration. People go lotus-viewing

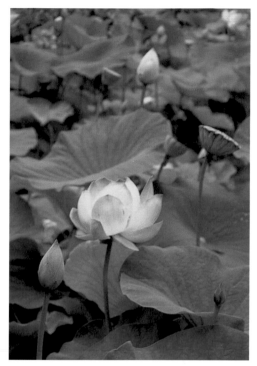

∾ *Above:* Pink lotus showing the tight, pointed bud (lower left fore-ground) and the fully open bloom (center). (Photo by the author)
∾ *Opposite:* In this family group, the mother (standing far right) and oldest daughter (standing third from left) have bound feet. Interestingly, the younger daughter (standing far left) has natural feet. (From *Two Gentleman of China* by Lady Hosie. J. B. Lippin-cott, Co., New York, 1924)

35

in the parks, and children wander through villages at night carrying lanterns in the shape of the lotus, or lighted candles nestled into lotus leaves.

Loose Binding

Local traditions in remote regions, and weather and working conditions in some areas, did not always accommodate traditional footbinding. A technique called loose binding was one of the substitutes adapted in its place. Loose binding gave women the appearance of bound feet without the permanent deformity. The effect was achieved by narrowing the foot, without pulling the heel forward and breaking the arch. The toes were wrapped under, but not with enough stress to break them as was done with normal binding. Because no

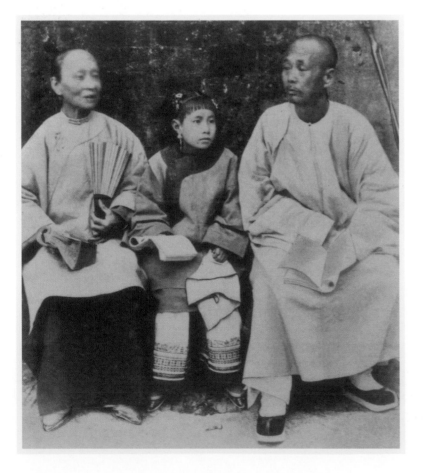

bones were broken, it was possible to walk and work with general comfort. And the illusion of small bound feet could be enhanced by wearing shoes with a special deceptive heel shape.

Some villages in the Shantou area had very relaxed binding techniques. The women had basically normal feet, and would wade streams and walk long distances barefooted. But upon approaching town on holidays or for festivals, they would stop and bind their feet in the manner of traditional binding. In other villages it was traditional for girls to have their feet slightly bound just before marriage, and to release them after the wedding.

A little-known but most interesting group of Chinese who loose-bound were the women of the so-called Lost Tribe who lived a totally isolated life in a mountainous area seventy miles west of Beijing. Although they were Han Chinese, they briefly allied themselves with the Manchus, and were forced to follow Manchu edicts, including the prohibition on binding

the feet. After the Manchus were deposed in 1911, the women of the Lost Tribe resumed the custom of footbinding. They did not bind their little girls' feet, but the adult women found a way to loose-bind, achieving a remarkable likeness to the real thing, including the ability to walk with the "lotus gait." There is a strong, though undocumented, possibility that some Manchu women also engaged in a form of loose binding.

The most surprising group of Chinese who engaged in loose binding were not women at all, but young men of the aristocracy in cities such as Shanghai during the fashion-conscious days of the 1920s. Many of them bound their feet lightly in order to squeeze them into the exceedingly narrow shoes that were all the rage at that time. Loose binding (as well as tight binding) was also popular with some male prostitutes and actors. Classical Chinese theater and its actors were very important throughout China, but particularly so in Beijing. Consequently, homosexual brothels flourished in Beijing, and much loose binding was found there.

Another instance of loose binding involved baby boys whose mothers wanted to fool the evil spirits into thinking that their sons were girls and therefore of no value. It was quite usual for mothers to dress the infant boys as girls, complete with loosely bound feet, as a form of spiritual protection.

Just as there are many theories regarding the origins of footbinding, there are a variety of legends in Chinese literature to explain how they came to be called "lotus feet." The tale I find most delightful tells of the Buddha being forced to jump from a rock high up on a cliff. He was saved by landing feet-first onto a lotus blossom floating in the pond below.

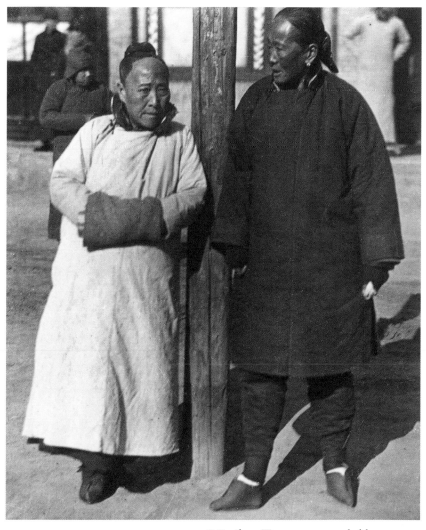

❧❧ *Above:* Two women, probably servants, gossip on a street corner in Peking. (From the Sidney D. Gamble Foundation for China Studies)
❧❧ *Opposite:* Both grandmother and granddaughter have bound feet. (From *A Passport to China* by Lucy Soothill. Hodder & Stoughton, Ltd.)

When I first became interested in lotus shoes and footbinding, I spent a lot of time reading old books about China, particularly those written by missionaries who served in hospitals and orphanages. In recent years I have had the opportunity to speak, with the help of translators, with many elderly Chinese women who had their feet bound as young girls. (Most of these women have since unbound their feet.) I also had a special interviewer in China who sought out women whose feet were still bound, and who asked them a series of questions I had prepared for her. These first-hand accounts have proven to be a rich source of information for me, and I have included a number of them in this book. They have an immediacy that no textbook descriptions can provide, and I am so grateful to the women who have shared their stories with me.

Following is the account of one of these women, Mrs. Wang Jifang, who was born in a small village near Beijing in 1905:

> At age six, my mother bound my feet. She followed the traditional way by using a long white cloth about 167 centimeters long and 9 centimeters wide. She bound my four small toes underneath my foot, leaving only the big toe out. Until the bones of the four small toes were broken, it had to stay bound. The suffering I experienced and the tears I shed were unspeakable. From the beginning of the binding until the time I could 'walk,' it took half a year. After that it was not even walking. I was only able to move by lifting the front part of my feet, using only the heel. One could even hear the sound of the heel heavily touching the floor like 'deng, deng, deng.' Therefore, look at my heels now. They are a lot bigger than yours.

> My feet were softer. They were easy to bind, narrow and pointy type of delicate feet. My mother was quite content. She felt that she had done something good for her daughter, hoping it would find me a good husband. I also think that my feet are pretty and I am grateful to my mother. My three sisters who have already passed away, had feet less flexible than mine. They suffered more. Because their toe bones were not easily broken, my mother had to use rocks to press their small toes. Finally she succeeded, but she always says my three sisters' feet were not as pretty as mine.

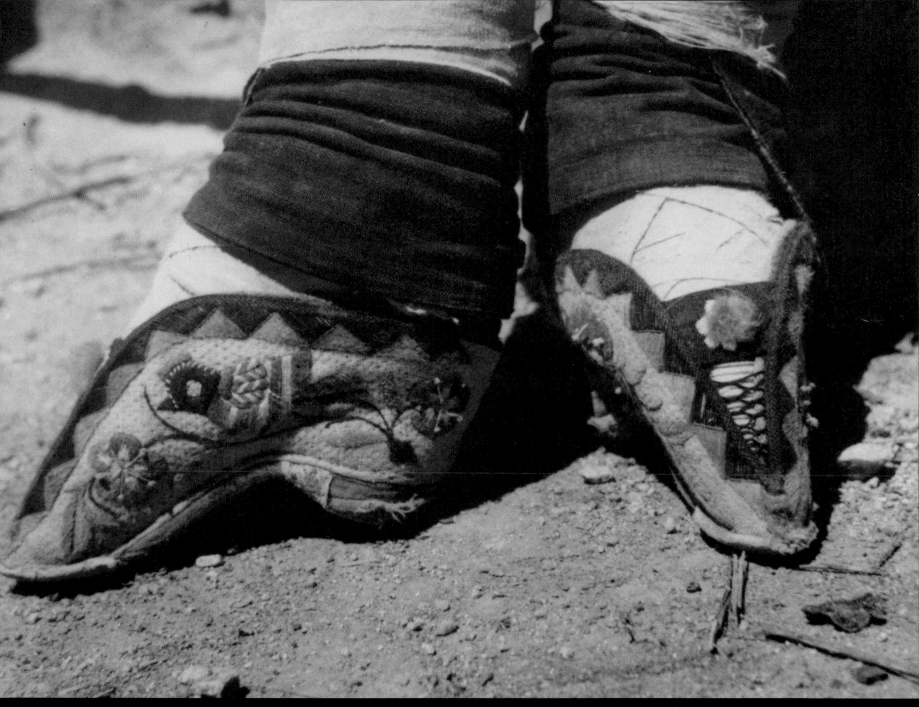

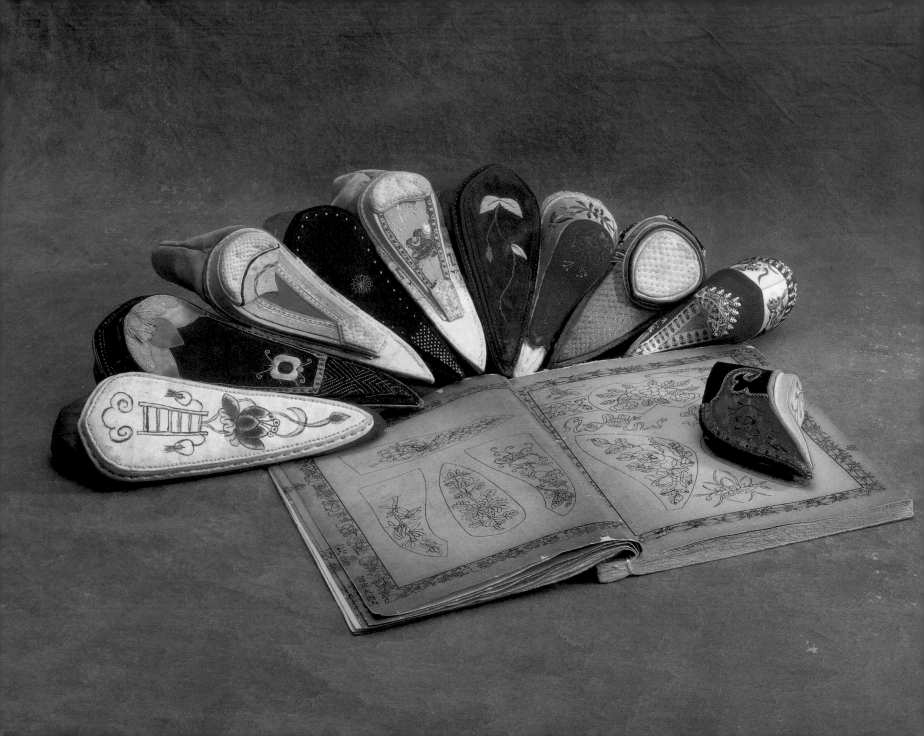

SPLENDID SLIPPERS
FOR LOTUS FEET

P hoenix Treasure wept until her heart and soul were dry. Her screams of pain brought no comfort from the grownups in the household, and only frightened glances from her brothers. When she tried to loosen the bindings, she discovered that the footbinder had stitched the bandages in several places to foil any attempts to escape.

The first time her new lotus shoes were placed on her tender, broken feet, her whole body went rigid and felt numb. When her amah lifted her from the chair and set her on the ground, she immediately toppled over. Unable to move, barely able to breathe, Treasure began to sense that her days of chasing insects in the garden, catching fish in the pond, and playing with her brothers were truly over. As young as she was, she knew that nothing would ever be the same for her again.

All she could manage was to hobble slowly and painfully about the house and courtyard, or sit and stare resentfully at Golden Peony huddled over her sewing. Though only thirteen, Peony was betrothed and seemed content to spend every waking moment studying her embroidery pattern books or patiently stitching, clipping, and knotting in an almost hypnotic rhythm. Her only real contact with the world beyond the compound walls was when the cloth and ribbon vendors came to offer their wares. Then Peony seemed to come alive as she pondered each color and texture, lavishing the most time and attention on the creation of her tiny shoes, all sixteen pairs.

Opposite: Collection of shoes showing the astonishing variety of embroidery styles, quilting stitches, and appliqué techniques used on the soles. In the foreground is an embroidery pattern book illustrated with designs for lotus shoes, as well as many other items of clothing. (From the author's collection, Larry Kunkel Photography)

⊚⊚ *Opposite:* Collection of wedding or special-occasion shoes ranging from brilliant crimson to deep fuscia to soft tomato reds. The rarest example (middle left) is heavily couched in gold and silver, has a padded interior, and is attached to a lacquered, fabric-covered split wooden sole imbedded with round metal pegs, or cleats, for traction on ice and snow. Note the great variety in shoe length and heel height. (From the author's collection, Larry Kunkel Photography)

❖ ❖ ❖

It was one of those dismal rainy days in Scotland—the kind of day when required sightseeing is out of the question, so one can wander the antique shops with a totally clear conscience. I wasn't looking for anything in particular, which, of course, is the very time one might stumble upon something special. And that day in Edinburgh it happened. I found something very small that was destined to become something very big in my life. Half-hidden sort of nowhere between some dreary Victorian glass and some ugly objects made of moose horn, something made of shiny red cloth caught my eye. It was a pair of tiny silk slippers with needle-point toes.

I knew instantly that they were Chinese shoes for bound feet. I had seen pictures, but this was the first time I had actually seen them—held them in my hand. Peeking inside the narrow, three-inch-long shoes, I noticed some words stamped inside one of them. It read "St. Mary's-in-the-Woods—Indiana." They only cost $20, and the weight was certainly minimal for carrying home. Of course, I bought them!

Alone in my hotel room late that night, listening to the rain pounding on the roof and beating against my windows, I took out my curious scarlet slippers. Though I knew little about them, I did know that they were referred to as "lotus shoes" and they were made for "lotus feet." Studying them, my thoughts drifted from the miserable Scottish night to far-off Cathay and lovely ponds filled with beautiful pink lotus blossoms.

For the rest of the trip the weather was bright and clear, and the shoes lay forgotten in my suitcase. And upon my return to California, I tucked them away in a drawer in the rush of catching up that always follows a faraway adventure. It was not until another rainy night several months later that I remembered them and sought out the neglected little treasures. And now, set out amidst my collection of lovely Chinese robes and kingfisher feather crowns, the little silk shoes took on a very special identity. They seemed to capture the essence of those ladies who had worn them, and once again, my imagination took me back centuries in time to ancient China, a world I had known only from books and my collections.

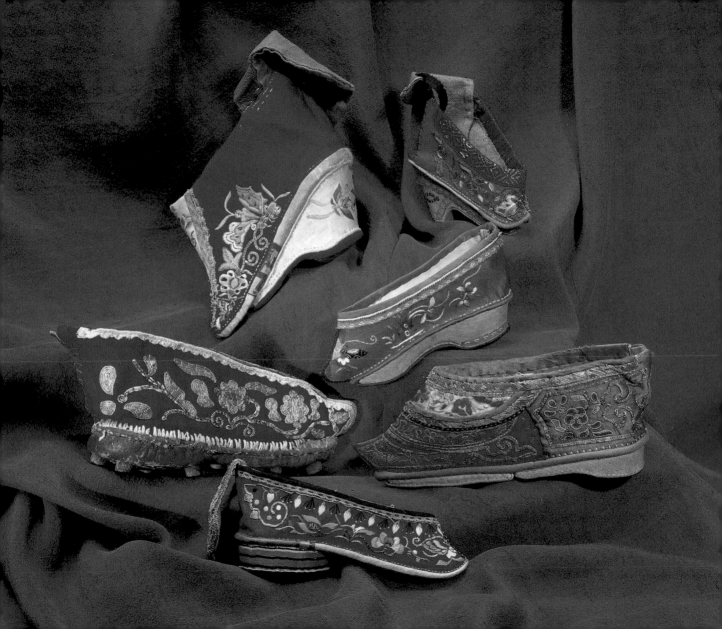

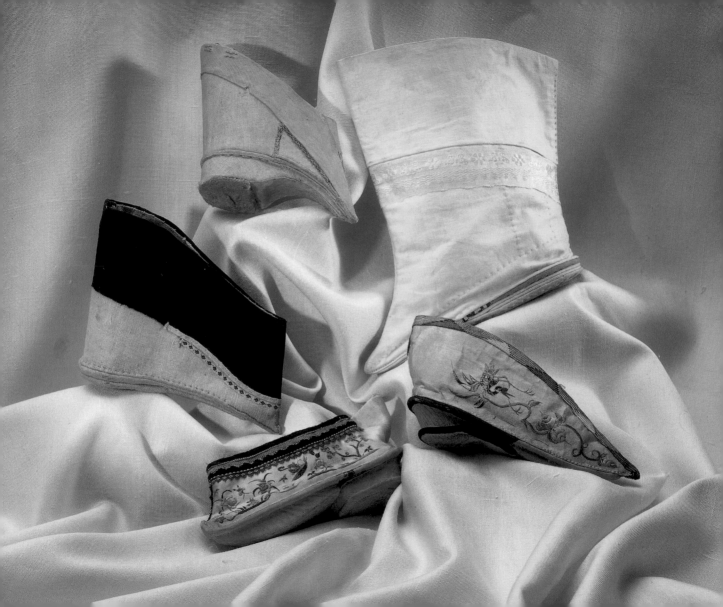

And then my quest for information on the origins of footbinding and the little shoes began. A few days later, I wrote a letter to the Indianapolis Chamber of Commerce, asking for clues to the identity of St. Mary's-in-the-Woods. It turned out to be the motherhouse for the Sisters of Providence who had operated orphanages and clinics in China prior to 1949.

I visited or wrote to secondhand bookstores throughout the United States and England, searching in earnest now for books with first-hand accounts of women with bound feet and/or the shoes they made for those feet. I hounded my Chinese American friends to contact their relatives to find out about members of their families whose feet had been bound. I made a business arrangement with a Chinese woman living in Beijing to search the city for women with bound feet and interview them for me. And I contacted all the antique dealers throughout the world from whom I had bought Chinese textiles and kingfisher feather ornaments and asked them to now search for lovely little lotus shoes for my collection.

The more I researched, and the larger my collection grew, the more astounded I was that the women who had endured so much pain to create something quite ugly (their withered bound feet), could also create such exquisite fantasies to cover them up.

I would look at a pair of delicate celadon green shoes in the swooping northern style, and marvel at the woman who had created them and had envisioned an arched fish leaping towards the toe. If she was an aristocrat, her only likely acquaintance with real fish would have been pet carp swimming languidly in an ornamental pond in her garden, or richly prepared on her banquet table. Had she been of a lower socioeconomic class, she would only have seen fish in the marketplace. And yet she had captured the shimmering, quicksilver spirit perfectly.

One of my favorite acquisitions was a pair of black padded silk shoes with wooden soles made for the long snowy winters in the north. To me they exuded a spirit of optimism, for they were magnificently embroidered with pale pink plum blossoms, these being the first blooms to appear on the leafless and apparently lifeless branches of any tree even before winter is past.

⊚ *Opposite:* A collection of shoes demonstrating the colors, fabrics, and decorative elements appropriate for the different stages of mourning. These range from the very plain, undyed sackcloth worn in the first stage; to intermediate stages of undyed silk (top left), plain white cotton (top right), blue, gray, or black cotton (middle left); to the final stage when silk and embroidery are permitted (bottom left and right). (From the author's collection)

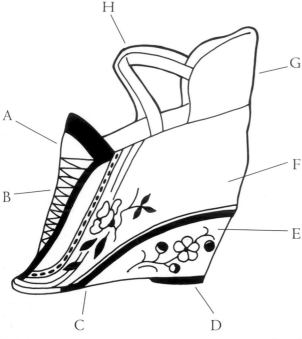

✺✺ The basic components of a lotus shoe. (Drawing by Akiko Aoyagi Shurtleff)

A. Moon gate

B. Ladder rungs

C. Front sole support

D. Rear sole support

E. Perfume storage

F. Inner heal

G. Heel lift

H. Heel lift reinforcement

❖ ❖ ❖

Those who collect lotus shoes can be faced with some confusion when trying to pinpoint exactly where a particular pair of shoes in their collection was originally made. No definitive shoe style can irrefutably be attributed to any one specific region of China since a bride might grow up in one province, make her shoes of local design, and then move to her husband's home in another province where the style was quite different. And in large cities, fashions changed quickly due to foreign influences. Thus, for novice and experienced lotus shoe enthusiasts alike, identifying regional styles is difficult to do with certainty.

It can safely be said that the majority of the shoes from cities were made of silk. In the villages and in poor sections of cities, cotton was the fabric used because it was less costly and more durable. Unusual shoes of leather such as pigskin were made in Shanghai in the 1920s, but have surfaced nowhere else.

Lotus shoes varied greatly in style not only according to geographical area, but also climate, lifestyle, and, in cities like Shanghai, according to fashion. In some areas, a higher heel was used to make the foot look smaller. The shoes of hard-working peasants and many of the minority peoples were not only less sophisticated, but made to be much more comfortable. These people were too poor to indulge in the luxury of high heels, and couldn't follow changing fashions even if they wanted to. Their shoes would be made of the least expensive cotton fabrics available, rather than the lovely fragile silks used by women of wealth, as mentioned above.

In general, shoes from northern China are larger than those from southern China. This is due to the fact that the Northerners were physically taller and heavier then their counterparts in the south, so their shoes were somewhat larger, too. The few Westerners who saw the wives and concubines of wealthy mandarins in Hong Kong, who were kept almost totally hidden from the outside world, report that they had the very smallest feet anyone had ever seen. (It is said these women were kept in bed and off their feet during the first years of

46

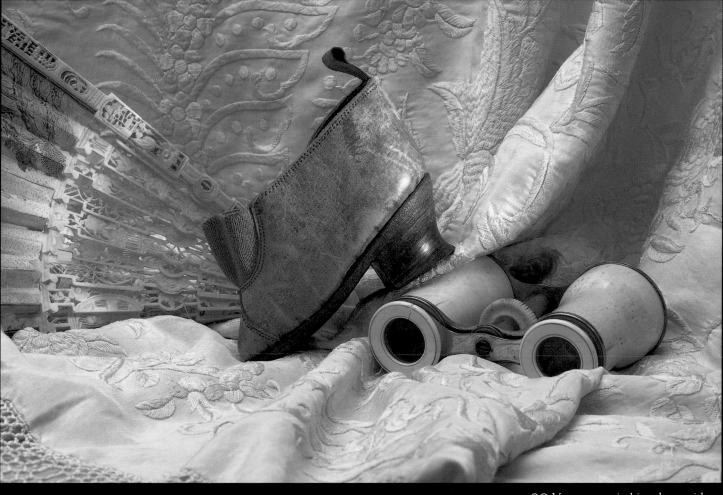

◎◎ Very rare pigskin shoe with a wooden, Western-style heel and an elastic front panel. Probably custom-made for a fashion-conscious young woman in Shanghai in the 1920s who wished to appear more modern. Length 3¾ inches. The fan is antique ivory and painted paper, and the opera glasses are celluloid, made to imitate ivory. (From the author's collection; opera glasses from a private collection)

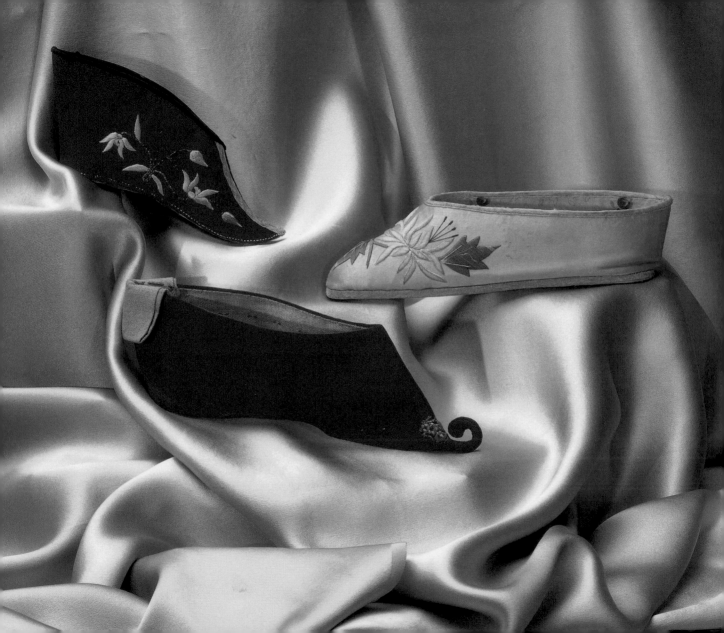

binding, and in later life were carried everywhere. The carrying could, of course, have been an additional demonstration of the family wealth.) In 1990, a Reuters News Service reporter, Mitya New, interviewed a ninety-three-year-old woman in Hong Kong who could not remember the size of her feet when they were bound. However, she remembered that it was so difficult to walk that she was carried everywhere on her maid's back. The only activities she could engage in without pain were sewing and embroidering.

Certain rules of construction applied to most lotus shoes. Both the toe and heel portions of the foot had to fit into the shoe. The big toe, which was the only toe left in a normal position, would protrude into the front of the shoe, but not all the way down to the needle-nose point so many of the shoes had. The rear upper part of the shoe was usually made wider to fit and cover the extra bulge caused by bending and stuffing the lower parts of the feet into the small shoes. Comfort very definitely didn't enter into any of this!

One type of shoe that is very easy to identify are those that were made for Manchu women. When the Manchu conquerors took over China in 1644, they desperately feared integration. Manchus were forbidden to marry Chinese, and Manchu women were not permitted to adopt the Chinese custom of footbinding. However, the Manchu men were not impervious to the sexual appeal of the tiny Chinese lotus feet and the sexy lotus gait. And their women were well aware of this interest, which eventually led to the Manchu woman's unique answer to footbinding—shoes elevated on platforms of various shapes that narrowed at the bottom. This platform made it appear that the wearer had bound feet, and even enabled the wearer to adopt the special walk.

The platform took the form of a very high extra sole made of cork or lightweight wood, covered with white kid or white paint. One popular style rose in the middle of the foot like a pedestal, supporting only the instep of the foot. Even the famous Empress Dowager Ci-xi, last empress of the Qing Dynasty, succumbed to this fashion. She particularly favored the high platforms as she was quite short. Shoes as high as six inches from the ground gave her a more imposing stature. Many of these shoes had strings of large pearls swinging like

∽ *Opposite:* Group of silk satin bed slippers. Because the bindings were never removed, regular shoes were replaced with soft sleeping slippers upon retiring for the night. (From the author's collection, Larry Kunkel Photography)

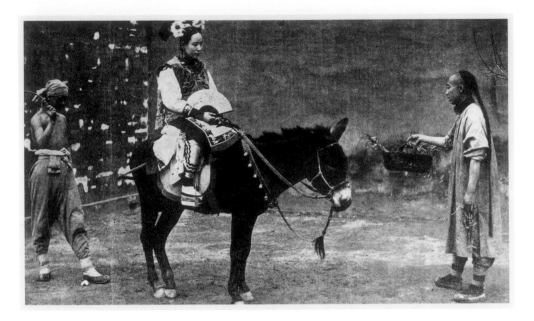

◉◉ A Manchu lady wearing high, cork-soled shoes. (From *The Old World and Its Ways* by William Jennings Bryan. Thompson Publishing Co., St. Louis, MO, 1907)

a fringe from the top of the platform. Two months after the looting of the emperor's summer palace by French troops in October 1858, one of the Empress's platform shoes with pearls appeared in the window of a fine jewelry store in Paris, and it sold for 600,000 francs, or about 24,000 English pounds.

Shoe Colors

Tradition figured heavily in the choice of colors utilized in Chinese garments and shoes. About 300 B.C., during the period known as the Warring States, *Li Chi, The Book of Rites,* was written. This record of rituals covered all phases of ceremonies and rites in China, and was strictly followed right on through to the end of the Qing Dynasty. There was even a Board of Rites which served to interpret the *Li Chi* much as our Supreme Court serves in interpreting our Constitution.

Colors and their uses were thoroughly covered in this book. The Chinese recognize five primary colors—red, yellow, blue (which includes green), black, and white—and each is designated for certain purposes or for use by certain people.

Red is the color for all festive occasions such as weddings, anniversaries, and New Year celebrations. Red is also a symbol of virtue. In the classical Chinese

theater, a man with a red face is usually a sacred person. The walls of the Forbidden City are red. Collectors of shoes for bound feet find many more red shoes than shoes of any other color. This is understandable, since, from the first pair of shoes made for Kuan Yin's altar to every special-occasion shoe thereafter, red would have been the color of choice.

Up until the fall of the Qing Dynasty, the color yellow was worn only by the emperor and empress and the heir apparent. Everything from their ceremonial clothing to the roof tiles of their palaces to the plates their food was served on was yellow. As Henry Pu Yi, the last emporer of China wrote, "We lived in a virtual golden yellow haze."

Blue had no confining rules. The combination of blue and red (purple), which many Western monarchies considered the royal color, was prescribed by the Board of Rites for the grandsons of the emperor but not for the emperor himself. Purple and bright green were considered suitable for young women, who often wore matching socks and shoes in these colors.

Middle-age demanded subdued colors such as blue-gray or blue-green, and black was the color for later years. There was a segment of the population who did not use black, however. Since black is the color of bruising, it was considered by some to be a sign of evil. It was also considered improper for older women to wear red shoes except on birthdays and holidays. (Black later became a very popular color with the chic modern ladies of Shanghai in their younger married years.)

White is the color of mourning in China, and there were very strict rules regarding its use. Plainness, such as using undyed material, was the basic idea. There were five degrees or stages of mourning to be observed. For the first period of mourning, immediately following the death of a parent or other close relative, mourners shoes had to be made of colorless sackcloth without hem or border. For the second period, a border could be added to the sackcloth. Pure white followed this stage, and after the first month, white shoes with embroidery or other adornment were worn for an extended period of time. Or the mourner could switch into dull blue, black, or gray. If the deceased was a

parent, children were expected to adhere to these rules for twenty-seven months. During that period, neither silk shoes nor clothing could be worn, and wearing red was forbidden.

How to Make a Lotus Shoe

Up until the early 1900s, almost all lotus shoes were made in the home by the person who was going to wear them. As a matter of course, girl children were taught how to make their own shoes at a very early age. One woman I spoke with was able to give me a very detailed description of exactly how hand-crafted shoes were made. Although she was in her late eighties, Mrs. Mou Xiu-chung had very clear memories of her childhood in Shandong Province.

According to Mrs. Mou, her shoemaking required two kinds of cotton fabric, one rough and thick, the other fine and thin. The fabrics were purchased from itinerant peddlers who passed through the narrow lanes where she lived. Then she needed a wooden board about six inches wide and three feet long, and a bowl of flour paste. (Mrs. Mou grew up in an area of China where wheat was the predominant crop. In rice-growing regions, a rice paste would be used.) Finally, she used a wooden form of her foot that had been made to order for her by a carpenter.

The first step was to prepare the sole of the shoe. Flour paste was spread across the top of the wooden board. A piece of rough thick cotton was laid on the board, and the paste was spread inward all over the cotton. A second piece of the same cloth was placed on top of the first, and this too was covered with paste. Then a third piece of cloth was added followed by more paste. This would be set out in the sun to dry thoroughly.

In many cities it was possible to buy this layered cotton already prepared. Small shops employed men to paste rags together for shoe soles. However, their product generally went to professional shoemakers and itinerant peddlers. Women who made their own lotus shoes were more particular about the quality and subsequent comfort.

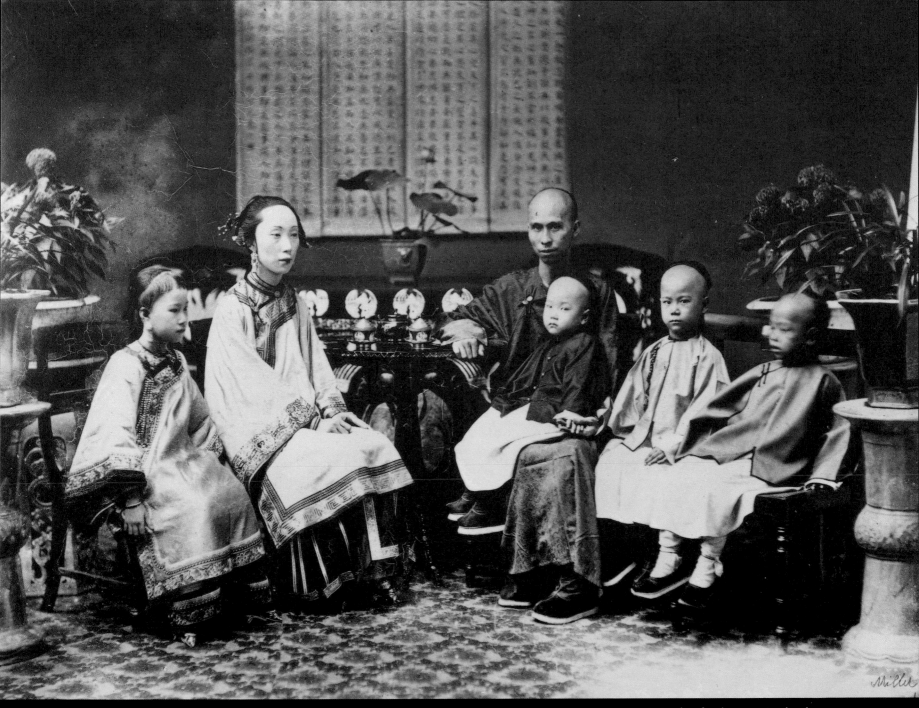

⊚⊚ In this family portrait, the three

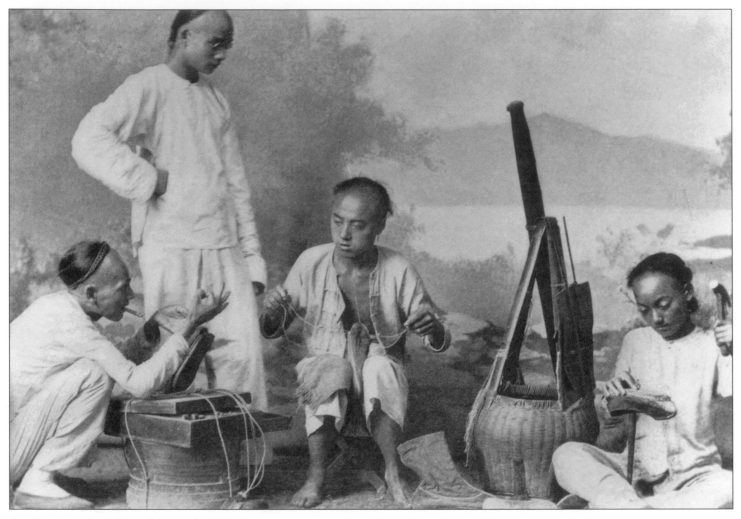

◎◎ Professional cobblers making men's boots (center) and Manchu platform-style ladies' shoes (far right). (From *The New America and The Far East* by G. Waldo Browne. Colonial Press, Boston, MA, 1907)

For those making their own shoe soles, once the pasted layers of cotton had dried in the sun, the paper pattern for the soles of the shoes was laid on the cloth and cutting began. This process was repeated two or three times, to give as many layers as were needed for the proper thickness of the sole.

Once cut out, the layers forming the sole were stacked, with each layer a bit smaller than the bottom side of the shoe. "The well-made sole should be thicker at the center than the edge for comfortable wear," Mrs. Mou said. The layers were then sewn together around the outside. Finally, using heavy thread and a large needle, she would sew small stitches all over the sole, giving it a

quilted look. This quilting process was quite common, though not used by all shoemakers. (It is interesting to note that the process for making these quilted soles for lotus shoes is very similar to the process used in making modern high-tech, laminated, fiber-reinforced composite plates that are commonly used components in aircraft, automobiles, and ships. With these plates, transverse stitches are used to increase the strength.)

Materials needed for the top of the shoe included several thick white cotton strips about one half inch wide, and two pieces of side cloth made of silk, cotton, or wool, about one inch wide. The two white cotton pieces were pasted together as with the materials for the soles. They provided a sturdy inner structure for the body of the shoe.

If the shoe was to be embroidered, this was done after the outer silk fabric had been cut from the pattern, but before the shoe was assembled. Pattern books were available for the embroidery designs. The small books could be purchased from notions peddlers, or in shops. They contained patterns for decorating lotus shoes as well as all types of clothing, hangings, and decorative panels. Some of the designs were extremely elaborate and challenged the skills of the finest needleworkers. (Recognition for original designs was found in certain villages where annual contests were held for the most perfect golden lilies. Very strict binding procedures were employed to insure a heritage of tiny, perfect feet. And for months, or even years, before a contest, the work went on of devising inspired new designs for the shoes that would cover them. Unlike other beauty contests, the contestants were seated hidden behind screens, with only the exquisitely shod feet showing beneath for the judges. Thus, an eighty-year-old woman stood as much chance of winning as did a sixteen-year-old beauty. It was all a matter of very tiny feet and very splendid slippers.)

With the embroidery completed, the top layer was now ready to be glued to the heavy structure, creating the top of the shoe. The alternative to this step was to sew the rear part of the top of the shoe to the heavy layer.

Women who could afford it had life-size forms of their feet carved out of wood. In later years, composition forms were molded. Another device used was

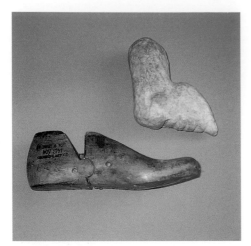

a homemade fabric form, the size and shape of the foot, stuffed with cotton, dried soybeans, or grain. These forms would be utilized to keep everything in place as the top of the shoe and the sole were sewn together. If a woman could not afford any type of form at all, soybeans or other grains were used to fill the shoe and help it keep its shape. In this position, the final pieces of decorative braid and those needed to hide seams were glued into place.

It was the general practice for women in cities to buy shoemaking supplies from street peddlers, as they rarely left their compounds to visit the shops and marketplaces. According to tradition, each peddler had his own musical sound or call. In this way, women inside the compounds would know exactly who was outside waiting with merchandise or services to sell. Many of the peddlers' cries and instruments have remained unchanged over the centuries, and some can still be heard in China today.

The cloth peddler, who was essential to the making of lotus shoes, used a small drum to announce his presence. It was about three inches in diameter, and rested on the end of a handle about twelve inches long. The cloth was carried in a bundle on the peddler's shoulders or pushed on a small two-wheeled cart. The really fine silks were not sold by these peddlers, however. For those, a maid or other servant or relative would have been sent to a fine silk shop.

Silk has always been the fabric of choice for Chinese women's clothing, if they could afford it. The Empress of Huang Ti (2609-2598 B.C.), who was deified and worshipped as the goddess of silk, is considered responsible for the discovery of the silk filament that silkworms produce for their cocoons. The secret of the beauty of this product lies in the layers of protein that cast a pearly sheen. Silk fibers are triangular and consequently reflect light like tiny prisms. (Hyde 1984) Wanting only the best for their diminutive bound feet, Chinese women would use silk to make their lotus shoes, if there was any way they could afford and obtain it.

The shoes were frequently trimmed with one or more kinds of braid. These were sold by the braid peddler who also announced his presence with a special drum beat as he wandered through the lanes looking for customers. He carried large boxes of braids on his back, all wrapped in blue cloth and held together

with ropes. He sold both plain and embroidered braids. Late in the Qing Dynasty, braids made in France and England were offered along with the Chinese products.

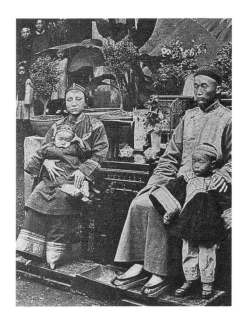

Items like scissors and thimbles were brought on the back of the notions peddler. The thread peddler sold the threads needed for sewing the shoes together and for the decorative embroidery. The boxes he pushed on a small cart contained silk, cotton, and hemp thread, plus buttons and all types of needles.

There were also shops that sold supplies to the women who ventured out of the family compounds, or to their servants. In pre-1949 China, shopkeepers hung out symbols of what was for sale inside. Outside a shop that sold the wooden parts for women's shoes, one would see a hanging pendant holding one of the central heel platforms of a Manchu woman's shoe, and below it, a wooden heel for shoes for bound feet. Stores selling fabric for ladies' shoes would have a sign consisting of an oblong piece of red cloth hanging from a yellow carved wooden frame. Here a woman could buy silks and velvets of finer quality than the fabrics carried by the street peddlers. (Crane 1926)

Han Chinese women would buy what they needed at these shops, then take the supplies home to make their own lotus shoes. Manchu women, however, would buy their supplies, then take them to a shoemaker who would make their normal-sized shoes for them. They would frequently embroider the silk part of the shoes themselves and give that to the shoemaker to incorporate into the finished shoe. Making their own shoes was not as important to the Manchu women as it was to the Han Chinese women.

Wedding Shoes

Shoemaking reached its height of importance in preparation for a girl's marriage. Her finest embroidery skills were called into play to decorate the dowry shoes, for these shoes would be examined very closely by the bride's new family and their friends. In some provinces of China it was customary to display the shoes the bride had made for herself, along with the other items of her dowry.

In addition to the special red wedding shoes, a girl prepared three other very important pairs of lotus shoes for her married life. The first was made with a purple top and white lower edge, because when the Chinese characters for purple and white are written together, they mean "a lot of children." The second pair was almond color (the only shade of yellow that could be worn by commoners), as yellow means a fortuitous date on the Chinese calendar. The third was a pair of red sleeping slippers.

According to tradition, before going to bed on the wedding night, the groom was expected to remove the bride's shoes himself. (The foot bindings themselves were not usually removed in his presence.) When the bride produced her red sleeping slippers on the night of their marriage, it was not unusual for the groom to find erotic pictures hidden inside them. The newlyweds would look at the pictures together in their bridal bed. Such pictures might have been embroidered by the bride's mother, or painted inside the shoes by artists who specialized in such work. The sleeping slippers were generally made of red silk, as it was thought that the contrast of red silk against pale skin was erotically exciting.

Sleeping slippers were generally less structured and very much softer than their daytime counterparts. Because they were not meant to be worn outdoors, or really even beyond the bedchamber, many were made without actual soles and can be folded flat as a handkerchief. Others have a nominal structure but were made with fewer layers of fabric for less stiffness and presumably more comfort.

Women never went to bed in only their bindings. The feet were always enclosed in some type of sleeping slipper. It was these slippers that were most coveted by romantic males. If a woman were to reward a lover with a pair of her shoes, it would usually be a pair of sleeping slippers.

A bride definitely wasn't limited to four pairs of shoes. If the family was wealthy, she would have many pairs, and they would all be displayed with the rest of her trousseau on her wedding day. The ideal was to have sixteen pairs of shoes, four for each season of the year. And it was a common practice to make a very special pair for the future mother-in-law, as well. Of course, she would

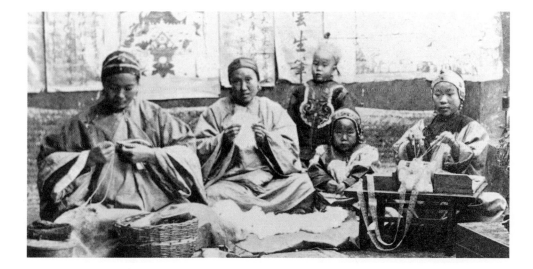

Women and children engaged in embroidery. Note the woman on the left is working on a lotus shoe. (From *Chinese Characteristics* by Arthur H. Smith. Fleming H. Revell Co., New York, 1894)

already have seen samples of her daughter-in-law's shoemaking and embroidery skills on the shoes originally brought by the matchmaker.

As mentioned earlier, girls sometimes got a little help in making their shoes. Because they were often betrothed at an exceedingly young age, if they came from a family with servants, their amahs would still be very much involved in their lives. Many amahs throughout history would secure promises of good behavior from their young charges in return for help with making these special shoes.

Although tradition dictated that mothers would make their daughters' first pairs of shoes, as well as the miniatures that were set upon Kuan Yin's altar the night before binding, once the feet were properly bound, each girl would make her own shoes for the rest of her life. But, as with everything in this vast country, there were exceptions to the rule. Sometimes amahs or grandmothers could be talked into lending a skilled hand with the shoes that the matchmaker would show to a potential mother-in-law and husband.

Other exceptions included the concubines of very rich men and actresses, whose talents and interests ran in directions other than embroidery. They would pay to have their shoes made. And these shoes would be particularly fine and unusually small, as concubines and actresses generally had the smallest feet of all.

The art of making the shoes, and the art of embroidery, were usually taught to the young by older female members of a family. In the 19th century, Western Christian missionaries maintained orphanages and frequently held classes to teach their girls these skills.

It was only after the Communist takeover of China in 1949 and the permanent eradication of further footbinding that women began to buy shoes that were commercially produced and sold. In the 1980s, the June First Children's Shoe Factory in Tianjin was manufacturing one million pairs of tiny black velvet, cotton, or leather shoes a year for women with bound feet. These shoes were sold throughout China. They are still being made today, in a greater variety of styles, but in smaller numbers as the women whose feet were once bound decrease in number. None of the women interviewed for this book still made their own shoes. And of those who lived in China, all wore the small, plain black cloth shoes sold in government stores. But many of them had tears in their eyes when they were shown photographs of the beautiful handmade shoes from my collection. What memories these pictures must have brought back!

While women in China today who have had their feet bound have to be satisfied with the locally available ready-made shoes, the descendants of the Chinese women who went to live in Malaysia long ago can still have beautiful little shoes handmade for them if they live in or near the port city of Malacca, which is located about seventy miles from Kuala Lumpur. My search for lotus shoes led me to Yeo Sing Guat who still operates a shoemaking business there, probably the only one of its kind in the world. The shop was founded by his grandfather back in 1918. At that time there were more than 1,000 women with bound feet in the area, most of whom had emigrated from southern China. Today, only ten or twelve women remain who still wear the tiny shoes. However, Mr. Yeo has found a way to keep his business flourishing by making lotus shoes to sell to tourists. When cruise ships sailing the Straits of Malacca put their passengers ashore for a day of

◎◎ Mr. Yeo Sing Guat still makes shoes by hand for the few women living in Malaysia with lotus feet. His shop is probably unique in the world and has become something of a tourist destination in Malacca, about 70 miles from Kuala Lumpur. (Photo by Virginia Hunter)

sightseeing, many of them head for Wah Aik Shoe Maker where Mr. Yeo plays host to his visitors by demonstrating his trade.

His shoes are not laboriously hand-embroidered, and he employs modern methods in constructing them, but it still takes him approximately one day to make each pair. He has added certain modern touches such as Western-style heels, a shoe tongue, brass-edged eyes, and gold shoelaces. Each shoe has his name and address stamped on the sole, and he delights in autographing each heel in Chinese characters. Even more than this, he enjoys posing for photographs with his shoes and explaining the history of footbinding. Tourists return with little reminders of a thousand years of China's past to share with family and friends back home.

Interestingly, it was a 19th century English missionary who gave us the first Western critique on lotus feet and lotus shoes. This early fashion critic, writing modestly under the name of S. Pollard, spent a good part of his life in Yunnan Province, writing about the Miao people and the unknown aboriginals of western China, the Nosu tribe.

In his book *In Unknown China,* he discussed bound feet: "The foreigner who has seen how Chinese little girls have their feet bound, never gets used to the lily feet of the celestials, and the slow walk of these sisters never calls forth his admiration.

Chinese women, by beautifully embroidered shoes, by highly colored ankle bands, by strikingly loud silk trousers trimmed with rich braid, try to make their lower extremities attractive, and in some way not understood by foreigners, have succeeded in doing so. Even in country villages, where one would expect the details of fashion would not have much control, the young men seeking wives are influenced by the size of the foot.

The girl with a three-inch-sole shoe and an ugly face has a better chance in the matrimonial market than a five-inch-sole shoed girl who might have a face like a madonna. There is no accounting for the taste of some men. Fashion is supposed to rule women, but men are just as big slaves to fashion, at least at some times."

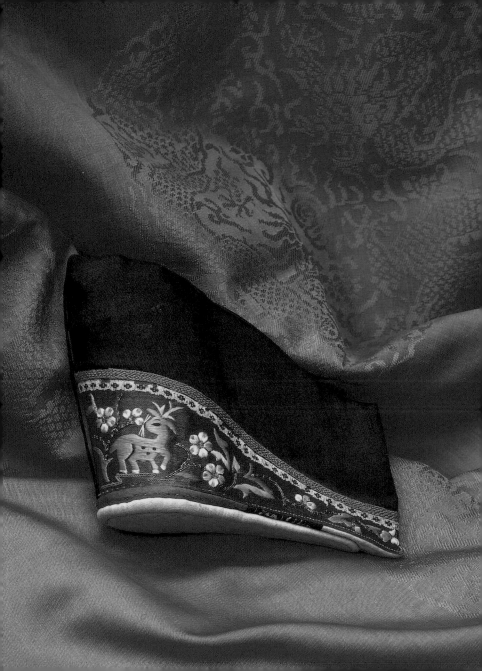

CHAPTER 4

GILDING THE LILY

The rain came down in great glassy sheets. "Sit down, Treasure, you're like a whole troop of monkeys in the house. Why don't you occupy yourself with something?" her amah asked. "Go and fetch Peony's pattern books. You haven't touched your sewing basket in days. Surely you want to have a beautiful trousseau like your sister had. You cannot go to your mother-in-law's house with drab clothes and plain shoes."

Phoenix Treasure stamped her tiny, tightly bound golden lily and cried, "I won't need a trousseau because I never want to have a mother-in-law because I never want to be married! I want to read and paint and write poetry and study like my brothers."

Amah laughed at the willful twelve-year-old before her. Of course Treasure would marry—she was already betrothed to a wealthy merchant's son in far-off Peking. Although it would be several years before she would make the journey to her new home and family, Amah knew that this high-spirited girl would never defy tradition and refuse. Girls *could* not refuse.

"Such nonsense! Why would a girl want to read? What use is painting and writing poetry to a wife and mother? You were born for the bedchamber, to please your husband, to bear him sons. You don't need to study for this. For this you need only to be beautiful and obedient and follow your destiny."

◎◎ *Opposite:* Although it has the appearance of having an elevated heel, in fact, this is a perfectly flat shoe with thin pieces of bamboo stitched into the heel area to hold it firmly in position. Lovely satin stitch deer and flowers adorn the deceptive "lift." Length 4½ inches. (From the author's collection, Larry Kunkel Photography)

Phoenix Treasure tried to stalk but only managed to totter out of the room with Amah's words still stinging her ears, vowing that *her* destiny would be different. But she had to admit, if only to herself, that sometimes her only moments of comfort came from her embroidery. At least with a needle and thread in her slender hands she was free to let her imagination wander where it would. Sometimes it wandered far beyond the compound walls where she imagined all manner of fanciful creatures, rendering them in wildly improbable colors like a black leopard with orange spots or a snowy white deer with blue antlers. Sometimes she faithfully reproduced what she patiently observed in her own garden such as a grasshopper on a newly opened chrysanthemum. A fan, a lantern, a teapot—even the humblest household objects served as models for her skilled fingers and observant eye. Now that Golden Peony was married and living in her husband's distant village, and her brothers were away at school, Phoenix Treasure was usually alone. Curled up beneath the window in the room she once shared with her sister, she sometimes worked for hours on a piece of silk only a few inches square. Like a monkey was she? Well then a monkey would adorn her latest creations. The last time she had seen one was during the New Year's festival when a peddlar had brought a charming little grayish brown rascal to the compound gate in a bamboo cage. Hers would be a lively golden honey color with sapphire blue eyes sitting in a clump of lime green bamboo....

<div align="center">◇ ◇ ◇</div>

Looking back, I realize that from the very beginning, it was the superb stitchery on the tiny shoes that truly captivated me. Because I had done complicated needlework myself for years, the delicate, imaginative embroidery on these shoes excited me tremendously. Collecting both the tiny lotus slippers and the larger Manchu-style shoes became the logical extension to my collections of Chinese textiles, as they completed the costumes. However, the lotus shoes have taken on a more personal meaning for me, perhaps because in addition to being exquisite examples of a craft, they also represent a kind of discipline, suffering, and resignation that we in the West cannot ever really comprehend. When I handle a pair of lotus shoes I often feel as if I am handling far more than an intriguing object.

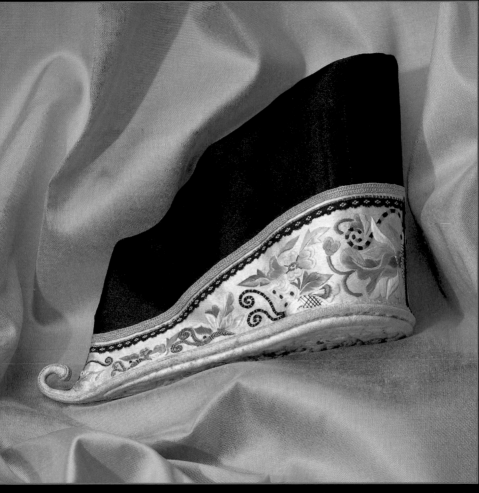

⊚⊚ Like a curling antennae, the highly
unusual curled "toe" continues the
insect theme of the embroidery on this

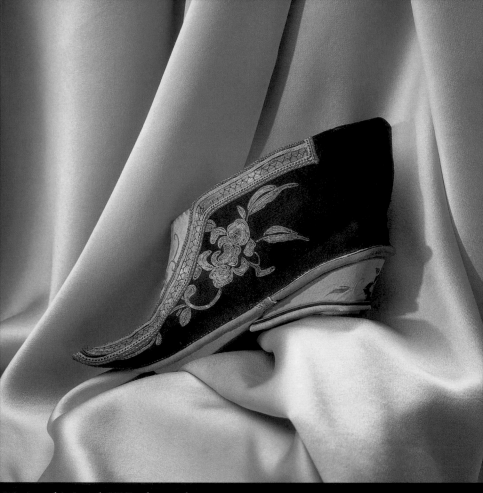

A sophisticated 1920s shoe with exquisite gold and silver couching and an exaggerated upturned toe. Length 5

Taking a small lotus shoe from the shelf, I set it onto the palm of my hand. The little treasure of white silk has no weight, but it has great power. The refinement of the embroidery amazes me. Flowering shrubs in full bloom grow upon it. A cricket flies across it. A mystical, colorful bird with minuscule sequin eyes perches on it. A tiny Endless Knot, symbol of the Buddhist path, worked in gold thread nestles into the toe. Most touchingly, two tiny weeping willow trees adorn this little white shoe of mourning. It is truly a small work of art.

Mountaintops, songbirds, flowers, and trees, pagodas, processions, dragons, and bees—almost anything might find its way onto the three or four-inch canvas the lotus shoes offered the artist working in needle and thread. Not confined to using only the commercially available patterns, a girl was restricted only by the limits of her own imagination, and nimble fingers. This was one time when creativity was permissible, even encouraged.

It is not unusual to find lotus flowers on the lotus shoes. Highly prized in the Orient, it is regarded as an emblem of summer, of purity, and of fruitfulness. In the Taoist religion, the lotus is one of the "Eight Precious Things," the symbol of Ho Hsien Ku, the female patron saint of housewives. For Buddhists, the lotus represents the promise of nirvana.

The soles of funeral shoes, made for the deceased to wear into the next life, frequently featured an embroidered or painted lotus blossom accompanied by a ladder. This signified a continual climb to heaven, based upon the rebus of the Chinese characters for the lotus and the ladder: lotus = continual; ladder = climb.

If it seems surprising to find these two signs for longevity on the shoes of the deceased, it is even more surprising to find the character *shou* is also used on funeral shoes. Shou, which means "long life," is also found on wedding clothing and garments for birthdays, anniversary celebrations, and other happy events. This may be done to imply that in spite of death, the lineage continues forward through the deceased's children, or it might be a euphemism to mask the finality of death. (Cohen)

Longevity is always an important theme in the Chinese culture, and there are countless symbols for long life. Tiny deer or curly-winged bats might be found

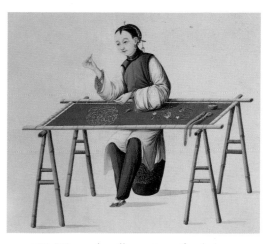

∾∾ Watercolor illustration of a lady at her embroidery. (Reproduced from the collections of the Victoria & Albert Museum, London)

flitting across lotus shoes, not only because they present attractive composition possibilities, but because they were also popular symbols of longevity. Other frequently used figures include the Chinese character shou, the swastika, crane, cat, butterfly, tortoise, monkey, peach, evergreen, sun, fungus, phoenix bird, and rocks. Pine trees, bamboo, and acanthus leaves are known as the three friends of winter since they all survive frost and snow and are also considered symbols of longevity.

The plum blossom is an important motif, as it is the first flower to appear after a hard winter, and signals the coming of spring. Joining plum blossoms in popularity are peonies, lotus, and chrysanthemums. These four were the flowers most commonly depicted on lotus shoes since they represented the four seasons of the year.

Decidedly less pastoral, though always charmingly rendered, are the "Five Poisons"—toads, snakes, lizards, centipedes, and scorpions—a powerful combination capable of counteracting bad influences. This fearsome quintet was frequently embroidered most beautifully on clothing and shoes worn at the Dragon Boat Festival on the fifth day of the fifth month, which coincides roughly with the summer solstice. At this time of the year, the intense heat of summer brought health threats such as cholera and the plague. Consequently, all possible precautions were taken to ward off disease and other evil forces.

The bottoms of the lotus shoes were not ignored. If the soles were made of layered cotton, they would usually be quilted in small embroidery stitches. And for ladies who expected to receive guests while sitting on a *kang* (bed), the soles might be elaborately embroidered for pleasurable viewing, should the sole of the shoe accidentally face the visitor. Dancers with bound feet embellished the soles of their shoes with brightly colored silk, embroidery, and sometimes small homemade sequins.

Researchers working on the history of embroidery have traced the beginnings of the art all the way back to prehistoric times. For instance, the clothed remains of a Cro-Magnon hunter dating back to 30,000 B.C. were discovered in Russia in 1964, near the city of Vladimir. His fur garments were decorated with rows of ivory beads sewn on with needle and thread.

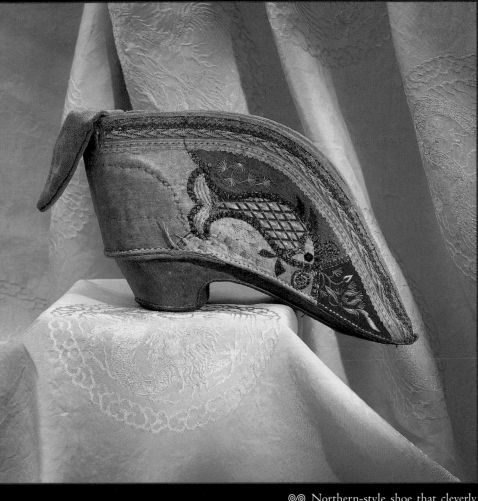

Northern-style shoe that cleverly incorporates a leaping fish in the downward curve of the shoe's shape.

Designs for embroidery still used in Romania today were traced back to body tattoos found on a man frozen in the Paz Yryk tombs in Outer Mongolia. In China, bodies covered in fur and hides dating back to 8000 B.C. have been found in the Yellow River Valley deltas. However, it is silk that we really associate with Chinese clothing. Silkworm cocoons from as early as 3000 B.C. have been found in Chinese pottery of that period. This takes the discovery of silk back further than the generally accepted date of 2640 B.C. Supporting the belief that embroidery was being done in China as early as 3000 B.C. is the fact that bronze, ivory, and bone needles were found with pieces of pottery from the Neolithic Yang-shao Painted Pottery Culture, also in the Yellow River Valley region. Designs on examples of this pottery have also given researchers an idea of what embroidery designs of the period might have looked like. Fragments of Neolithic silk embroidery have also been discovered in Shang tombs (1766-1122 B.C.).

Among the earliest surviving samples of embroidered fabric from China is a piece that dates to the 6th century B.C. found in a tomb near Chang-sha. Two pairs of women's boots of the same period were also found in the tomb. Both the upper parts and the soles were decorated with embroidered designs. The upper parts of the boots actually featured embroidered lotus designs. (Chung 1979)

Embroidery really came into its own as a fine art during the Han Dynasty (206 B.C. to 224 A.D.) when the Chinese silk industry was going strong. Early in the 20th century, the famous explorer Sir Aurel Stein discovered a vast assortment of Han Dynasty silk fragments in a tomb in Tun Huang that were embellished with eight different embroidery stitches. These same stitches are still used to this day.

Another great find of ancient treasures was at the excavation of the Han tomb of the Marquise of Tai, known as Lady Cheng. This was discovered in 1972 near Chang-sha, in the same general area where the 6th century B.C. fragments were found. Among the finely embroidered textiles found in the tomb were embroidered silk slippers. There were also numerous embroidered robes, uncut yardage that was already embroidered, and a very important funeral banner that

꠶ Watercolor illustration of a lady stretching as she takes a rest from her embroidery. Note her impossibly small feet clad in exquisite pink shoes. (Reproduced from the collections of the British Musuem, London)

features a portrait of Lady Cheng wearing an embroidered robe with typical Han designs.

Tombs in Hubei Province have provided the world with specimens of embroidered clothing and bedding from between the 4th and 3rd centuries B.C. Their bright colors have been preserved, and they show a high level of quality in the embroidery techniques used. (Young 1979)

During the reign of Emperor Qian Long in the mid-18th century, Chinese embroidery achieved its highest level of quality and creativity. After that there was a decline in quality until a design renaissance in the imperial workshops towards the end of the reign of the Empress Dowager Ci-xi. (Hong Kong Museum of Art 1995)

◎◎ *Right:* Girls at the Cheng Ting Fu Mission are working at their embroidery. (From the author's collection)
◎◎ *Opposite:* Young women, all bound-footed, find employment sorting tea. (From the Peabody & Essex Museum, Salem, MA)

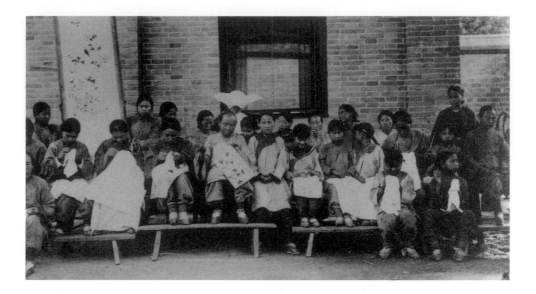

Embroidery has always been taken seriously throughout China's history. It has even figured in traditional religious celebrations and festivals. One of the unexpected periods of worship in which embroidery has a presence is on the second day of the second moon, approximately at the time of the spring equinox. According to legend, this is when the dragon raises his head from a long sleep, having been hibernating all winter. It is the time for spring cleaning—a thorough washing of water jars, the airing out of bedding, and similar chores. However, the one activity that is not allowed at this time is embroidery or any other type of needlework, for fear of accidentally pricking the awakening dragon with the sewing needle. Not only would the dragon be wounded, but the woman could develop a sore on her own body in the very same place where the dragon was pricked.

Some of the old myths have died out, having run their course from ancient times to the computer age. But ancient methods of doing certain things continue just as before. Embroidery started with silk thread and silk thread is still used. The ancient Chinese worked on silk and linen cloth and modern Chinese still work on silks and linens. In fact, very little has changed since the imperial embroidery workshop was set up during the Song Dynasty, when hundreds of embroiderers worked to satisfy the needs and desires of the royal family. Artisans

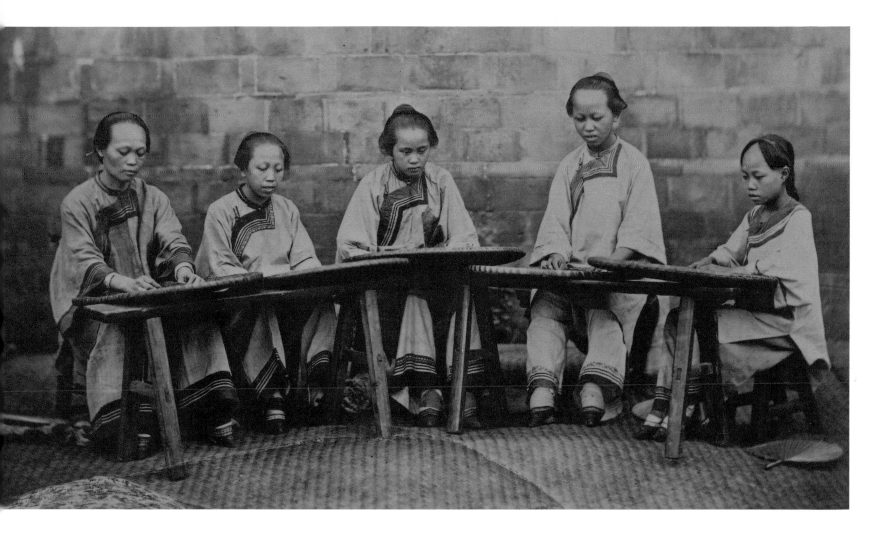

of the period devised techniques of color blending that have influenced embroidery worldwide ever since.

Among the few changes, most notable would be that while ancient embroiderers used silk thread that was twisted by hand, today, most thread is machine twisted. Also, the needles found in ancient tombs were made of ivory, bronze, and bone. In modern times, needles are made of steel. But ivory needles were used through the 19th century. Many of them made their way into Western collections through the Chinoiserie sewing boxes that were so popular in England. These black lacquer boxes painted in Chinese designs of gold were outfitted with

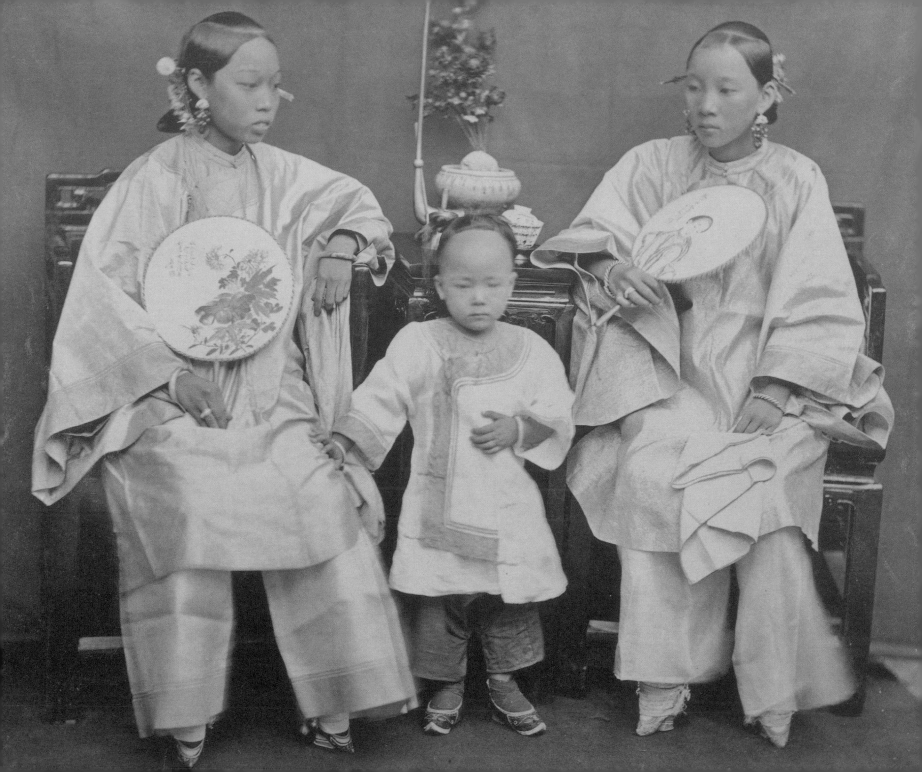

needles, bobbins, spools, exotically shaped thread holders, and other sewing accessories all finely carved in ivory.

Embroidery was an art Chinese girls learned from a very young age. Royal princess to lowly peasant, every girl had to know a variety of stitches, even though she might be uneducated in all other fields. Women of the upper classes spent much of their time embroidering, since their lives and movements were very much limited to their own homes, and with numerous servants, they had little else to do. Peasant women did their embroidering in exhausted moments when their daily work was finally finished. They generally used very simple stitches with heavy thread. And many earned extra money working long hard hours under deplorable conditions, doing embroidery for others. In homes of the aristocratic and wealthy merchant classes special sewing amahs were employed full time. One friend of mine told me that her grandparents employed thirty full-time sewing amahs in their family compound in Shanghai. The only things the sewing amahs did not work on were the lotus shoes for the women of the households.

Embroidery stitches have changed very little over the centuries. The satin stitch is and has always been the most commonly used of Chinese embroidery stitches. The important thing in working this stitch is that each thread must match the adjoining ones perfectly to create a smooth, seamless appearance—like satin. The satin stitch can be made in either slanting, horizontal, or vertical designs, and there is also a fishbone version.

The mixed straight stitch is used most successfully to create realistic effects. Among the stitches used for outlining are the running stitch, the backstitch, the laced backstitch, and the stem stitch. Chain stitches are also used extensively, with many variations on the traditional chain stitch we know in the West.

The most famous (or infamous) stitch in Chinese embroidery is the Peking knot, which is frequently and incorrectly called the "forbidden stitch." This tiny French knot was never actually forbidden, but because working on it was so hard on the eyes, there were occasional threats to ban it. But this was never done.

Opposite: According to the tenets of "Thrice Following," should the mother of this young boy become a widow, she would find herself in the position of having to obey the wishes of her son. (From the Peabody & Essex Museum, Salem MA)

Antique embroidered items purchased in the West today are much more expensive if parts of the design are executed in the Peking knot.

Couching is a process of overlaying a gold or silver-covered thread on the fabric and fastening it down with tiny stitches. To obtain the gold and silver thread, the precious metals were pounded into leaf. Long narrow sheets of paper coated with a mixture of thoroughly pounded clay and glue were covered with the gold or silver leaf. Next, to bring a bright shiny finish to the gold or silver papers, they were rubbed firmly with pieces of crystal attached to bamboo rods. Sharp knives were used to cut very thin strips of these papers, which were then wound around silk threads. A cheaper way of producing the same effect was to use paper painted in gold paint. Embroidery done in gold couching was very much in favor in the imperial court and with the aristocracy. And after all, they were the ones who could afford this luxury. The earliest example of gold leaf couching was discovered in Liaoning Province in the town of Yemaotai in a tomb built about 960.

One reason for the extensive use of couching, other than the dramatic effects it could achieve, was economy. By stitching the gold or silver-colored threads, which lay flat on top of the fabric, in place with another silk thread, the metal-covered thread did not have to be pulled through the underside of the garment. Thus, a great deal of otherwise wasted, expensive thread was saved. Gold foil could also be glued onto sheepskin or paper, then cut into thin strips and used in place of thread. This technique had already been perfected by the Tang Dynasty (618-907).

Gold or silver wire was sometimes used to achieve the same effect as the couching. A less frequently used technique, but one quite magnificent in its results, was to incorporate peacock feathers into the embroidery. The feathers were twisted with thread and fastened to the silk with fine stitches, in the same manner as gold couching.

While embroidery was the predominant choice of ornamentation, some shoes, particularly those constructed of glazed cotton, had painted decoration. Another less commomn choice was the use of padded appliqué.

People in the peasant class and members of minority tribes used traditional cross-stitching to a great extent. It is interesting to note that very similar cross-stitch work is found in the embroideries of South and Central America, as well as Romania, the Czech Republic, Poland, and regions throughout the former Yugoslavia. Researchers have long been fascinated by this common bond between such diverse areas.

Chinese embroidery has always been the most highly esteemed in the world. Fortunately, many examples of the magnificent work executed for the emperors and empresses of China and members of their court have been preserved for all to admire and study in museums and private collections throughout the world.

◉◉ At least three generations of a wealthy family sat for this portrait. All of the women seated in the foreground wear lotus shoes. (From *Five Years in South China* by John A. Turner. S. W. Partridge Co., 1894)

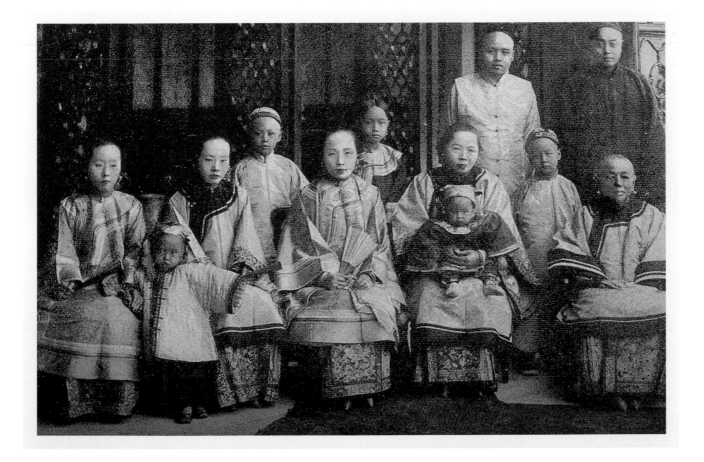

SPINNING CLOUD SILK FOR THE GODS

A heavy cloak of snow shrouded the garden, festooning the bare tree branches and trimming the high compound walls like her mother's best fur-lined robe. The ornamental pond was covered with a thin skin of ice and the great rocks from Lake Tai seemed to bend like old men under their huge white loads. It was far too cold to go out of doors, and Phoenix Treasure had tired of trying to sew by the dim wintery light. Golden Peony was visiting with her new daughter, Autumn Moon, who never stopped wailing (and over whom Treasure's amah was fussing quite shamelessly). With her own wedding approaching, Treasure longed to ask her reticent sister about her husband, her home, her life. She gazed down at the squalling babe and wondered how it would feel to have a child of her own. Would she love such a struggling, miserable creature? Had she been so unhappy (and so loud)? As she pondered her future, Amah scooped up the red-faced infant and began to recite an old, old love story in a rhythmic, sing-song voice, about the Weaving Lady and the cowherd

❖ ❖ ❖

It is almost impossible to study any phase of Chinese art without encountering the legends and myths that permeate almost every facet of life and culture in China. In the course of my research, I searched for some bit of fact in these folktales that would help me trace the origins of footbinding. But slowly

◉◉ *Opposite:* A lovely late 18th century famille-rose porcelain box. Not only do all the women in the central tableau and side panels have bound feet, but the seated lady (center) is sewing a lotus slipper. (From the collections of the British Museum, London)

I fell under their mystical spell and simply climbed aboard a magical Chinese carpet to leave the real world behind.

One of my favorite stories tells about Chih Nu, the Weaving Lady, and Niu Lang, the cowherd. The Weaving Lady is one of the most poetic and prettiest figures in Chinese mythology, and her story is one of the most beloved, and most frequently retold of all Chinese legends.

◇ ◇ ◇

Chih Nu, the Weaving Lady, was one of the seven daughters of the Kitchen God. She spent her days weaving garments for the other gods, but sometimes she and her sisters would go down to earth to bathe in a lovely cool stream. One day, a poor cowherd was in a pasture nearby, watching over his magical talking cow. The cow told the cowherd about the seven maidens who were bathing nearby. "The seventh maiden is beautiful and kind and wise," the cow told him. "And she spins the cloud silk for the gods, and is the patroness of the loom and needle for women on earth. You could become her husband and gain immortality if you take her clothes away while she is bathing in the stream."

The cowherd did indeed hide Chih Nu's lovely red silk robe, so she was unable to fly back to heaven with her sisters when they left. She stayed on earth and married the cowherd, and for three years, they lived together very happily. They were blessed with two fine children who brought them great joy. But in heaven, Chih Nu's loom was silent, and the gods were angry because she was no longer weaving their clothes. They ordered her to return to heaven, and return she did.

Saddened by her master's grief at losing his beloved wife, the cow told him, "When I am dead, wrap yourself in my skin, and that will enable you to get to heaven to be with your wife." And the cowherd did what the cow instructed.

But the cowherd's arrival in heaven was not greeted with joy by his celestial mother-in-law. She traced a line across the heavens that became the Celestial River (or Milky Way), and she changed the Weaving Lady and the cowherd into stars, and placed them in the heavens so that they were separated by the Celestial River. Their sadness was so great that ultimately the Jade Emperor decided they could meet once a year on the seventh night of the seventh moon. On that

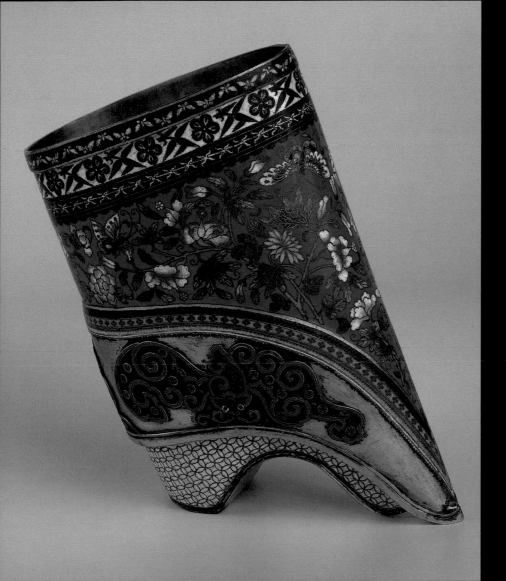

A splendid cloisonné shoe, possibly made as a gift to be presented by a concubine to her lover, or vice versa. Note the similarities to the shoes pictured on page 14. (From the collection of Gerard Levy, Paris)

◎◎ An extraordinary pair of late 17th century porcelain wine cups. Note the similar "ladder rungs" on the shoe on page 26. (From the collection of the Wine Museum Chateau Mouton Rothschild, Pauillac, France. Reproduced with the permission of Baroness Philippine de Rothschild)

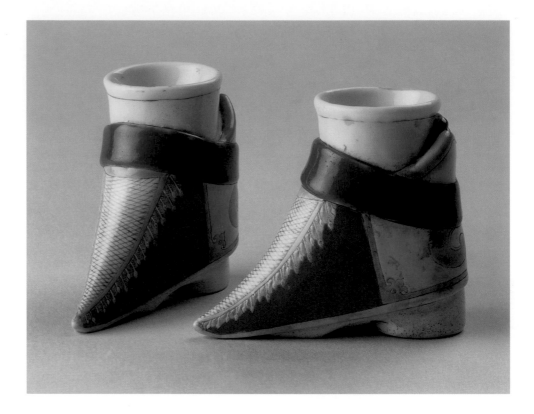

night, he decreed that all the magpies and crows would gather together and spread their wings to make a bridge over the Celestial River so that Chih Nu could go to her husband. Some say that she wrapped her feet in lengths of silk so that she could move more easily across the narrow bridge of birds.

◇ ◇ ◇

Foxes and fox fairies figure prominently in Chinese mythology. In fact, superstitions about demons in fox form still exist in China today. In rural areas, one can still find shrines dedicated to the fox, and people who fear this animal will burn incense and leave offerings in order to stay on respectful terms with it. Among the supernatural powers attributed to the fox is the ability of a fifty-year-old male fox to take the form of a woman. And at one hundred years, it could assume the guise of a beautiful young girl who could create endless mischief and destruction. The story that follows attributes the beginning of footbinding to one of these fox fairies.

In the year 1146 B.C., the Emperor Chou Wong had an empress, Ta Chi, who was said to have been the most beautiful woman on earth. But she was also vicious beyond human understanding. (The fall of the Zhou Dynasty, a dynasty that produced Confucius and Lao-Tzu, the founder of Taoism, has been attributed to her.) According to the legend, Ta Chi was actually a fox fairy in a beautiful woman's body, and she was sent to earth to hasten the destruction of China. Her transformation from fox fairy into the form of a woman was incomplete, however, and instead of human feet, she had fox paws. To disguise these tell-tale paws, Ta Chi kept them bound at all times in silken bandages.

Another popular legend tells of an empress with a club foot. She was tired of being different from all the other women in the land, and convinced the emperor that the only thing that would bring her peace was if all women had crippled feet, too. And so, to please his wife, the emperor decreed that all the women in the empire must bind their feet.

◇ ◇ ◇

Sleepwalking and big feet were the basis of still another popular legend about footbinding. An empress named Ti Chin, known throughout the country for her great beauty, was also admired for her fine fourteen-inch-long feet. Unknown to her husband, Emperor Yang Shun, the empress had walked in her sleep since she was a child. She had hoped that her marriage would scare away the evil spirits that took her hand and compelled her to walk about in the night. But the emperor's power did not prove to be strong enough, and, although he was not aware of it, she continued to walk in her sleep.

Then one night, having been alerted by a maid, the emperor kept watch over his sleeping wife. Eventually, he saw her rise out of bed and walk off in her sleep. He followed silently, and brought her back to bed without awakening her. The next morning he confronted her, and she admitted that it had been a problem since childhood. She confided that she had always suspected the problem was her large feet. Being an empress meant a life of sitting a great deal. "Maybe my feet are restless and want to walk," she said. "But since I sit during all my waking hours, they must wait until I am asleep."

Opposite: A magnificent pair of late 17th, early 18th century famille-verte, double-gourd shaped, hexagonal vases. The blue-robed, green-slippered maiden (right) hopes to catch a butterfly, while the yellow-robed, red-slippered maiden (left) contemplates the capture of a spider hanging from a pine bough overhead. (From the Ralph M. Chait Galleries, New York)

This made sense to the emperor. If her big feet were the cause, then her big feet must go, because if she continued to walk in her sleep, one night the spirits might not bring her back. The finest surgeon in all of China was summoned to the palace to cut off nine inches from each of the empress's feet. The operation was a great success, and she never walked in her sleep again.

However, the empress was still unhappy, but now it was because her feet were tiny, and all the other ladies of the palace had naturally long feet. Wishing to make his beloved empress happy once again, the emperor decreed that all the ladies of the palace, in fact all the women of China, must thereafter have small feet, also. So from then on, the women of China were forced to bind their feet to make them small—but not quite as small as hers.

❖ ❖ ❖

One of the best-loved of all Chinese legends concerns a famous bell of Peking and a young maiden's lost lotus shoe. The event allegedly occurred during the period when Emperor Yung Lo ruled China from the Forbidden City. He ordered two great watchtowers to be built. One was to house the finest, loudest drum in all the land which would sound the hours of the day for all to hear. The other would house the grandest bell. This bell would be rung each evening to signal that the city gates were about to be locked, or to warn the citizens should there be an attack upon the city.

The emperor ordered the bell to be made of gold to make its tones rich, silver to make them sweet, and iron and brass to make the bell strong. The finest bellmakers in all the land went to work with the metals the emperor had ordered. But the bell was flawed. When it was taken from its mold, it was full of tiny holes.

The chief bellmaker Kuan Yu was ordered to make another bell, but when the second bell was unmolded, it too was full of tiny holes. The emperor ordered Kuan Yu to try one more time, and if this third bell was a failure, the unfortunate Kuan Yu would be beheaded.

Kuan Yu had a sixteen-year-old daughter who was very beautiful and who had tiny feet like perfect lotus blossoms. The poetry she wrote was as beautiful as she, and her embroidery was perfection. Her name was Ko-ai.

Ko-ai worried night and day about her father as he set to work creating the third and final bell. She went to a fortune teller to find out if there was anything she might do to help her father. The fortune teller told her that the brass and gold and silver and iron for the bell would not blend together properly unless they were mixed with the blood of a maiden. Only a maiden's blood could save her father's life.

Because she loved her father so much, Ko-ai decided to make the supreme sacrifice. She asked her father to allow her to watch him cast the bell. As the metal was poured into the gigantic mold, Ko-ai called out, "I do this because I love you, my father," and threw herself into the mold with the molten metal. She disappeared instantly, and all that remained of her was one of her beautifully embroidered lotus shoes that was left in the hand of the old amah who had tried to catch her as she jumped.

And so, Kuan Yu's life was saved by his daughter's sacrifice. When the bell was unmolded, it was perfectly formed, and when it was struck, its tones were rich and sweet. However, each time it was rung, the pealing of the bell was always followed by a whispering wail. People who knew of Ko-ai's sacrifice claimed it was Ko-ai asking for the beautiful little shoe she had left behind.

◇ ◇ ◇

China has always revered its poets, and accorded them the greatest respect. From its origins in the centuries before the birth of Christ up to modern times, there have been scholar-poets, emperor-poets, soldier-poets, and even revolutionary poets (Mao Zedong wrote many poems in the classic style and was quite well regarded by critics). There is an immense body of work, most dealing with philosophical ideals and lyrical contemplations on life, but there is also satire, rhetoric, and romantic poetry.

For poets, the golden lotus evoked an idyllic vision of beauty, a misty idealization of love, and sometimes a sad memory of lost love.

> Airing clothes and belongings in the courtyard,
> Suddenly I spy some shoes from my home.
> Who was it gave them to me long ago?
> The pretty daughter of our neighbor to the east.

86

I remember the words she spoke when she gave them to me:
'With these let's promise to be true forever.
Our vows will be as lasting as these shoestrings;
We'll go as a pair, rest as a pair.'
Since I was exiled to Chiang-chou
I've wandered like a drifter three thousand miles.
And because I was moved by her lasting love,
I've carried the small shoes with me all the way.
This morning I'm filled with sad thoughts,
Turning them over, examining them without end.
I am single, but the shoes are still a pair—
How little we resemble each other!
I sigh, thinking how pitiful they are,
With their brocade tops, their embroidered lining,
Particularly now when they've come through the raining season,
Their colors darkened, their flower and leaf patterns withered.

 Sentimental poem by Po-Chu-i, 772-847.

 (From *The Columbia Book of Chinese Poetry* edited by Burton Watson.

 ©1984 by Columbia University Press. Reprinted with permission.)

∞∞ A charming carved boxwood statue of a grandmother and her grandson. (Reproduced by permission of Li Yin Tsai, Lin Yi Co., Taipei, Taiwan; currently in the collection of Alexander Acevedo, Alexander Gallery, New York)

Novelists walked the same moss-covered path as poets when it came to the idealization of lotus feet. At the end of the Ming Dynasty, a 16th century author wrote an erotic novel titled *Chin P'ing Mei,* which translates to "The Golden Lotus." In recent years scholars have attributed authorship to Hsiao-hsiao-sheng. Often compared to *Gone with the Wind,* many Westerners as well as Chinese have called it the greatest novel ever written.

The title of the book, *The Golden Lotus,* does not come from lotus feet directly. It comes from the name of one of the six wives of Hsi Men, the novel's protagonist. Golden Lotus, the most beautiful and calculating of the six wives, used her perfectly bound little feet as a tool to get what she wanted throughout her life.

Whether a two-line poem or a lengthy, classic novel, the mystique of the perfectly formed lotus feet and the beautiful shoes that covered them provided inspiration for writers just as they did for painters, sculptors, and most of all, lovers.

Whether they were the focal point or just a minor detail, lotus feet were very much a part of all the fine arts of China. They were so ingrained in the Chinese culture that artists didn't really concern themselves with historical accuracy. It is not unusual to find paintings and ceramic figures of legendary figures and goddesses portrayed wearing lotus shoes, although the myths originated centuries before the practice of footbinding had even begun. The Weaving Lady is a good example, as she is always pictured with bound feet.

The tiny toes of lotus shoes peak out from beneath the robes of wealthy matrons depicted in ancester portraits, if the sitter had bound feet. Before the importation of portrait photography to China, these marvelously detailed paintings provided the ancestral images necessary for the continued respect and worship of the deceased by subsequent generations of family. To modern costume collectors they offer highly accurate examples of clothing and accessories.

After some initial suspicion, the Chinese embraced the new innovation of photography with enthusiasm. Many of the photographs that appear in this book were taken either late in the last century or in the early part of this one. Not surprisingly, family portraits were extremely popular. Individual portraits were less so, except among certain classes of professional women—namely actresses and prostitutes. In this group of portraits, lotus clad feet are always proudly displayed.

◇ ◇ ◇

One area in which I expected to find significant evidence of footbinding and, much to my surprise, found very little, was on Chinese porcelains. I have searched endlessly, and found few examples. But my quest has had some amusing results with many of the leading art dealers in the United States and England. They claim my search has totally changed how they look at Chinese porcelain painting. "It is driving me quite mad," one dealer wrote. "I no longer get the great joy of that first look at a new piece, because I am immediately looking to see if the feet show and if they are bound!" As a rule on porcelains, the gentle folds of skirts fall to the ground, discreetly hiding the feet.

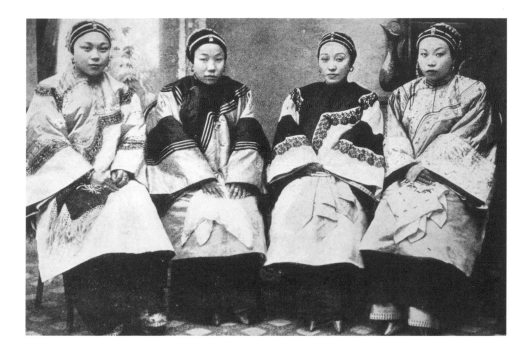

∾ Four beautifully dressed and coiffed ladies, each shod in lotus shoes. (From *The New America and The Far East* by G. Waldo Browne. Colonial Press, Boston, MA, 1907)

This search became a challenge for the curator of porcelains at the British Museum. She was able to locate only one piece in their vast collection. But that one piece was a treasure. It is a razor box on which a servant with bound feet is bringing tea to a scholar working at his desk, while his wife, who also has bound feet, sits at his side sewing a lotus shoe.

As evidence of their importance in China, lotus shoes were reproduced in silver, and were carved from jade, ivory, and rare woods. Art objects like these are sought after by collectors from countries around the world today, and high prices are being paid. For instance, a unique lotus slipper-shaped porcelain incense burner from the Qing Dynasty was sold in London a few years ago for close to $1,000. In 1995 a magnificent cloisonné lotus slipper was exhibited in the Paris gallery of Gerard Levy. The price—$25,000.

When feet were still being bound, porcelain lotus shoes were often exchanged between lovers, or given as wedding presents. In the latter case, they were given in pairs to symbolize married harmony. The finest examples were produced during the K'ang-hsi period (1662-1722), decorated with enamel on bisque.

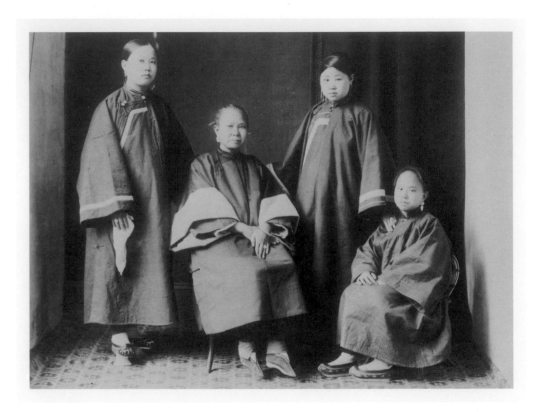

◎◎ The serving staff in this household are both Manchu (left and right) and Han (center). (From the collections of the Bibliothèque Nationale, Paris)

Factories in China today are still producing porcelain lotus shoes, but these are for the tourist trade.

◇ ◇ ◇

There is a unique genre of Chinese art that was once highly coveted by Westerners, and that served, in large part, as the Western world's introduction to China and its culture. These were watercolors that were produced especially for export. It is known that Portuguese sailors brought a few Chinese paintings back to European shores early in the 16th century. However, the period that brought the greatest exchange between East and West began when English merchants started direct trade with China in the 1720s.

A great many of these paintings were purchased by sailors to bring home to their families and friends as evidence of the strange world they had visited. People in the West were intensely curious about the people of Cathay. What did they look like? What did they do? How did they live? Until then, China had

been a land closed to foreigners, so very little was known. These questions were answered to some degree by the colorful export paintings which were quite different from the subdued, classical brush paintings the Chinese desired for themselves. Artwork made for foreign trade was generally done in bright opaque gouache. Sets of paintings on specific topics or industries, sold in folio form, were very popular. They gave the viewer a complete overview of the topic, with no need for written commentary. A series on silk, for instance, would start with the culture of the mulberry leaves on which the silkworms survived, illustrate every phase of silkworm culture, and end with the making of silk thread and lengths of richly colored silk cloth.

Because the women in these paintings usually had bound feet, it was largely through this artwork that the Western world first learned about the phenomenon. Although, to my knowledge, no paintings depicting the actual footbinding process were ever produced.

In 1800, a very famous book of paintings was published in England that also helped to inform Europeans about life in China. This was George Henry Mason's *Costume of China.* It featured 100 original paintings by Mason, a professional soldier who stayed in Canton for several months in 1790. He painted the Chinese exactly as he saw them as they went about their daily tasks. One picture shows women working at their big embroidery frames, with minute slippers protruding from under their trousers.

The success of *Costume of China* made it increasingly popular to paint the everyday people of China doing everyday things. Interior scenes that depicted families in fine homes were much sought after, as were paintings of the imperial family, complete with their splendid thrones, carpets, draperies, and accessories. However, certain liberties were taken in many of these paintings, since the empress was frequently depicted being attended by a beautifully costumed servant with bound feet. Manchu empresses were almost always attended by Manchu servants, not Han Chinese. And of course, their feet would not have been bound.

A NIGHT
AT THE OPERA

Phoenix Treasure retreated to the garden after yet another argument with her amah. "You know perfectly well that young, unmarried women do not attend such entertainments," she scolded. Not for the first time, Treasure felt envious of the seemingly limitless freedom her older brothers enjoyed. Tonight they were off to town to see a visiting theatrical troupe perform *The Patriotic Beauty,* a favorite story that she had seen nearly ten years ago. Since then all such innocent pleasures had been denied her, and always with the same excuse.

If only she could have stayed a child forever, she thought. The soft twilight-tinted breeze brushed her cheek as she lost herself in memory . . .

"Hurry, Treasure, we don't want to miss anything."

"I am hurrying. How can I go any faster? Your legs are longer than mine."

"Why don't I swing you up on my shoulder and carry you like a monkey?"

Through the trees up ahead she glimpsed the theater, and for a moment, she fancied it looked like a great dark ship, anchored in a river of bobbing, winking lanterns. Clinging gratefully to her eldest brother's broad back, she and the boys were instantly caught up in the swelling current of humanity that flowed toward the center of town. It was rather exciting to be borne along above the swaying, chattering tide of townsfolk, though not half as exciting as the performance they had come to see . . .

Treasure came to her senses with a start. The sweet memory fled as the

Opposite: Male actors who played female roles created the appearance of bound feet by using a specially made wooden support that was slipped into a lotus-style shoe and wrapped tightly against the actor's calf. This example is most likely a theatrical costume supplier's sample. (From the author's collection, Larry Kunkel Photography)

◎◎ *Opposite:* A richly carved and painted theatrical idol wears a symbolic yin/yang mask and actor's shoes for bound feet. His fan reads: "When seeing beauty, the smile is full of the cheek. When meeting ugliness, the anger is all over my face." (From the Sidney D. Gamble Foundation for China Studies)

present crowded in on her. In a fortnight's time she would make the long journey to Peking to be married to a man she had never seen, and who had never seen her. Like the "Beauty" in the opera, she would soon be living amongst strangers in a strange house in a strange city. But that is where the similarity ended, because for Treasure there was no guarantee of a happy ending.

◇ ◇ ◇

One of the world's most fascinating art forms, and one that I've come to enjoy immensely, is classical Chinese opera. In general, I must admit, it is a rather difficult medium for Westerners to understand and appreciate. The music might be described as loud and dissonant, the actors' jerky and exaggerated movements can prove distracting, and the heavy humor of the stories that is so important to the Chinese is lost on most Westerners.

However, upon closer examination, one finds that Chinese and Western operas are surprisingly similar in many ways. Both contain demanding singing, complex musical compositions, histrionic acting techniques, and fantastic costumes. And, most interestingly, both were developed as popular entertainment. Chinese opera, however, places greater emphasis on social morality and attempts to penetrate the meaning of life. Chinese opera indulges quite heavily in acrobatics, something not found in Western opera. (The idea of Luciano Pavarotti, Placido Domingo, or Jose Carreras going through the antics of a leading man in Peking opera is beyond all comprehension!)

Imagination is on full alert throughout a Chinese opera, as well. A character might knock on an imaginary door or ride an invisible horse, or that waving banner of silk might represent a flowing river.

You will not find the Chinese mounting innovative or avant garde versions of a beloved, much-performed story. Every movement is executed according to ancient rules; the music, costumes, makeup—everything—is done according to tradition, down to the most minute detail. Chinese opera requires the viewers' familiarity with each story. The audience recognizes the characters by their heavy, stylized makeup. Every hand and foot gesture has a specific meaning to the narrative. Pantomime and mimickry are used extensively.

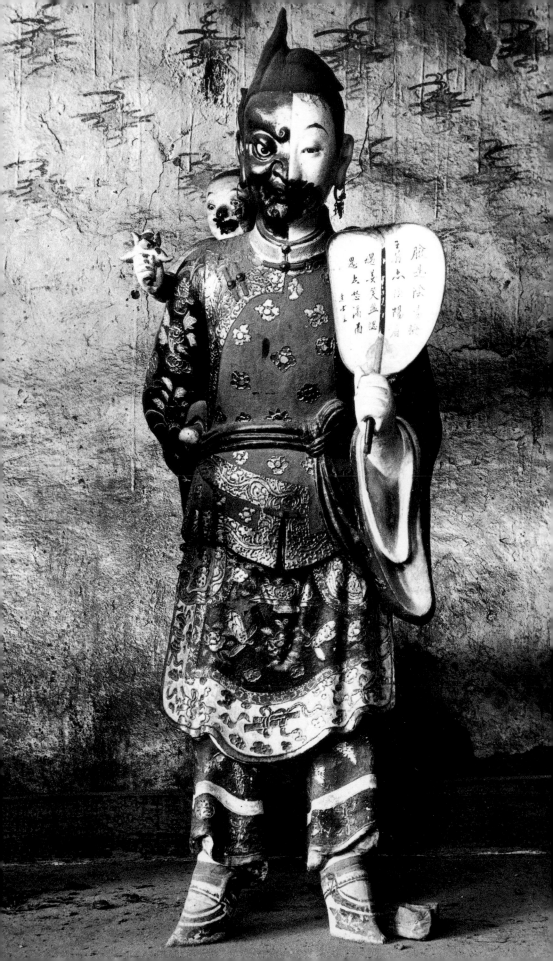

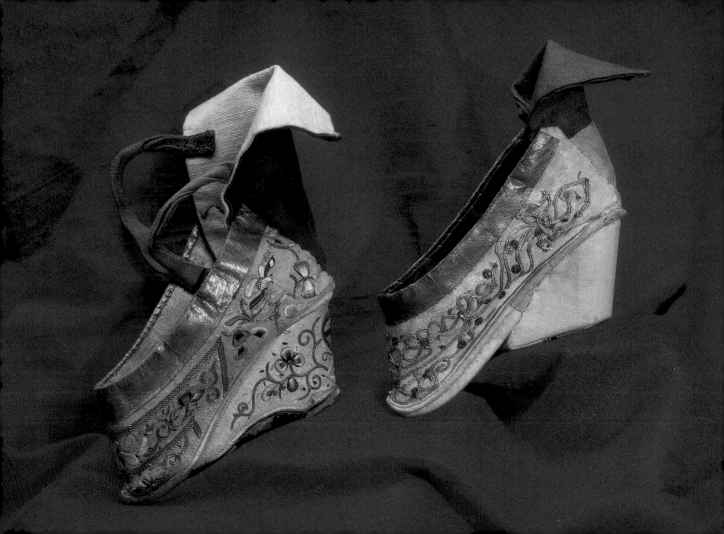

In fact, there is no Chinese word comparable to the Western word "drama." The nearest equivalent is the word *hsi* which means to ridicule or to make fun of when used as a verb. But the greatest difference between Chinese and Western opera is that all major female roles in Chinese operas have traditionally been played by men.

Until the Yuan Dynasty (1277-1368), the leading role in all plays was the male role. However, with the Yaun Dynasty the *t'an* (female) role was elevated and allowed to share the leading parts. T'an roles were divided into four characters; the virtuous woman, the female warrior, the coquette, and the old woman. An aspiring actor began studying for the classical Chinese opera at a very early age, as young as seven years old. He endured rigorous training for seven years, living and working with scores of other hopeful children in large, strictly run schools. By the age of twelve or thirteen it was generally determined whether or not a boy had the right qualities to play t'an roles for the rest of his life.

If this was his destiny, his training became even more exacting, for he had to master all the attributes of being a woman—the feminine voice, the gestures of the hands and head, and most difficult of all, the mincing lotus gait. They were taught to walk with the toe of the front foot only a few inches ahead of the back foot and with the feet always close together. Things were different for the men playing t'an roles in the military operas. These roles consisted of very strenuous acrobatics choreographed to symbolize combat, and many of the female generals and warriors the t'an played had bound feet.

How did a man pretend to have bound feet? Quite a few did not pretend at all. Some young actors, upon learning they would be playing t'an roles, had their feet bound as described in Chapter 2. The majority, however, resorted to simulating bound feet with the use of a specially carved wooden splint that was wrapped tightly against the back of the actor's leg. The splint was actually shaped like a ladle with a flat bottom that terminated in a carved wooden lotus foot form. The false foot would be the size of a bound foot, about three inches

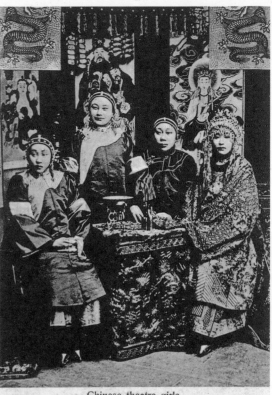

Chinese theatre girls

◐ *Above:* A group of Chinese actresses. (From the author's collection)

◐ *Opposite:* The pale blue silk dancer's shoe (left) combines delicate couching, extremely refined satin stitch embroidery, tiny sequins, and burnished gold kid skin trim. The pale green dancer's shoe (right) retains most of its rich gold couching and almost all of its metallic sequins. Length 3 inches, each shoe. Despite their remarkably small size, both show quite a bit of wear. (From the author's collection, Larry Kunkel Photography)

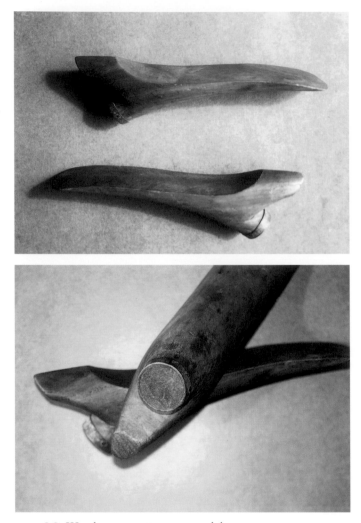

◎◎ Wooden supports were used by male actors in civil operas. (Photos by Don Cohen)

high. This apparatus was used in military operas and was called a *wu ch'iao (wu jiao)*. It gave the wearer the sensation of walking on stilts, with all the body weight borne at the center of the foot. Very wide, soft silk trousers were worn to cover the splint, and the hems of the trousers were pulled in tightly at the bottom to hide all except the small false foot in its embroidered lotus shoe. For civil operas, the t'an wore a similar appliance called a *tz'u ch'iao (ci jiao)*. Rather than a flat bottom, it ended on a slant terminating in a carved false foot with a large round heel which threw the actor's weight forward onto the ball of the natural foot. Again, all that was visible to the audience was a pair of lotus shoes.

In past generations, wearing, balancing, and maneuvering on these contraptions while learning to do the traditional walking and running steps was difficult enough. However, the 20th century brought a change that made the training and presentation even more difficult. In earlier times, a t'an was not allowed to kick. But now it is allowed for a t'an playing a military role to kick a foot or leg. The rules say that the actor must stand erect on the right foot, lift the left thigh to a horizontal position, and kick out strongly to the right or left. Now you must remember, all this is being done with the t'an balancing on those fourteen or fifteen-inch cotton-wrapped wooden splints atop tiny four-inch shoes. And the rules say that not the slightest bit of swaying is allowed!

Indicative of how important lotus shoes were in the opera, on the lists of important movements actors must learn one always finds "Making Shoe Thread." And the instructions for this "symbolic action" are more extensive than for any other on a very long list. As an example of how these choreographed motions might figure into an opera, in *A Comedy of Errors* (nothing to do with Shakespeare), a maid is ordered to make a pair of shoes for a lady with bound feet, and the t'an who plays the part must use the classical gestures.

Lotus feet and lotus shoes figure very prominently in a number of other operas. In *The Great Trial at the Fa-Men Monastery*, the daughter of a rooster seller catches the eye of a wealthy young man who passes by while she is sitting in front of her house embroidering. A matchmaker is engaged as a go-between, and the girl gives the matchmaker one of her embroidered lotus shoes to be delivered to the young man as a token of her consent. A butcher steals the shoe, and tries to use it for extortion purposes. Before the opera reaches its conclusion, the butcher has cut off a couple of heads, and even the Empress Dowager gets involved in the crime when she visits the monastery of the title.

In *The Woman Robbers,* an even more complicated opera, an old woman and her daughter plan to become rich by murdering some guests at a small roadside inn. Their first intended victim is a young woman who is traveling with her maid. The maid dresses up as a young man (a safety precaution), and passes herself off as her mistress's brother. The "brother" is given a sleeping draught; the old woman's daughter comes in to rob him, but falls in love with him instead, and decides she wants to marry him. In the end, the daughter discovers that "he" is a "she" when she starts to undress him and finds that "he" is wearing a pair of lotus shoes.

The Patriotic Beauty is the tale of Hsi Shih, one of the four most famous beauties of ancient China. Although she allegedly lived around 494 B.C., centuries before feet were bound, she is played by a t'an on lotus feet. Hsi Shih, a very poor girl, is coveted by the wicked King Fu-cha who has conquered her country. She diverts his attention by dancing for him on her tiny lotus feet. The king is so delighted by her and her performance that he builds a splendid palace in her honor. The palace is called Echoing Corridor for the sounds of her delicate footsteps as she walks on her enchanting golden lilies. The drama ends with the wicked king committing suicide and Hsi Shih marrying his good prime minister. Thus, it was on those tiny feet that she danced her country and herself to freedom.

◇ ◇ ◇

Classic Chinese opera was the most popular form of entertainment in the cities, and opera singers were accorded great respect. While the peasants in

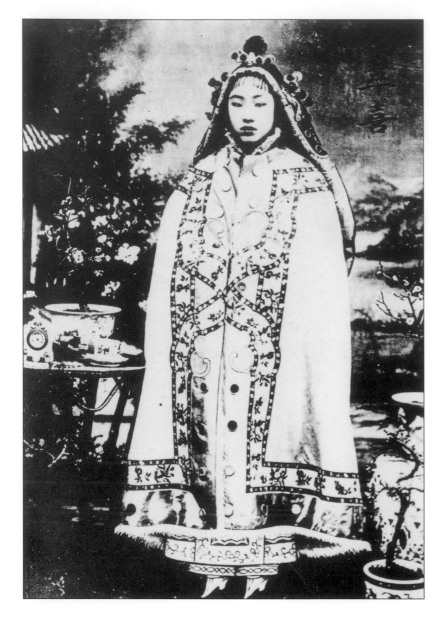

remote villages had no access to classical opera, they had their own entertainments. Theatrical troops toured the countryside, performing at village fairs. They would set up their stages right in the street or any open space where crowds could gather to watch. Villagers were thrilled to have this happy break in their monotonous, hardworking lives, and would sit for hours watching the performances.

Aside from professional touring companies, there were amateur companies that gave small-scale productions called "a little theater." Actors in these troupes were often farmers who got involved for the excitement of stage life after the crops were harvested. They would return to their villages for spring planting, well fed and with the extra money they'd earned from their stint on the stage. Village theater in China can be traced back to the Tang Dynasty and Emperor Ming Huang who appreciated and promoted the arts. The emperor even established a college to train young boys and girls in music and dramatics, and he himself gave lessons on occasion.

Women could participate in these traveling troupes both as actresses and singers. Groups of women singers who toured the countryside were called *chang chu* and were at the opposite end of the social scale from performers in the classical opera. In fact, they were frequently prostitutes. The actresses stood a bit higher up on the social ladder, but the majority of both singers and actresses had bound feet.

Lotus feet were also to be found in the ancient art form of Chinese shadow plays. The "actors" in these plays are puppets made of pierced and painted leather. Wires and bamboo sticks were attached to serve as handles so they could be

manipulated. Shadow plays were a favorite form of entertainment for more than a thousand years, with puppeteers traveling from village to village. Among the plays in which the female puppets had bound feet were *Boating on the Lake* (a tale about two fairy snakes who lived on the sacred Mount Emei and turned into two very pretty young women), and *Yang Paifeng*, named for a famous woman warrior who accomplishes great feats of bravery on horseback in spite of her elfin feet.

While full-blown opera productions may not have reached the hinterlands of China, Chinese opera did find its way to California during the Gold Rush days. By the mid-1850s, more than 20,000 young Chinese had emigrated to the United States to make their fortune in the gold and silver mines, or to work on the transcontinental railroad. A number of touring companies actually crossed the ocean to perform for their countrymen. In 1852, for instance, the Hong Took Tong Company from Guangdong sent a company of 123 performers to San Francisco.

The Hong Took Tong, and other theatrical groups that followed them, often ventured beyond the city, bringing these ancient yet familiar stories to homesick immigrant laborers all over the West. What an astonishing sight it must have been to see an actor in brightly embroidered silk robes adorned with tiny glittering mirrors, tottering around on what appeared to be bound feet—on an improvised stage in the middle of a crowded tent city in a remote mining or railroad camp.

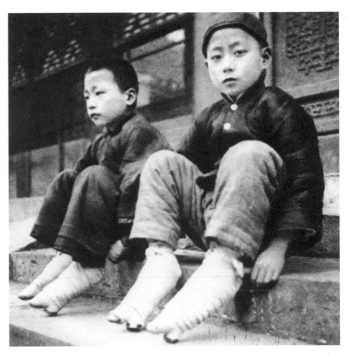

৩৩ *Above:* Young boys in training for careers in classical opera who specialized in playing female roles had their feet bound with wooden supports like those shown on page 98. (From the author's collection) ৩৩ *Opposite:* Actresses were famous for their exceedingly small bound feet, and this one has all the trappings of a popular star, with her elaborate headress, her fur-trimmed, heavily embroidered cape, and her Wesern-style carriage clock on the table to her right. (From the author's collection)

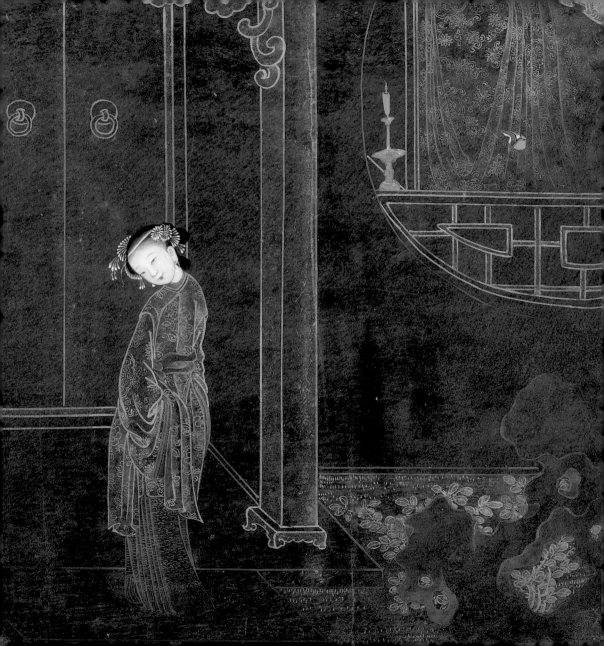

CHAPTER 7

SEX AND THE BOUND-FOOTED GIRL

Two nights before her wedding journey would begin, Phoenix Treasure sat out in the courtyard under the moon surrounded by dozens of bales and bundles. Her new life lay wrapped and tied around her, ready to be carried off toward an uncertain future. Treasure felt as helpless as on the day, ten years earlier, when her amah had called her in from the garden and she saw the old footbinding lady come to the same courtyard with her strange looking stool and curious bundle of tools and bindings.

The journey to Peking would begin at dawn and take most of the day, perhaps longer if spring rains slowed their progress. She had visited her sister only once since Peony's marriage, on the occasion of Autumn Moon's footbinding day, and she had made that trip with her mother. Except for the dozens of guards and bearers sent to carry her and her rather impressive dowry, this time she would travel alone.

Would her meeting with her new family be a happy one? What would be expected of her? With regard to the wedding night, her amah had told her that it was her duty to obey her husband's wishes and that she should not know anything beforehand, as this could cause him to question her innocence. On her brother's last visit from the university, she had begged him for clues as to what those husbandly wishes might be. He gave her a book of love poetry, with a warning not to let their mother or father catch her with it, which Treasure had found quite

Opposite: Eroticism at it's most subtle and elegant. Note the elevated position of the red lotus slipper protruding through the bed curtains, suggesting that the wearer's foot is resting on her lover's shoulder. Gouache on paper from an erotic album. (From a private collection)

beautiful—and utterly unenlightening. Alone in the moonlight, Phoenix Treasure could only guess at the meaning behind all those exquisite images and metaphors.

◇ ◇ ◇

Serious collectors of any form of Chinese art are bound to stumble upon Chinese erotica as they search through the antique shops and auction houses. I'd glanced at erotic porcelain figurines or at sexually explicit paintings with a casual, sophisticated interest, but no intense curiosity. Well, perhaps there would be an exchange of raised eyebrows, a smile, or other unspoken acknowledgment between the dealer and me. I don't know exactly when I first realized Chinese erotica almost always featured women with bound feet. But one day, the correlation between sex and footbinding hit me. And I truly understood the sexual power of the shoes themselves when I saw the exquisite erotic painting opposite where, on the blackened bedroom scene, a single, elevated, red and green lotus shoe emerges from between the bed curtains. The tiny, isolated slipper creates the painting's intense sexual excitement, so subtly but so powerfully.

Chinese erotic art can also be found in ceramic form, in carvings, painted inside snuff bottles, painted or embroidered inside shoes for bound feet (particularly wedding shoes and the shoes of prostitutes and courtesans). Much of the art is quite explicit. The feet are painted as objects for the man to caress, or as participants in the act of lovemaking. There are even drawings showing men masturbating before empty pairs of lotus shoes. The shoes themselves, I learned, could be the most potent stimulus of all.

It was not unusual for men to go to great lengths to acquire a pair of shoes belonging to a woman they coveted. The theft of lotus shoes was quite common. Women in the north of China were known to sew their shoes to their socks before going to village plays or entertainments so that aggressive males could not steal them in the dark while their attention was diverted. Of course, the shoes men most desired were the special red silk shoes worn at bedtime, and these were the most difficult to obtain.

The colorful leggings that were worn as a rule over the bindings, above the lotus shoes, were also considered to be sexually stimulating for many men. A

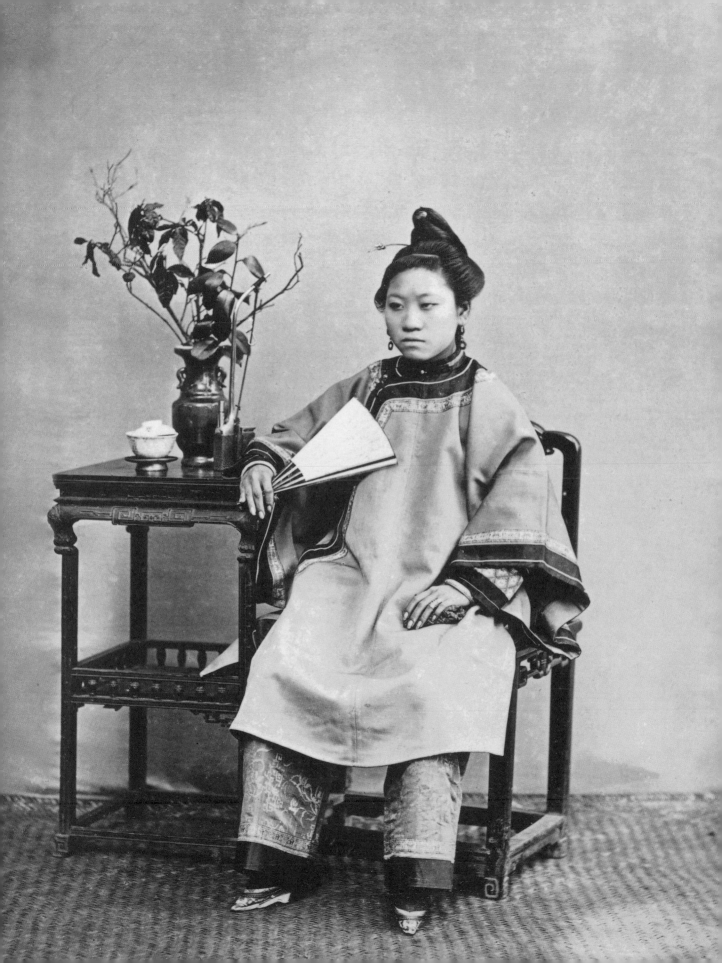

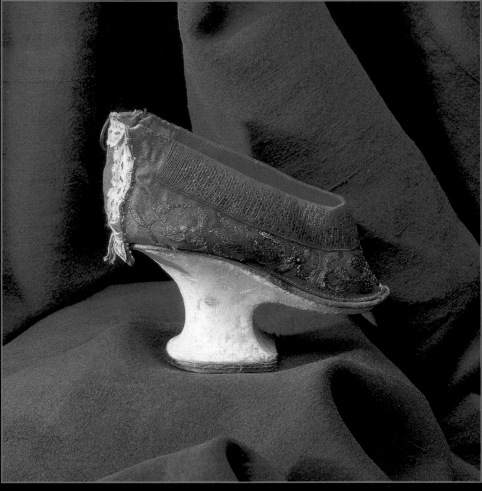

◉◉ Exceptionally rare silver couched, pink silk slipper, length 4 inches. Although made for a bound foot, the shoe sits on a Manchu-style mid-sole wooden pedestal painted white, height 1½ inches. It probably belonged to the Han Chinese concubine of a Manchurian gentleman, thus explaining the unusual fusion of styles. (From the author's collection, Larry Kunkel Photography)

man wishing to express sexual interest might simply touch or play with one of the desired woman's leggings. No words were necessary to convey the meaning of the action.

In the late 1890s, an important Chinese diplomat was sent to Russia. Unable to take any of his lotus-footed women with him, he took along a huge collection of his favorite concubine's lotus shoes. And it is said he kept himself quite contented sexually for his entire extended stay in Russia.

Part of the titillation in just looking at the shoes was due to the fact the feet encased inside those shoes were generally a total mystery. Very rarely would a Chinese man ever see a bound foot without the white bandages covering it. He might know what every other part of the woman's body looked like, including the genitals. Her body was very real to him, but the feet were literally shrouded in mystery. In his mind, they could be as beautiful and desirable as he wished them to be. Those mysterious bound feet offered countless opportunities for dreaming and fantasizing. And sexual fantasy can go in endless directions.

◇ ◇ ◇

Just as a wine connoisseur judges wines by certain standards, several hundred years ago, an aristocrat named Fang Xun attempted to do something similar with bound feet. First he identified fifty-eight types of lotus feet, and then he ranked them for quality. A plump foot was at the top of his list, as it implied voluptuous beauty. Softness also merited high ranking. At the very bottom of his list was the woman whose heel was so large she gave the impression of a climbing monkey. For each foot, he had special names that could be quite descriptive. There was the Long Hairpin Lotus, which was shaped like a bamboo shoot but was too long and thin to satisfy critical aesthetic standards. Herring Feet was another unflattering name for feet that were too long and thin.

Fang Xun cautioned men to respect both the feet and the women themselves. He advised men to control their curiosity, to be satisfied with the foot in its white bindings, and never to unbind it. "If you remove the shoes and bindings, the aesthetic feeling will be destroyed forever," he wrote. For Fang Xun, the ultimate erotic experience was to hold a bound foot in the palm of his hand. He

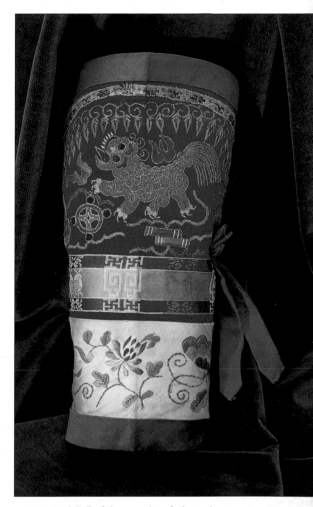

∽ A delightful example of the colorful leggings that were worn to cover the plain cotton bindings, incorporating the use of decorative ribbons, gold couching, satin stitch embroidery, and Peking knot on the lion-like creature, (center). Height 9¾ inches. (From the author's collection, Larry Kunkel Photography)

also found it sexually exciting to see the imprint the shoes left in the snow, or to see them perched on a swing. Not surprisingly, a glimpse of lotus feet peeking out from under his blankets was a sight he savored above all.

"Fragrant lotuses are noble in three ways," he said. "They are plump, soft, and elegant. Fragrant lotuses have three 'ons,' three 'withins,' and three 'belows;' on the palm of the hand, on the shoulder, and on the seat of a swing; within the blankets, within the stirrup, and within the snow; below the curtain, below the screen, and below the fence. Fragrant lotuses have two 'good fortunes;' an ugly woman enjoys good fortune if she has small feet, for she will attract the praise of others; a lewd prostitute has good fortune if she has small feet, for she will acquire everyone's love."

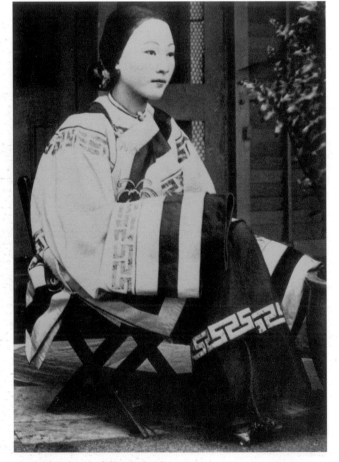

◎◎ This beautifully dressed woman has both a lovely face and fantastically tiny feet. (From *The Chinese* by John Stuart Thomson. Bobb-Merrill Co., Indianapolis, IN, 1909)

Of particular sexual importance was the crevice in the foot that was created by the breaking of the arch during the original binding process. This crevice was sometimes treated like a second vagina. A man could utilize this crevice while gazing upon the woman's genitals, giving him a sort of double pleasure. Or he could enjoy viewing her genitals unobstructed while holding and caressing her feet, or rubbing the feet against his own genitals. (This custom was not practiced everywhere, however. In some areas it was considered very unlucky for a man to view a woman's genitals.)

Handling the feet during lovemaking was a very important factor. Squeezing the two feet tightly while penetrating a woman was standard practice. Having a woman sit cross-legged on a man's lap in the lotus position with her feet in his hands was also popular, as was positioning those little feet in their red satin bed slippers upon his shoulders. Another special position was having the woman's legs wrapped around the man, forcing him to reach behind his back to caress her feet.

Just thinking of the feet, or calling them by one of their special, erotically related names was adequate stimulus for many men to achieve full arousal.

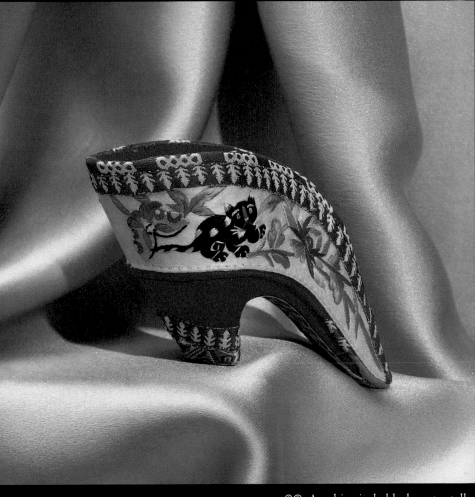

⊚ A whimsical black cat stalks
through a silken garden of butterflies
and chrysanthemums. This exquisitely

Among the names whose very mention could achieve so much were Jade Bamboo Shoots, Spring Bamboo Shoots, Red Water Chestnuts, Lotus Hooks, Fragrant Hooks, Twin Hooks, and a vast assortment of dumplings. (It should be understood that dumplings are very special in Chinese cuisine. Different kinds of dumplings are associated with certain special holidays and important events. (Remember the red bean-filled dumplings the little girls ate the night before binding began?) And dumplings can have very impressive names, not always indicative of their contents. The popular Four Happiness Dumplings, for instance, have a filling made with carrots, peas, chives, bamboo shoots, minced pork, and mushrooms.)

In spite of all the lovely pet names for the tiny feet, the poetic descriptions of them, and the theories of gentle treatment, there is no doubt that sado-masochism did enter the bedchamber. There is definitely a link between bound feet and sado-masochism centering around the pain the woman had to endure to achieve her tiny feet. This pain measured up to just about any that could be inflicted by a whip or any other form of punishment the man might administer. The concept that the feet had been bound up for years, and that they must continue to be bound, plays up to the sado-masochistic link with bondage and master-servant domination. Where Western cultures have opted for black leather and chains, Chinese men had narrow white linen bandages upon which to project their fantasies.

Stories of tiny lotus feet being the inspiration for brutal punishment go beyond one-on-one sexual relationships. Tales are told of bandits in the north of China at the beginning of the 20th century who forced their female captives to remove their bindings and socks, and to walk in front of them, knowing what tremendous pain it caused. When not satisfied with this torture, they forced the women to dance for them on sharp rocks with nothing to protect their poor mutilated feet.

Fetishes other than those associated with bondage also surround footbinding. Men with odor fetishes found the often fetid smells of the feet and their bindings and shoes a great stimulant. Many men were excited by the smell of the

unwashed, perspiring feet. Licking unbound feet, biting them, or taking the entire little foot into the mouth were among the sexually stimulating activities some men enjoyed. And for others there was a sexual satisfaction in the sound made when the feet were manipulated between the hands.

Whether a matter of foot fetishes or normal lovemaking, lotus feet were a major stimulant. I have rarely found any form of erotic Chinese art in which the woman's feet are not bound, whether it be paintings, books, ceramics, carvings, or embroidery. And generally, the erotica is not subtle. Even the diagnostic figures (tiny female nudes, usually reclining, carved of ivory or wood, that a husband would take to show a physician where his modest wife was having pain), usually have bound lotus feet.

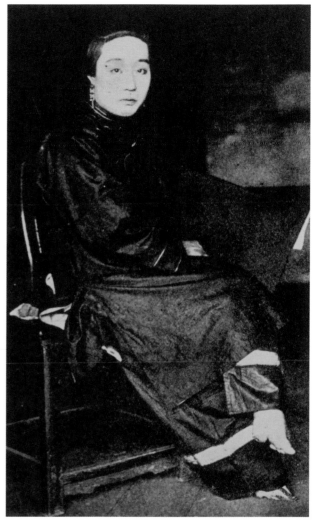

❖ ❖ ❖

Bound feet figured heavily in sex with prostitutes. Certainly, no successful prostitute ever had big feet. Because their feet were such an important part of their profession, high-class prostitutes and courtesans often went to extremes to create exceedingly small feet and exceptionally beautiful shoes. A man going into a house of prostitution would not be looking for a pretty face or large breasts. He chose his prospective partner by judging the size of her feet from the size of her shoes. (This may seem incomprehensible to the Western mind, until one remembers that sexual customs and standards of erotic beauty differ, sometimes quite dramatically, throughout the world. For instance, in certain cultures breasts are regarded as a convenient means by which to nourish children—period—with no particular erotic connotations. And there is one tribal culture in New Guinea where the males would not dream of sleeping with their wives before or after sexual intercourse.)

An integral part of sex with prostitutes or courtesans was the games that were played before going to bed. Drinking games were extremely popular, the ultimate goal of which was for the client to sip wine from the lotus shoe of the

◔◔ It was rare for anyone but a prostitute or concubine to pose willingly with her feet unbound. (From *The New America and The Far East* by G. Waldo Browne. Colonial Press, Boston, MA, 1907)

III

chosen woman as it was thought to be especially stimulating. One drinking game that became a great favorite had the prostitute assume the role of the legendary concubine Hsi Shi, consort of the Prince of Wu in ancient times. This game involved throwing dice, and depending upon the participant's luck, he might have to sing or play a musical instrument. Or he would have the privilege of drinking from one of Hsi Shih's shoes.

Another game involved tossing seeds or beans into the shoe of a prostitute. One of her shoes was placed in a basin, which she held about a foot and a half away from each guest in turn. Each man would have five tries at tossing little red beans or lotus seeds into the shoe. The prostitute was in charge of doling out the drinking penalties for inaccurate throws, and those drinks were consumed

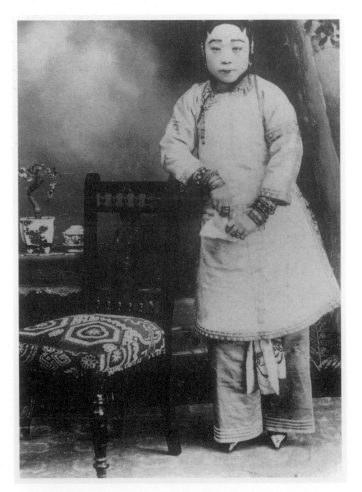

⊚⊚ Unlike the woman on page 105 who was photographed in an Oriental-style setting with Chinese furniture, the photographer chose a Western-style chair for her portrait. (From the author's collection)

from a cup inside her second shoe. Another way to delight a customer was to allow him to dip a tiny foot into his cup of tea before he drank the tea. The ultimate aphrodisiac had to wait until later in the encounter when the prostitute held and caressed a man's penis with her delicate lotus feet covered in their silken bed slippers.

Courtesans, or concubines, were trained in the skills of delighting men both in bed and out. Many of them were fine musicians, while others had lovely singing voices, or were well-versed in poetry. And unlike the wives who were confined to the home, these women were skilled in the art of conversation and kept their clients amused. They also knew how to use their feet. There is said to have been a special training manual for prostitutes which detailed in great variety how to use their feet during sex. Its author was a monk, Ti Ming, from the south of China, who allegedly engaged in homosexual relationships before switching to sex with very young girls with bound feet.

Male brothels could also be found in China. There are records of homosexuality in China dating back more than 2500 years. Homosexual men were known to both tight and

loose-bind their feet. The appeal of homosexual men with bound feet was that it offered their partners three appendages to utilize in sexual play instead of just one.

Homosexual brothels enjoyed acceptance by the aristocracy and even members of the imperial court patronized these brothels. The Qing emperor Xian Feng, who reigned from 1852 to 1861 was not permitted to consort with Han Chinese women within the confines of the Forbidden City. So he assumed disguises and visited various houses of prostitution outside the palace walls to enjoy the pleasure of bound feet. His proclivities took him to homosexual brothels too, and he was known to have had an extended relationship with one leading actor in the Peking Opera.

The abundance of opera companies in the capital city probably accounts for the unusually large number of homosexual brothels there. Because the male performers who played the female roles had to practice being feminine at all times, it was certainly reasonable that bisexual or homosexual behavior came to be associated with the theater and its actors. So many of these actors were involved in homosexual relationships that the expression "actor's house" became a synonym for male brothels. (Byron 1987)

Quite accurate statistics were kept on the brothels in Beijing at the beginning of the 20th century. In 1912, the government licensed the prostitutes and gave public recognition to a segregated district there. By 1920, there were 377 brothels and 3,130 registered prostitutes. They were divided into four classes from the young, pretty, well-trained girls sixteen to twenty years of age in the first-class houses, to the older, coarser women in the fourth class.

The first-class girls frequently trained for many years to be proficient in the art of pleasing a man. Many of them were well educated, in addition to being attractive and beautifully dressed. The most sought-after courtesans came from Suzhou. There is an old saying in Chinese that the most perfect women have faces from Suzhou and feet from Yangzhou. Yangzhou feet were the most perfectly bound feet in all of China in the opinion of the experts, and it was there that the leading bound feet beauty contests were held. The price for a first-class prostitute

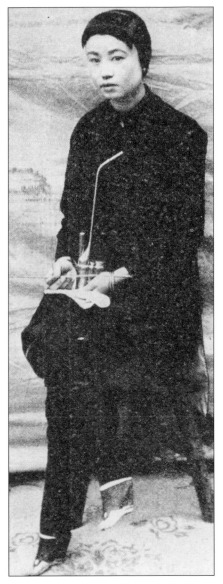

✆ This haunting portrait of a teenager leaves the viewer with the sad conclusion that she, perhaps, didn't much enjoy her profession. (From *The Old World and Its Ways* by William Jennings Bryan. Thompson Publishing Co., St. Louis, MO, 1907)

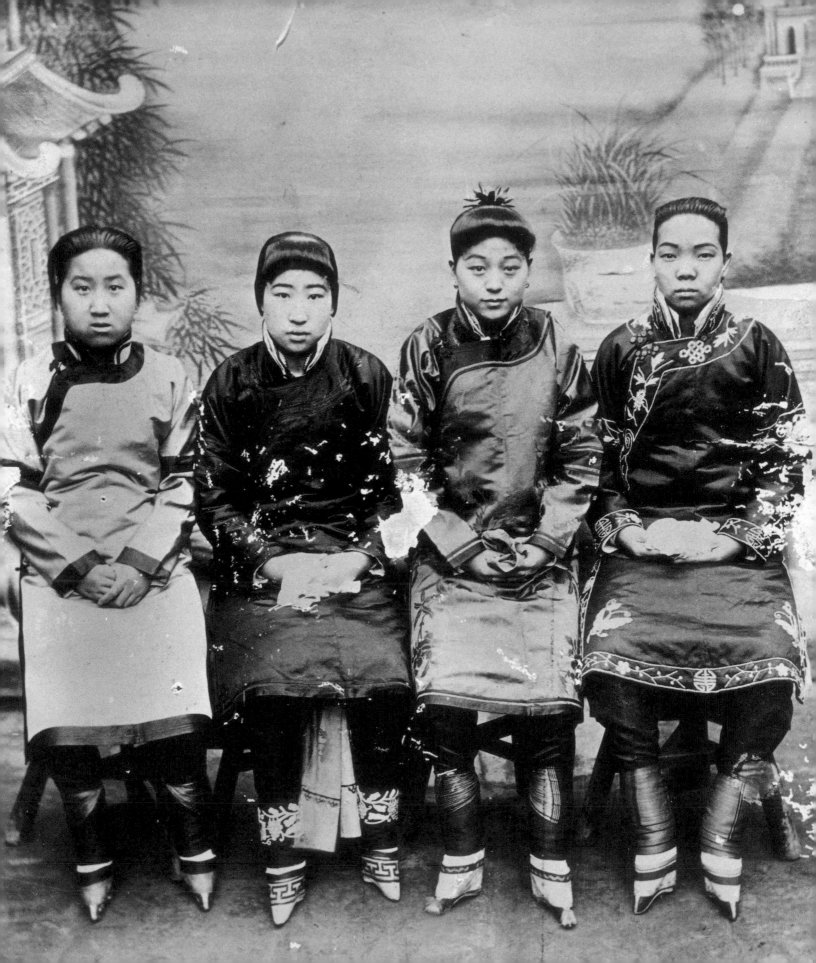

during the first quarter of the century was about $3.00 to attend a dinner party or to play party games, $1.00 to sit and talk, and $8.00 to spend the night.

Procurers paid parents approximately $200.00 for a six or seven-year-old girl. The younger the girl, the more she was worth. Should the little girl be sold as a concubine to a wealthy official or merchant after her training, the profits would be divided between the house manager and the parents. (Gamble and Burgess 1921) The very rich would often pay large sums of money for the privilege of deflowering a virgin.

Lower-class prostitutes found extra work in the small theaters of Beijing. In some of these theaters, all the entertaining was done by women from the licensed quarter. Clients frequently lined up at the theaters after the performances, endeavoring to arrange a rendezvous later in the evening with the girls.

Shanghai was even more notorious than Beijing for its vast number of prostitutes. In 1913, it was estimated that one out of every twelve Chinese houses in Shanghai was a brothel, and that one out of every 130 residents of the city was a prostitute. (Seagrave 1985)

The ultimate venue for a first-class girl was a club in a splendid mansion in the French concession on Rue Girard. There were guide books in Shanghai at the beginning of this century that listed districts and streets where each type of prostitute could be found. Here a man could gamble at Western gaming tables, dine on fine French cuisine, enjoy cups of hot wine, lie on a lacquered divan, and have his favorite girl roll opium paste into a pellet, roast it over a flame, and offer him the pipe. Or he could wander up the lovely staircase to where other beautiful women were on call for his pleasure. It was during the period in 1860 when the Taiping army occupied Shanghai that many courtesans moved their base of operations from the walled Chinese part of the city into the safety of the international settlement, and in the early 1920s they moved again into the French concession. Some of the glamorous old houses in Shantou Lu and Fuzhou Lu still remain, although they now house different types of businesses. In the old days, these houses had such names as "The House of Sure Satisfaction" or "Hall of Beauties" inscribed in red on the welcoming glass lanterns outside the front door.

Opposite: Four prostitutes. These were not high-class courtesans but lower-class working girls. Note the inexpensive robes, and absence of jewelry or hair ornaments—the emphasis is directed to their very small feet, good shoes, and nice leggings. (From the author's collection)

Courtesans weren't exactly hidden in the early 20th century in Shanghai. They were big news! The tabloids of the day followed the fashions worn by the leading courtesans, reporting everything in detail. They set new fashion trends in a city where Western-style clothing was becoming the rage in a country where styles had hardly changed in centuries. The Western influence in dress was an important factor in the decline of footbinding for the fashion-conscious girls in the city. The new styles called for high heels and normal feet, or at least unbound feet.

The leading courtesans of the city also enjoyed the luxury of that newly imported innovation—photography. They dressed in their finest and posed for their portraits.

Many of the surviving photographs and postcards of women with bound feet from this period are of the most famous courtesans of the day.

Things were not so glamorous for the fourth-class prostitutes who were concentrated in the alleys in rougher sections of Shanghai along Foochow Road. Called "pheasants" or "bacon" by other Shanghai residents, they often fought over customers. Even lower than the fourth-class prostitutes were the street-walkers who catered to foreign sailors. They generally did not have bound feet, and worked the area along the Soochow River. (Chou 1971)

Information on courtesans in China has come down to us in some detail through the fictional work of literary scholars who wrote about them in stories of love, crime, and scandal. The books were known as "mandarin duck" and "butterfly fiction," and frequently the authors used real names of famous courtesans and their houses. (Hershatter 1997)

At the end of the 19th century, prostitutes who left their houses and went out on appointments to restaurants, or other places, didn't walk there on their golden lilies. It was the custom for the male assistants in the "sing-song" houses, as they were known, to carry the women on their shoulders instead of sending them off in rickshaws. These male assistants were known as "tortoises" and were less respected than the prostitutes they carried. The name comes from early in the Tang Dynasty when a playful emperor assigned his feminine singers and

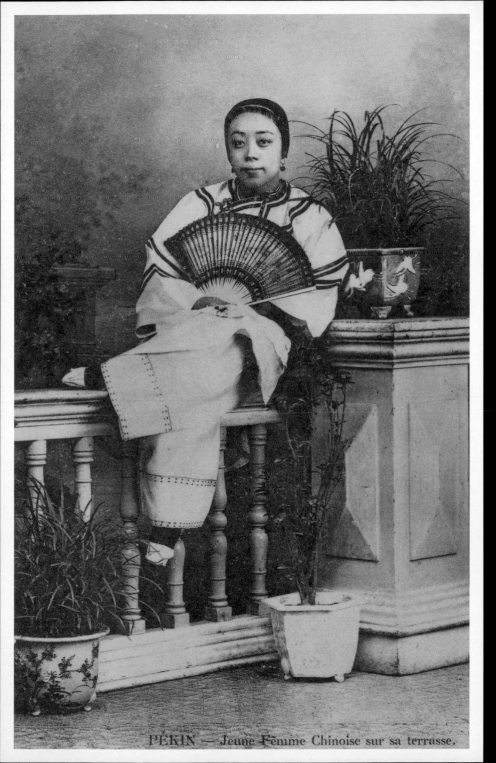

PÉKIN — Jeune Femme Chinoise sur sa terrasse.

◎◎ The delightfully demure pose of this Peking damsel is an interesting counterpoint to the sensual display on page 119. (From the author's collection)

dancers to a training quarter that later became the authorized houses of prostitution. The husbands of the women were relegated to the lowest possible rank and forced to wear green scarves around their necks, signifying the color of the tortoise's neck. During the Ming Dynasty, the "tortoise" class was emancipated, but the name remained and was attached to all male assistants working in houses of prostitution. (*Shanghai Evening Post & Mercury* 1947)

The term "sing-song girl" is a name frequently used in reference to prostitutes and courtesans. No definite source has been determined for this term which in Chinese is *xiansheng,* and originally pertained to story-telling courtesans. Several Chinese writers have suggested that it came from the Chinese word meaning "proof readers." Before the invention of the printing press, checking for mistakes in handwritten books was commonly done by having one person read the copy aloud while a second person checked what was being read against the original manuscript.

❖ ❖ ❖

Lesbianism is often found in, though certainly not restricted to, brothels, and China was no exception. Such relationships flourished between nuns, and between concubines and their servants. There are also many stories of lesbian activities in the women's quarters of the large compounds of titled or very wealthy men who could afford numerous wives and concubines. Weeks, months, even years could go by without a conjugal visit. Since they were closely watched, it was almost impossible to have male lovers. So the women would turn to each other for sexual release, and those tiny bound feet could prove a versatile substitute for the male organ.

Lesbianism has been a common theme in Chinese erotic art through the centuries. It even turns up in paintings of heterosexual lovemaking with a maid entwined with the man and woman, playing with one of the woman's bound feet, or two women engaging in romantic play while the foot of one woman is being enjoyed by the man and the other woman is serving him sexually in a more conventional way. These are sometimes referred to as "three-sided games."

◎◎ *Above:* A boxwood carving of a "tortoise" or male assistant, whose job it was to carry bound-footed prostitutes piggy-back-style to their professional assignations. (From a private collection, Larry Kunkel Photography) ◎◎ *Opposite:* Her richly embroidered slippers proudly displayed for the camera, the suggestive position of the left hand, the come-hither expression, and recumbent pose show an innate understanding of media manipulation. (From the author's collection)

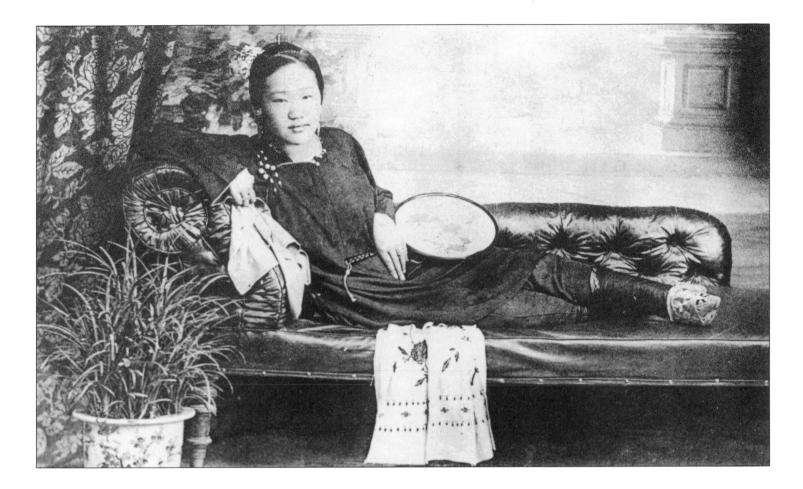

Particularly popular with painters of erotic albums was a device shaped like an erect penis, and used as a sexual stimulator. It was attached to the ankle above the lotus foot and entered a woman by pressure of the foot against her hip. The vendors who supplied such gadgets were usually old women who visited the compounds of the wealthy where there was a great demand for such items.

❖ ❖ ❖

Women with bound feet had sexual lures beyond the golden lilies themselves. Because of their tiny feet, they were forced to walk with a unique posture and gait. The chest was thrust forward and the pelvis pushed backward, placing the center of gravity over the heels. The resultant walk consisted of short hobbling steps coupled with a swaying movement.

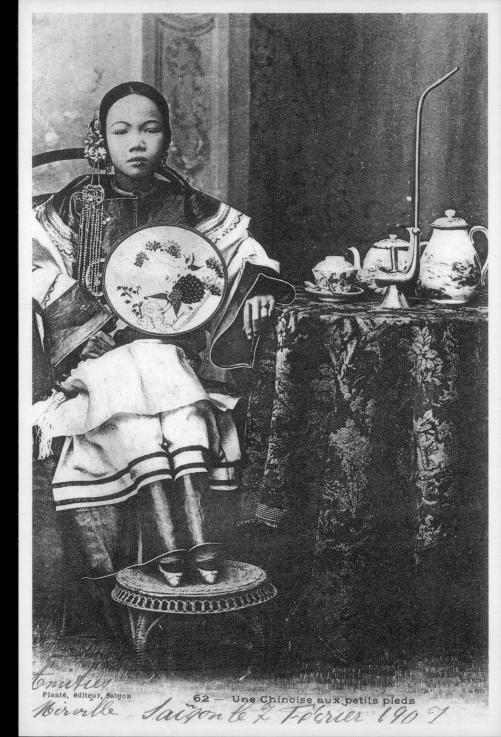

Dressed in their finest, famous courtesans enjoyed and exploited the newly imported innovation of photography. (From the author's collection)

Planté, éditeur, Saïgon

62 — Une Chinoise aux petits pieds

This walk, which was called the "golden lotus limp" or the "lotus gait," forced the tightening of the muscles in the upper legs, hips, and vagina. With the body's weight carried constantly on her heels, a woman developed fat thighs which made her most voluptuous in the eyes of a Chinese male. The walk caused the muscles of the vagina to tighten to such an extent that Chinese men have claimed that making love to a woman with bound feet was like making love to a virgin every time. Thus, when watching a woman take her cautious, wobbling steps, the male must have been reminded continually of exquisite sexual delights.

There were certain aural pleasures that came into play also. Sometimes bells were hidden in the heels of lotus shoes, and the sound of these bells could prove very exciting. In the late 18th century, it was the custom for affluent Chinese women to attach thin horse-shaped pieces of jade to their skirts. When they walked, the jades made a melodious tinkling sound that could be quite sensuous. The sound of the jade served as a constant reminder to walk slowly and gracefully. It was said that jade horses caused a woman to walk as if she were floating on water.

❖ ❖ ❖

Although they were undoubtedly a handicap in every other phase of her life, the tiny golden lotus served a woman well when it came to sex. They were a woman's weapon for survival in a restrictive and claustrophobic society.

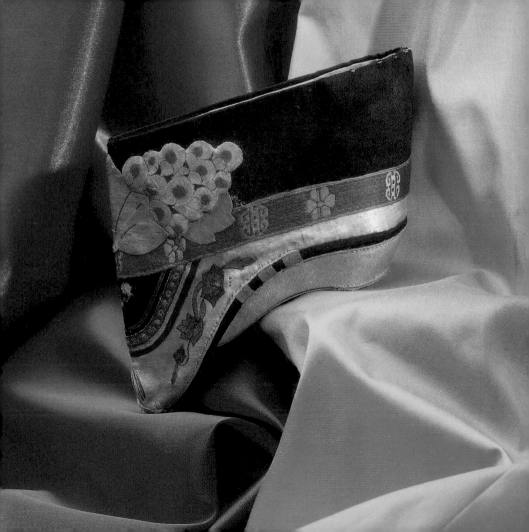

CHAPTER 8

SACRIFICE AT THE ALTAR OF BEAUTY

Phoenix Treasure's husband was heir to a large mercantile fortune in Peking with aspirations toward international expansion. Trading with European and North American companies was enthusiastically supported by his father. However, this necessitated a certain amount of contact with the foreigners themselves, a group about whom Treasure's mother-in-law was deeply suspicious.

"I know that you will be in the position of meeting the foreigner's wives. You must remember to be discreet at all times. Do not draw attention to yourself in any way. These people have strange customs and you must not subject yourself to such influences."

Phoenix Treasure nodded to her mother-in-law, yet inwardly smiled for she found the foreigners fascinating—as they did her. Only three days earlier she had attended a ladies' tea at an American mission hospital. The startlingly stiff white *kai tows* worn by the nuns had amused both the guests and their hostesses when Treasure likened them to junks in full sail.

Far less amusing was the visit she paid to the young girl with the massive white dressing on her left foot who sat disconsolately in a small courtyard. It was explained to the assembled group that her bound foot had become infected and had turned gangrenous, leaving her helpless and in pain. Although Phoenix Treasure had often felt exasperation toward her hobbled feet, her anguish was almost

◉◉ *Opposite:* A shoe that employs appliqué, ribbon, and painted decoration, but no embroidery. The grapes symbolize fertility with the specific wish for many sons. Length 4½ inches. (From the author's collection, Larry Kunkel Photography)

👁👁 *Above:* Padaung tribeswoman, Thailand. (Photo by Gail Fisher) 👁👁 *Opposite:* This is the only known (to the author) example of a shoe of this style, showing a pronounced Western influence with the possibly unique innovation of the strap and the very unusual heel, delightfully embroidered with exotic fruit. (From the author's collection, Larry Kunkel Photography)

always tempered by the pride that came from the compliments that their very small size and shape elicited. This was first time in her life that she had ever felt an inkling of shame and regret.

<center>❖ ❖ ❖</center>

From a distance, the girl walking towards me on Telegraph Avenue in Berkeley, California, looked like a typical young college girl of the 90s. She had a trim body and an assertive stride. Her jeans fit well, and she wore a very chic jacket. But when she got closer, I realized that she was certainly not what I would think of as average or mainstream. Her face was heavily tattooed in a black lacy pattern, and she had three-inch-long curved ivory tusks coming out of the sides of her nose!

Across the world from Berkeley, in the Indonesian half of New Guinea called Irian Jaya, the Korowai women adorn their faces with the thin bones from a bat's wing protruding from either side of their noses, like insect feelers.

The "Giraffe Women of Burma," as they were called by the 19th century Western explorers who first discovered them, have their own unique form of beauty enhancement. The female members of the Padaung tribe, now ensconced in the remote village of Panphe, near Lake Mo Bye in Thailand, wind brass coils around their necks to stretch them to abnormal lengths. The little girls of the tribe have the first few coils of brass wound around their necks at the age of four or five. By the age of fifteen, a girl will be wearing up to twenty-four coils weighing a total of ten pounds.

When questioned, the Padaung women claim there is no special discomfort in their stretched necks. In cases of irritation from rubbing, a poultice of spider webs and rice flour is applied. And contrary to the general conception that removal of the coils could cause the neck to break, the coils may be removed at will and without incident. These unusual looking women lead perfectly normal lives. They take care of their homes and their children and work in the fields.

The married women of the Nbebele people of South Africa also wear neck coils similar to those of the Padaung. In Africa, however, straw is stuffed between their long stretched necks and the metal coils which they call *iindzila.*

<center>124</center>

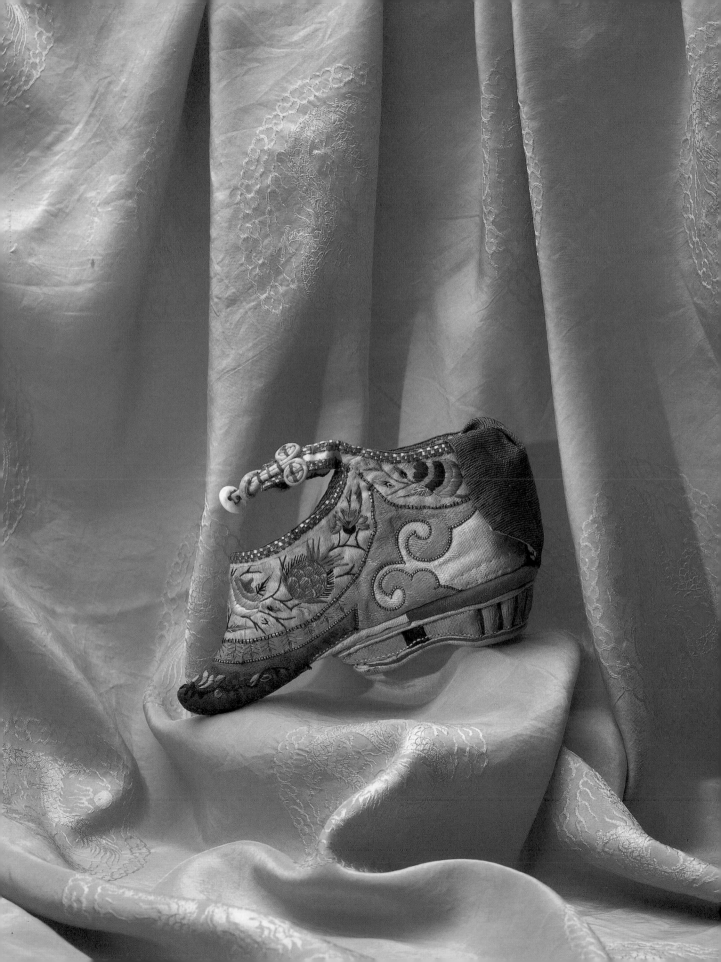

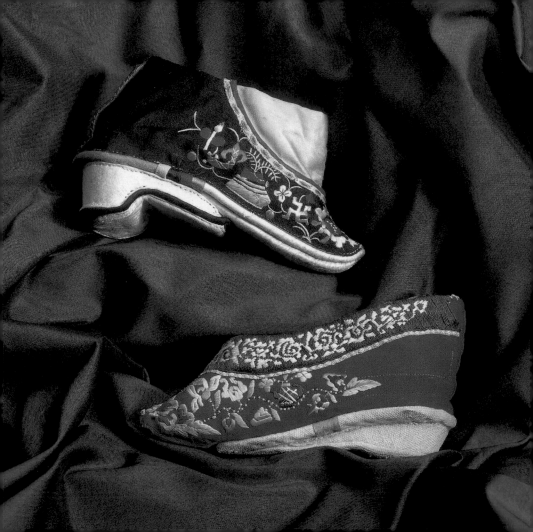

Unmarried women may wear the iindzila on their arms and legs, but not on their necks.

In East Africa, the focus for beauty among the women of the Masai tribe moves up to the ear lobes, which are artificially elongated by the weight of beaded ornaments. The inner section of the ear lobes of Masai girls are slit when they are young, and wooden plugs inserted to keep the slits open. Tribal sterilization practices leave much to be desired, and blood poisoning and lockjaw are not uncommon. Because of this, it is standard practice with the Masai to have the incisor teeth removed at a young age so that anyone who is affected can be fed through the gap in the teeth.

〜 *Above:* Masai tribeswoman, Kenya. (Photo by Gail Fisher) 〜 *Opposite:* Charmingly imaginative embroidery grace two peasant shoes: The black shoe (above) shows a normal-sized shoe being used as a flower pot. It also has a pink swastika design (with its crampons directed to the left) which was said to be the fourth of the sixty-five auspicious signs left on Buddha's footprint. Length 4¾ inches. The red cotton shoe (below) has a delightfully domestic teapot nestled into the flowers. Length 5 inches. (From the author's collection, Larry Kunkel Photography)

Men are not immune to the temptation of unusual body beautification. In Japan, it is mainly the men who subject themselves to a particularly painful practice of body tattooing called *irezumi*. Frequently this involves tattooing the entire body, including the penis. It can take one painful hour for the master artist to "paint" just one square inch of a man's body. The inks are said to be laced with cocaine to help deaden the pain. Some of the ink colors contain elements that can be very risky to the health, such as the red dye which contains cadmium.

Though commonly associated with the Japanese mafia or *yakuza,* both men and women from all walks of life have succumbed to the needles and inks that turn their bodies into walking art exhibitions. In the past, some Japanese courtesans had certain body parts normally hidden by clothing invitingly engraved. Today, a surprising number of Japanese men have covered themselves with flowers, animals, copies of famous Japanese engravings, and popular scenes from Kabuki theater. Elaborate floral compositions and colorful serpents winding around the penis are popular. (To achieve this, the penis is held taut by two assistants while the tattoo artist proceeds with the painful work.)

Elaborate tattoos are also found on Russian prisoners. Because Russia has one of the largest prison populations in the world, it is not surprising that between twenty-eight and thirty million inmates are estimated to be tattooed at this time. The practice is much more common with male prisoners than female prisoners.

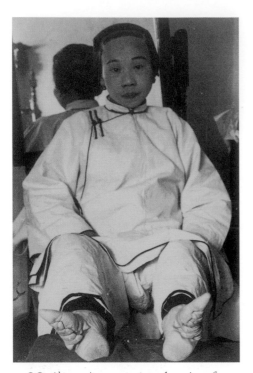

⊘⊘ *Above:* An unwrapped pair of golden lilies. (From the collection of the Library of Congress) ⊘⊘ *Opposite:* An *amah* shopping in the market, her atrophied leg muscles clearly apparent. (From *Two Gentleman of China* by Lady Hosie. J. P. Lippincott co., New York, 1924)

Frequently inmates do their own work, taking years to complete the tattoo. The dye, which they make themselves, is a mixture of urine and scorched rubber. Popular subjects are the fairy tale scenes found on Russian lacquer boxes. Nursing mothers, Russian onion-domed churches, angels, and other religious iconography can be found stretching from neck to waist.

The male members of the Dai minority people of China, who live in a remote region near the border of Myanmar, cover their thighs with an extraordinary tattoo in a blue-black lace pattern. This practice began during China's war with Japan to show the Japanese that they were Dai, not the Han Chinese who were fighting them. There is no proof that the painful tattoos saved anyone. However, the postwar generation of males found the lace tattoos quite handsome and continued the custom.

From the lacy tattoos on an Asian man's legs to the lacy tattoos of an American student's face, interpretations of physical beauty vary and also have similar themes.

I have given lectures on lotus shoes and golden lilies all across the United States, and invariably, when I describe the process of footbinding, I get a lot of negative reactions—looks of disbelief or disgust, and people muttering "How could they?" or "How horrible!" While I understand these sentiments, I patiently point out to my audiences that the Chinese were not alone in inflicting terrible pain upon the human body for beauty's sake, and cite some of the examples above. And I remind them that we must consider such customs in the context of the time and the mandates of the culture.

The late Wellington Koo, who served as China's ambassador to France prior to World War II, and later as ambassador to Great Britain, the United Nations, and the United States, often spoke out on the subject of bound feet. On many occasions, Koo would point out that while Chinese women may have bound their feet, Western women bound their waists—conjuring up memories of Scarlet O'Hara clinging to the bedpost, shouting "Pull harder, Mammy, pull harder!" in *Gone with the Wind,* as her corset strings were cinched up tighter and tighter. Had Koo lived to the end of this century, he might have diplomatically thrown in a word or two about body piercing as well!

He might also have commented on Western women staggering about on their stiletto-heeled shoes, doing tremendous damage to their feet, legs, and backs. In 1991, the American Orthopedic Foot and Ankle Society did a survey and found that 90 percent of American women wore shoes that were too small for their feet, and 80 percent had foot problems of one sort or another.

It is interesting that the earliest comments on footbinding were written more as observations than as criticism. William Dampier, who visited China in the late 1600s, wrote: "The women have very small feet, and consequently but little shoes; for from their infancy, their feet are kept swathed up with Bands, as hard as they can possibly endure them for every Night. This they do purposely to hinder them from growing, esteeming little feet to be a great beauty."

He described the women as stumbling about their homes, seldom leaving them, and suggested that it was "the Stratagem of the Mens, to keep them from gadding and gossiping about and confine them at home." He mentions further that they are fine "Needles Women" and make their own shoes. "But if any Stranger be desirous to bring away any for Novelty's sake, he must be a great Favorite to get a pair of Shoes of them, though he pay twice their Value."

There are numerous first-hand accounts written by Westerners in China at the end of the 19th and early 20th centuries. In *Footprints, An Autobiography*, New York society leader and philanthropist Brooke Astor reminisced about her childhood days in China. She recalled an incident that occurred a short time after the death of King Edward VII in

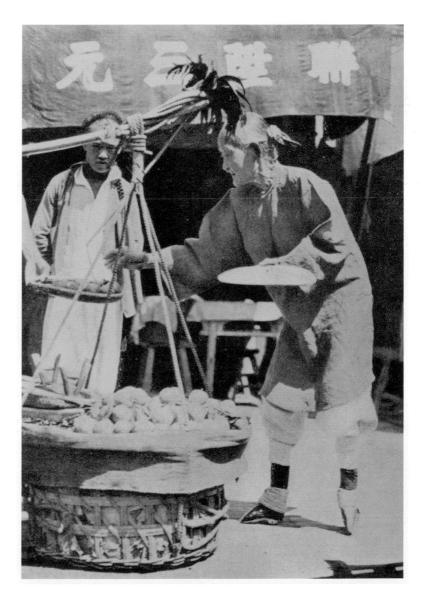

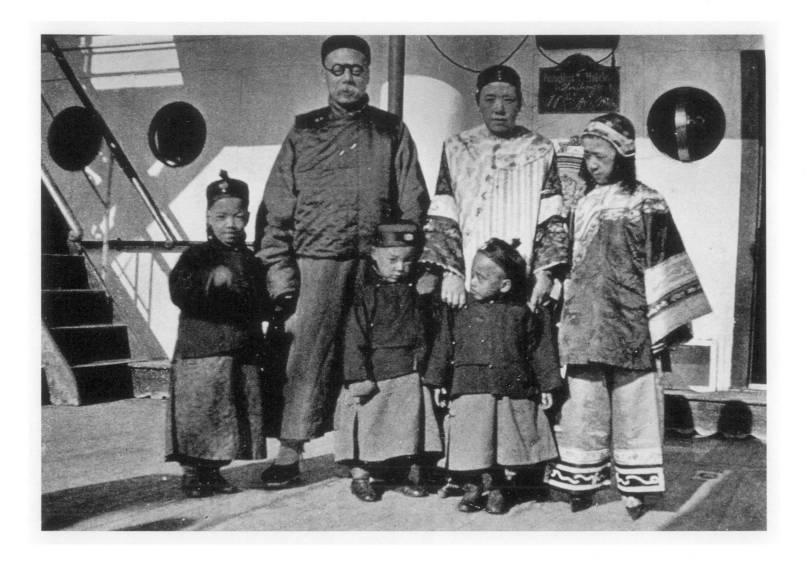

1910, when his mistress Mrs. George Keppel, and her brother Sir Archibald Edmonstone stayed with Mrs. Astor's family in their home near Beijing:

> I was only a little girl but I have never forgotten her [Mrs. Keppel's] lovely voice and charming presence, even though she had asked my *Amah* to unbind her tiny 'lotus feet' and show them to us. I had never seen *Amah's* feet and had always thought them pretty as they were only about three inches long and were covered with gleaming white socks and little black satin slippers. When the white socks were off and I saw them I was profoundly shocked. Little girls in

130

China up until the first decades of this century had their feet broken and bound in early childhood. The toes touched the heel and the foot only grew up into an arch. It was considered seductive to totter and sway on these tiny feet. I had often run away from *Amah* when she wanted to brush my hair or make me take my bath, but I never did it again after I saw her deformed feet. I felt sure it must hurt her to run after me. (Astor 1980)

Lucy Seaman Bainbridge told a similar story in her book *Jewels from the Orient*. She wanted to see what a bound foot looked like, but could not find any Chinese woman with golden lilies who would permit this. One friend finally offered to ask her amah; the amah was horrified at the idea and said the American woman would despise and revile her. The amah was finally convinced that Bainbridge was sympathetic, and she unbound her little foot. "I was allowed to approach and examine the deformed and shapeless foot," Mrs. Bainbridge wrote. "It was a little bag of dried and seemingly lifeless skin, filled with a pulpy mass of bones and muscles. One of the toes had rotted off during the binding process and the others, except for one, had been twisted under and imbedded in the sole. The instep bones had been crowded up and pushed together, while the heel had been drawn forward, making an indentation nearly an inch deep in the upper part of the foot. The limb, to the knee, because of the lack of circulation, was only skin and bone, and the ankle, which is usually kept carefully covered with silk wrappings or an embroidered pantleg, was a bulging deformity." (Bainbridge 1920)

Guliema F. Alsop traveled from America to China in the early part of this century, which was a very long journey in those days. On board the ship she became captivated by the young daughter of the Chinese minister to Berlin. The minister was traveling with his wives and several of his children, but it was the eleven-year-old daughter who captured Mrs. Alsop's interest. The little girl wore colorful, wide trousers and embroidered silk coats. But most fascinating of all were her tiny, pointed, embroidered black satin shoes.

One day, curiosity overwhelmed Mrs. Alsop, and she asked the young girl about her feet. The girl told her that her feet had been bandaged from the age of

∽ *Opposite:* The Chinese minister to Berlin and his family on shipboard in 1902. His eleven-year-old daughter Gun-Di (far right) was befriended by the American Guilema Alsop. After questioning the child's mother about Gun Di's bound feet, she was told: "Custom demanded small feet in the East as fashion required a small waist in the West." (From *My Chinese Notebook* by Susan Townley. Methuen & Co., London, 1904)

three. She explained that it had hurt her a great deal at first, and she could still remember the tears she had shed, but that she no longer minded. Towards the end of the voyage Mrs. Alsop asked the girl's mother why she had done this cruel thing to her child. The girl's mother replied, "Custom demanded small feet in the East as fashion required a small waist in the West." (Alsop 1918)

The arrival of the Western missionaries of various denominations in China at the end of the 19th century, have left us some interesting insights into the custom and its problems.

The Italian Mother Superior of a school for orphan Chinese girls told of the anguish it caused her and the other nuns to have their wards' feet bound. There was no alternative but to follow the custom if the girls were to find husbands. The girls were allowed to miss classes on the days their bandages were tightened, and the nuns tried to make it as easy for them as possible. But the Mother Superior admitted that the nuns who had to be present when the Chinese footbinders came each week could not stay with this task very long. There were constant replacements for this job.

Sister Ann Colette Wolf served in China from 1946 to 1967 in schools established by the Sisters of Providence, the same order whose name I found stamped in my first pair of lotus shoes. In her book *Against All Odds* she described the limitations of the Chinese employees at the order's schools and orphanages whose feet were bound. "It was pitiful to see them walk. They could not do any work which required them getting up on a ladder. And they had other limitations. Usually a person had to employ two women to do the work which one woman could have done if she had not been so crippled. . . . It seemed to the sisters and other foreigners as well that all through its history, China had treated her women like children. The women were simply helpless with their untrained minds and their incapacitated feet." (Wolf 1990)

Fortunately, not all the missionary stories are that grim. Sister Ignatia McNally, who now lives a very active and productive life at the Maryknoll Sisters' retirement home in Monrovia, California, spent fifty-seven years as a missionary in China. Her first experience with bound feet came in 1935, when she was

assigned to Mercy Hospital in Shanghai to work in the psychiatric ward. One of her patients was a petite Chinese woman the staff had nicknamed Queenie. They called her this because of her habit of tearing her clothing into strips which she twisted into crowns for her head, rings for her fingers, earrings, bracelets, or anklets.

Queenie could be quite ferocious, especially when kept from smoking cigarettes in the ward. Patients were only allowed to smoke in designated, fenced-in areas outdoors because of the fire hazard. Queenie obviously had a secret inside source for cigarettes and matches, and time after time she was caught smoking indoors, resulting in yet another battle for control. "One day I decided to watch Queenie without letting her see me," Sister Ignatia said. "Suddenly she reached down and took off her tiny little silk slippers, unwound her bindings, and there, tucked under the compressed toes of one foot were her cigarettes, and under the toes of her other foot, the matches!"

A pair of bound lilies means a big urn of tears.
(Ancient Chinese proverb)

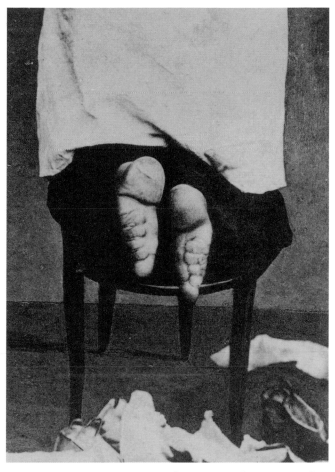

◎◎ Another view of unwrapped golden lilies. As was often the case, this woman was too shy to show her face. (From the author's collection)

Perhaps Westerners have been particularly horrified by the custom of footbinding because it was inflicted on innocent little girls who had no choice in the matter. Possibly, the only custom comparable to footbinding in its brutality, is genital mutilation as practiced today in the Middle East and Africa.[1]

To get some idea of the terrible pain bound-footed girls had to endure, one has only to realize that each square inch of skin in the feet has thousands of nerve endings. And one quarter of all the bones in the body are in those little feet. Lucy Bainbridge gives a chilling description of a little girl who had just had her feet bound. After hearing the sounds of a child sobbing, she went with a companion to investigate. Inside a nearby home, she found a palefaced little girl about eight years old:

◉◉ In 1874 at a missionary hospital in Canton, Dr. J. G. Kerr received a female patient whose feet had frozen and were sloughed off due to dry gangrene. After finally convincing the distraught woman that her feet could not be reattached, he was presented with the grisly specimens, one of which resides in Great Britain, and the other in the United States. (From the Mütter Museum, College of Physicians of Philadelphia, Philadelphia, PA)

She lay moaning because of the pain in her crushed feet. It was time for the dressing and we were only permitted to remain with the payment of a little cash. The festered feet were placed in a pail of warm water and the woman in charge rubbed off the dried skin, then sprinkled powdered alum into the cracks and worked the foot into the desired form. All as speedily as possible for the cloths must again be adjusted and with ever-increasing tightness before the flesh should swell.

My curiosity was mixed with abhorrence for what I had seen. "And how long must the child suffer?" I asked my companion, as we left the house. "When the foot is dead, as the Chinese say, the pain ceases. But it always takes two years and often several more for the dreadful process."
(Bainbridge 1920)

And in addition to the pain attached to the binding process itself, there were medical complications of all types. Foot infections were the most common complaint. Blood poisoning and paralysis could also result from improper binding and improper care. Internal maladies and low-back problems were frequent, since the full weight in walking went on the heel and tended to jar the spine.

Gangrene was one of the most feared complications and amputation was something to be avoided at all costs. The Chinese believed that a person's body must enter the next world whole and intact, and if the person was missing a foot or an arm, or, as in the case of palace eunuchs, the genitals, they would be similarly crippled in the afterlife. So firm was this belief, that they often preferred to risk death rather than have an infected limb removed. Western surgeons who were aware of these beliefs refused to perform amputations without securing the family's consent in writing and tried to avoid such operations if at all possible[2].

Sometimes nature itself did the amputation. In 1908, Mrs. Archibald Little wrote about such an event in her book *In the Land of the Blue Gown.* In 1874, Dr. J. G. Kerr, who spent much of his life as a missionary doctor in China, received a patient at the Medical Missionary Society's hospital in Canton (Guangzhou). Her feet had mortified from cold and were sloughed off as a result of dry gangrene. She presented them to the doctor preserved in lime, and begged him to

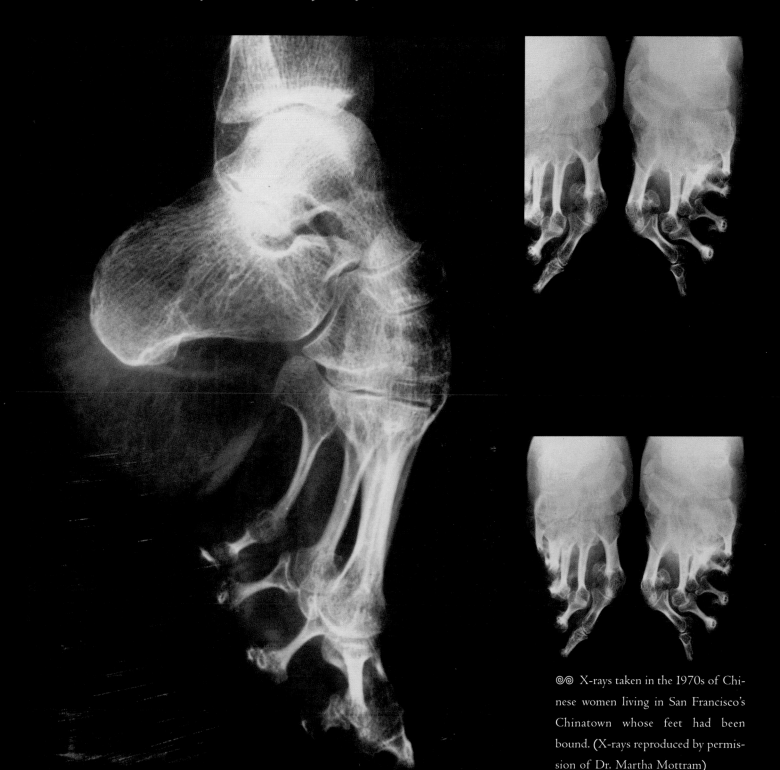

X-rays taken in the 1970s of Chinese women living in San Francisco's Chinatown whose feet had been bound. (X-rays reproduced by permission of Dr. Martha Mottram)

sew them back on again. After Dr. Kerr persuaded the patient that the feet could not be reattached, she gave them to him. He in turn sent one to a doctor in England, and the other to the College of Physicians of Philadelphia. The foot can be seen today in the college's Mütter Museum.

Paradoxically, unbinding could cause almost as much pain as the binding itself did. Much important medical information on footbinding became available in the United States in the late 1800s when married Chinese immigrants sent for their wives, most of whom had bound feet.

In the early 1970s, Dr. Martha Mottram and Dr. I. Roger Pyle studied and interviewed Chinese women living in the San Francisco area whose feet had been bound. Surprisingly, they found that a large number of the women had only partially deformed feet. This indicated that most female immigrants from China whose feet had been bound had loosened their bindings at some time.

Dr. Mottram told me that she and Dr. Pyle found some women who would not allow them to take X-rays of their feet, and others who did not want the doctors to look at their feet at all. One must remember the tradition of modesty these women had grown up with. Many would never have allowed anyone to view their bare feet, not even their husbands. And the idea of X-rays could well have aroused frightening body/spirit superstitions. However, others were quite relaxed about the medical examinations and willingly participated in this pioneering study.

From these two doctors we have an exact medical description of the bound foot:

> The phalanges and metatarsals are grossly misshapen; many of the phalanges are rotated, subluxateded, and/or eroded. The longitudinal arch is extremely high and short, and the tarsal bones are consequently molded. There are flexion deformities of the toes and the great toe is also rotated. There is associated soft tissue atrophy of the foot and of the lower leg.

For those who are interested, here's a more detailed medical description reported in 1995 by Dr. Eugene E. Berg, an orthopedic surgeon connected with the University of South Carolina School of Medicine:

> The sole of the bound Chinese foot is markedly shortened and the arch massively increased as the calcaneus [heel] and matatarsals [forefoot] are approximated. Normally, the matatarsals have an inclination of 20 to 30 degrees from the axis of the talus; which with the golden lotus is increased to between 60 and 80 degrees. The calcaneus is vertically oriented. The outer four toes are inverted and flexed under the sole of the foot, to give the desired short and pointed effect. With these alterations, the Achilles tendon is elongated, the plantar fascia shortened, and the leg muscles atrophy. The small tarsal joints are deformed and are minimally mobile. The small surface area for ground contact provides the foot with a smaller platform to support the body weight.

END NOTES

1. Genital mutilation continues in many parts of the world, but principally in Arab cultures and in Africa. Both footbinding and clitorectomies can be realted to the control of sexuality.

2. In an attempt to end the centuries-old belief that all body parts would be needed in the next life, before his death Deng Xiaoping made a final, shocking request. Following his death on February 19, 1997, it was announced that the Deng family, out of respect for the patriarch's wishes, donated his corneas to an eye bank and his body parts for medical research. This donation, and subsequent cremation, countered ancient Chinese tradition in the name of science.

Opposite: Westerners are most frequently disturbed by how very young the girls were when footbinding began. This little girl can be no more than about five or six years old. (From the Peabody & Essex Museum, Salem, MA)

THE END OF AN ERA

"No, dearest mother-in-law. With the greatest respect, I will not have her feet bound before we sail. I have learned that no one in the United States binds they're daughter's feet. It is thought to be barbaric and surely we do not wish these foreigners to think of us as barbarians."

"Very well, wait until you return home. But it must be done or Little Willow will have no chance for a husband."

Phoenix Treasure sighed and nodded her head. Of course her mother-in-law was right. But just then her little daughter's high pitched giggle floated in through the open window. Treasure felt a momentary wave of guilt wash through her followed by a stab of defiance. Why must she cripple her beautiful, healthy child? How could she justify such cruel pain and mutilation? In her heart, she knew that what her mother-in-law said was true—in China. But perhaps her Little Willow would not grow up in China. Perhaps her husband's business interests would keep them in America.

Treasure felt a small pang of remorse. She should not be thinking this way. It was disloyal to her mother-in-law who had shown her nothing but kindness from the moment Treasure had stepped down from the wedding palanquin six years earlier. "You will be the beloved daughter I did not have," were the first words spoken by the slight, birdlike creature who was presented to her as her husband's mother. She knew that not all brides were so fortunate. Treasure often

◉◉ *Opposite:* Silk damask Western-style pump made by a Shanghai shoemaker, most likely for someone who had regular contact with Europeans or who had traveled to Europe herself, possibly the wife of a diplomat. Length 6 inches. (From the author's collection, Larry Kunkel Photography)

Opposite: Collection of Manchu shoes in front of an official flag of China, abolished in the rebellion of 1911. Scarlet shoe (top right) with delicate gold couching and a cork platform covered in linen, a style favored by the Empress Dowager, although her platforms were usually made of carved ivory. Blue silk shoe (middle right) with unusual lattice needlework flanking the toe and a mid-sole wooden platform. Manchu women often made only the upper parts of their shoes and employed shoemakers to complete them. Green boat-shaped shoe (center) on a lower wooden platform with boldly stylized butterflies and cherry blossoms. Crimson boat-shaped shoe (left) with black velvet applique and embriodered ducks. (From the author's collection, Larry Kunkel Photography)

thought of the bitter she-dragon with whom her poor sister had to live. Secret thoughts of permanent exile were surely no way to repay the generosity of her husband's family. Yet she could not stop the creeping sense of betrayal she felt whenever the subject of binding came up. And it had come up rather frequently since Willow's fifth birthday. Every time the bright-eyed laughing little girl ran into her mother's arms, Treasure found herself at odds with her own past and her daughter's future.

❖ ❖ ❖

There is a story of a British legation wife in China who became friendly with the wife of a wealthy Chinese man. At one point she asked her friend, "What would you like to be if you come back after death?" Looking at her tiny bound feet, the Chinese woman replied, "I would like to come back as a dog. Then I could roam wherever I pleased."

As steeped in tradition as old China was, even there, time did not stand still, and toward the middle of the 18th century, things were starting to change. While people continued to follow the old customs as they had for centuries, with their lives based on family rule and obedience to elders, contact with the outside world was beginning to have some influence. Western traders and missionaries were bringing new ideas with them. Chinese in high places were beginning to be concerned, to some limited extent, about how the outside world looked at them. Chinese diplomats, men of education and wealth who traveled outside China, became aware that theirs was considered a barbaric culture. And the custom of footbinding was a large contributor to this assessment.

In the 18th century, a few important Chinese poets, scholars, and novelists spoke out publicly against the custom of footbinding. The poet Kung Tzu-chen felt very strongly and voiced his protests through his poetry which was widely read throughout China.

Lie Ju-chen, a writer of the same period, wrote a novel with a decidedly feminist twist entitled *Ching-Hua Yuan* which approached the topic in a most unusual way. In this story, which is set in the 7th century, all the male and female roles are reversed. An empress rules, and her concubines are male, and the boys had

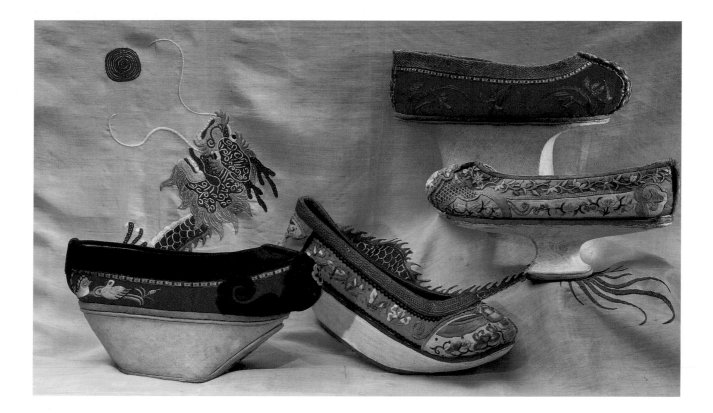

their feet bound, not the girls. The author offers his arguments against foot-binding through the male character, Lin Chi-yang, a cosmetics peddler who comes to court to try to sell his wares. The empress orders that he is to be imprisoned, and his feet are to be bound. An exacting description of the binding of Lin's feet is given. Late the first night, unable to stand the excruciating pain, Lin releases the bindings. When this is discovered the next day, he is whipped with a long, thick bamboo rod. His feet are rebound and round-the-clock guards are assigned to keep him from committing suicide. He is forced to go through the entire process of decaying flesh and atrophied ankles and legs, after which he is able to walk only when supported by his attendants.

Explaining his views about footbinding, the author said, "I thought that all women must have been unfilial, and their mothers bound their feet to protect them from the death penalty. [The strict rules of filial piety carried severe punishment for those who disobeyed.] I had no idea they were bound for beauty. If

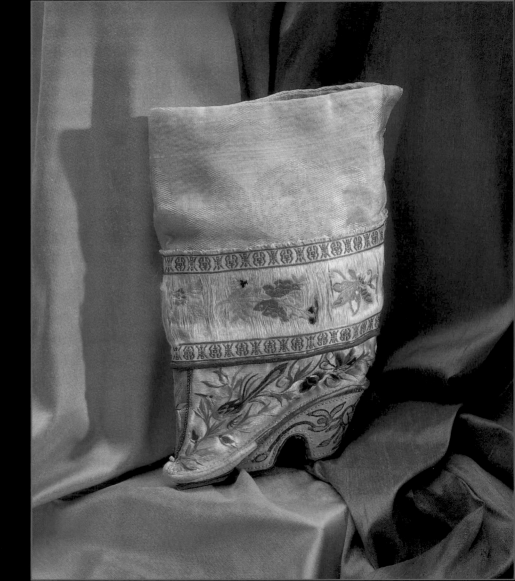

High-style pink boot, probably made in Shanghai in the early 1900s. The shoe has been extended upward to give the apperance of a legging. Length 3 inches. (From the author's collection, Larry Kunkel Photography)

we cut off someone's nose to make it smaller, wouldn't that person be considered deformed?" In the final analysis, according to Li, footbinding was a demonstration of male lewdness.

A few modest Chinese feminist movements developed late in the 19th century. One of the most famous activists was Qiu Jin who was born in 1875 in the port city of Xiamen (Amoy), where there was a fair amount of contact with Westerners. She was fortunate to have a mother who had had some schooling, and a father who wanted his daughter to get a good education. He encouraged Qiu Jin to take part in activities that might not have been considered appropriate for a young girl in her social position. By the time she married, she had abandoned such traditional pastimes as embroidery and could use a sword and ride horseback even though her feet were bound. (Old customs had evidently prevailed on that point.)

Her husband was quite modern in his thinking. He gave her a great deal of freedom early in their marriage, although his traditional family disapproved. But after some years, and the birth of two children, serious problems developed between them. In a letter to her brother, she complained that her husband was now treating her like a slave. In 1904, she sold her jewelry, left her husband and children, and went to Japan to further her education. Among her new friends were exiled Chinese intellectuals who were conspiring to overthrow the Manchu regime.

Upon returning to China in 1906, she taught Japanese in various schools for wealthy girls. She lasted at each school only until the administrators discovered she was teaching the students her revolutionary ideas. She founded a feminist newspaper in which she spoke out against footbinding, as well as other issues such as arranged marriages. At one point, she almost blew up her classroom while experimenting with explosives.

This brash young woman, whose feet had once been bound, along with her small army of female students, had intentions of capturing Hangzhou, the capital of Zhejiang Province. But her plans were discovered and she was arrested. On July 15, 1907, at the age of thirty-two, Qiu Jin was decapitated for her revolutionary activities.

❖ ❖ ❖

Westerners began to join the anti-footbinding movement around this time too. Alicia Little, an English writer, was the outstanding leader of this work. She came to China in 1887 as the forty-one-year-old bride of an important merchant. Her first years in China were spent in the western province of Sichuan. She was a keen observer and later wrote about the domestic and social life of Chinese families in both fiction and nonfiction. She was unusual in that she urged her readers not to make judgments about the Chinese based on just a few fragments of information. In addition, she was one of the first Westerners to discuss the informal influence Chinese women could wield over their husbands.

She was to become best known, and best remembered, for her efforts to end the custom of footbinding in China. She wrote: "Instead of a hop, skip, and a jump, with rosy cheeks like the little girls of England, the poor little things are leaning heavily on a stick somewhat taller than themselves, or carried on a man's back, or sitting sadly crying." She learned about the infections and other health problems allied with footbinding from the missionaries who had medical training.

In 1885, she founded the Tian Zu Hui (Natural Foot Society). She began with a group of Western women living in Shanghai that included the wives of various foreign consuls. Her aim was to establish an international group to work on ending footbinding. On return trips to England, Mrs. Little raised funds for the Natural Foot Society and rallied media support for her cause. It is said this effort was very effective even though it was thousands of miles away from the problem. The more publicity the anti-footbinding cause received in England, the more it influenced Chinese diplomats and scholars, and the more impetus it added to the movement back in China.

Gradually, the anti-footbinding message spread. The viceroy of Hebei ordered his officials to discourage binding in each of their districts in 1896. Then the governor of Hunan forbade binding in his province. A No Bind Feet Society was formed in Guangzhou, led by a man named Kang Yu Wei. The No Bind Feet Society urged fathers not to allow their sons to marry girls with bound feet. In

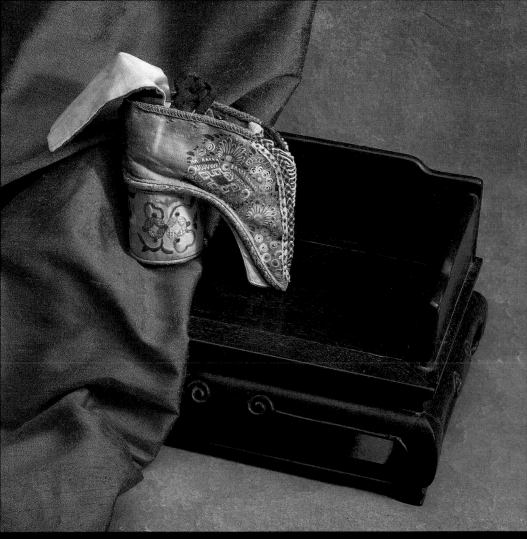

⌖ Unusual, elaborately painted cotton chintz shoe with embroidered silk barrel heel and an exaggerated slope terminating in a unique flattened "V" tip at the toe of the sole. Length 3¾

June of 1898, Kang Yu Wei sent a memorandum to the Empress Dowager in which he stated: "For some time now, foreigners have taken photographs to circulate among themselves and laugh at our barbaric ways. But the most appalling and the most humiliating is the binding of our women's feet. For that your servant feels deeply ashamed." Later, Kang's daughter, whose feet had not been bound at her father's insistence, turned up in Shanghai as one of the fashionable ladies working on committees in support of unbinding.

About this same time, another very powerful man jumped on the bandwagon. He was Duke Gong Hui-zhong, one of the lineal descendants of Confucius. He wrote, "I have always had my unquiet thoughts about footbinding, and felt pity

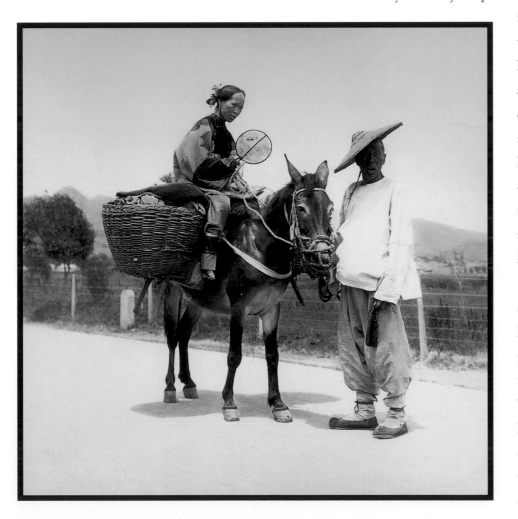

for the many sufferers. Yet I could not venture to say so publicly. Now there are happily certain benevolent gentlemen and virtuous daughters of ability, wise daughters from foreign lands, who have initiated a truly noble enterprise. They have addressed our women in animated exhortations, and founded a society for the prohibition of footbinding. They aim to extinguish a pernicious custom." So said the descendant of Confucius.

An essay called "On Women's Education," written by Lian Qi-chao in 1897, had considerable impact on many high-placed men who had previously given little thought to the education of females. The timing was right, because the following year, the twenty-six-year-old emperor Guang Xu initiated a movement that became known as the Hundred Days of the Reform. He and his advisors did

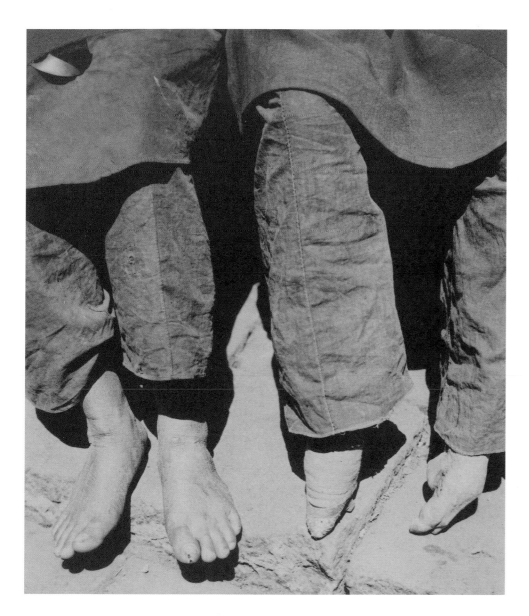

∽ *Left:* "For some time now, foreigners have taken photographs to circulate among themselves and laugh at our barbaric ways. But the most appalling and the most humiliating is the binding of women's feet." Memorandum to the Empress Dowager, 1898. (From the Peabody & Esssex Museum, Salem, MA) ∽ *Opposite:* A Tartar woman riding a mule. (From the collections of the British Museum, London)

discuss the topic of women's traditional position in China, although it was not a major part of their reform plans. The issue of footbinding was not brought up. The reform movement was brought to an abrupt halt by Empress Dowager Ci-xi who removed the young emperor and his wife from power, confining them to an island in the south lake of the Sea Palaces in the Forbidden City, and resumed the throne once again.

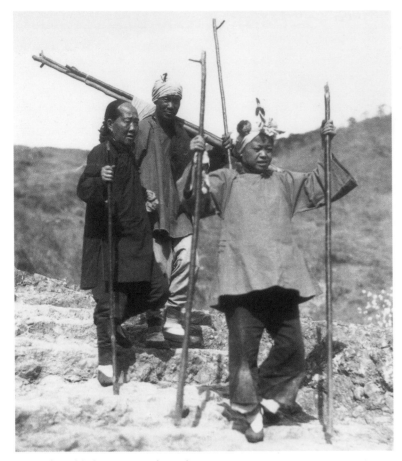

◉◉ The elderly woman dressed in black doesn't allow her bound feet to keep her from climbing a mountain, c. 1930. (From the Sidney D. Gamble Foundation for China Studies)

The same year a fashionable high school for young Chinese ladies was opened in Shanghai. There were sixteen girls, and the majority of them had let out their feet, even though it was not a requirement. Education and unbinding were already intermingling, and all these scattered attempts were indicative of a trend.

The Western missionary schools were somewhat limited in what they could do towards abolishing footbinding. They could try to help educate the Chinese, but they didn't want to be overly intrusive, or upset the local customs. And sometimes the demands of the order might conflict with the realities of footbinding. For example, when the Sisters of Providence opened their middle school in Kaifeng in 1921, girls with bound feet were not accepted because they could not take part in the calisthenics that were required by the school board.

It was the Boxer Rebellion that indirectly led to the next serious anti-binding action. In the late 1800s, a secret society called the Righteous and Harmonious Fists was formed to fight against foreign influences in China. This group was known to Westerners as the Boxers. The Boxer's rise to popularity amongst their countrymen was due to the humiliating military defeats China had suffered from the Japanese during the Sino-Japanese War (1894-95), and from the British during the Opium Wars (1839-42 and 1856-60). The resentment of foreigners in China was felt strongly all the way up to the imperial court, and even the Empress Dowager Ci-xi herself secretly supported the Boxers.

In 1899, the Boxers began a campaign of terror against Christian missionaries in the northeastern provinces. Gathering more and more support, the Boxers marched into Beijing to attack the foreigners in their legations. At first, the

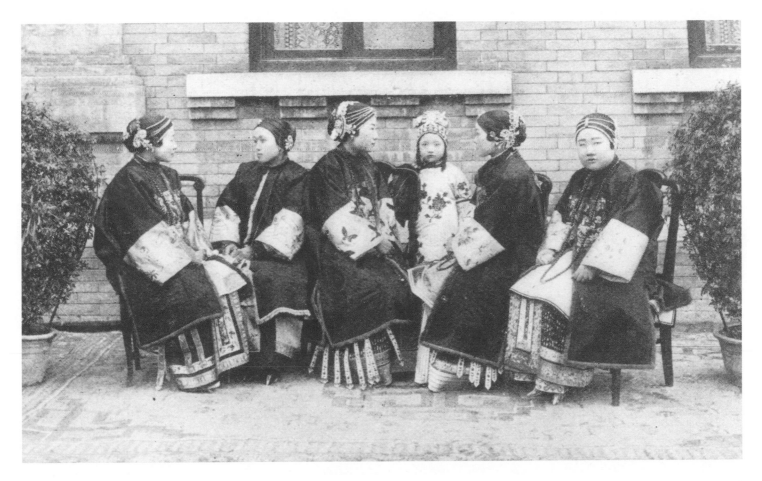

Empress Dowager Ci-xi ordered them to stop, but she later reversed this decision, threw her powers behind the Boxers, and on June 18, 1900, ordered all foreigners killed. The foreign legations were kept under siege for several months, until a combined force of British, Russian, German, American, and French troops arrived to defend them.

This defeat not only cost the Chinese incalculable commercial losses, it also spelled doom for the Manchu regime. Forced to flee Beijing in October 1901, Dowager Empress Ci-xi returned in January 1902, only to face the fact that certain reforms were needed in order for China to hold its own against European dominance. The empress was in the regrettable position of having to not only

∞∞ A group of elegantly dressed and coiffed diplomats' or ministers' wives relax in the courtyard of one of the foreign legations. (From *Court Life in China* by Isaac Taylor Headland. Fleming H. Revell Co., New York, 1909)

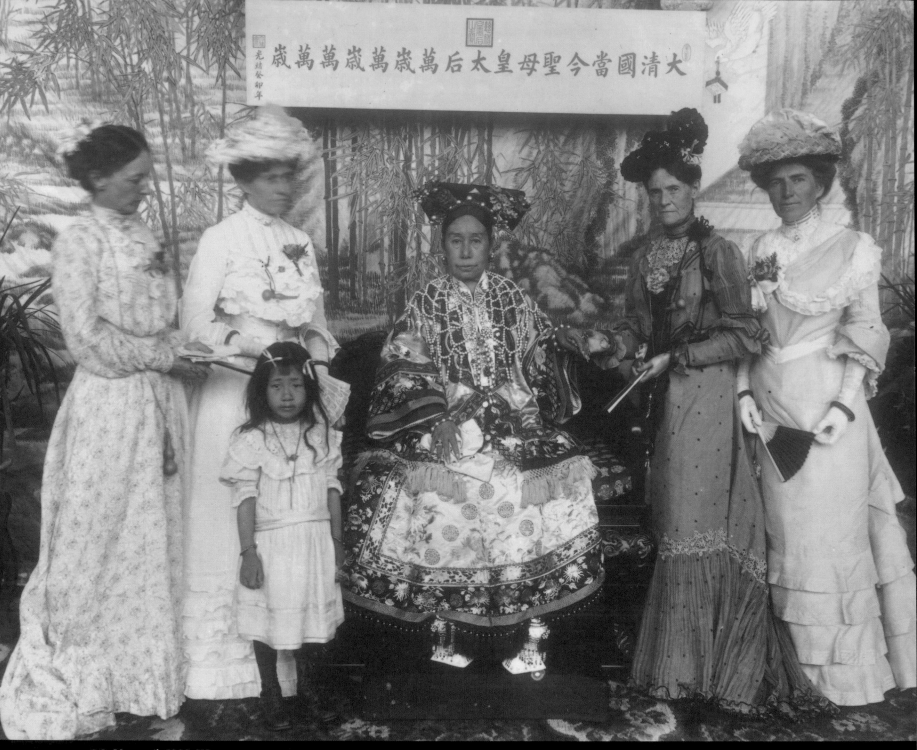

大清國當今聖母皇太后萬歲萬歲萬萬歲

☙ Up until 1902 Western women would not have been entertained by the Empress Dowager Ci-xi. Note the fantastic ivory shoe platforms beneath her magnificent robe. (From the collections of the Freer Gallery of Art)

put up with the foreign legations, but to curry their favor because of the damage done by the Boxers.

Always the clever diplomat, one of her first moves was to enter into social relations with the foreigners. One American, Mrs. Isaac Taylor Headland, was physician to Ci-xi's mother, sister, and many of the princesses for more than twenty years, and saw the Empress Dowager from time to time. On one occasion, the two women discussed footbinding. In Isaac Taylor Headland's book *Court Life in China*, written in 1909, he quotes from his wife's notes:

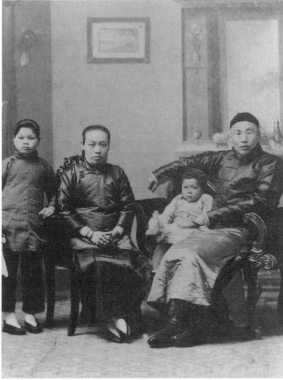

≈≈ A family portrait in which the mother (seated left) has bound feet but the daughter (standing left) is to have natural feet. Shanghai, 1900. (From the author's collection)

> The Empress Dowager was as much opposed to footbinding as any other living woman. Nevertheless, she would not allow a subject to presume to suggest to her ways in which she should interfere in the social customs of the Chinese, as one of her subjects did. This lady was the wife of a Chinese minister to a foreign country. One day she said to her Majesty, "The bound feet of the Chinese women make us the laughing-stock of the world."
>
> "I have heard," said the Empress Dowager, "that the foreigners have a custom which is not above reproach, and now since there are no outsiders here, I would like to see what the foreign ladies use in binding their waist," she said to the Chinese diplomat's wife who, with her daughters, had come back to China in Western dress.
>
> Since a request from Ci-xi was a command, the mother turned to one of her daughters and asked her to comply. Once she had seen, she ordered proper Manchu outfits for the two daughters, saying, "It is truly pathetic what foreign women have to endure. They are bound up with steel bars until they can scarcely breathe. Pitiable! Pitiable!" The Dowager Empress was also of the opinion that just as Chinese women slept with their feet bound, the foreign women slept with their corsets.

After her brief period of exile, the empress went into action on many fronts. One of her edicts required government officials to study international law and political science. And she appointed a special commission to plan a public school system, the first of its kind in China. The government only gave academic

examinations to men for military and civil service. The rich had tutors for their sons, and in some cases, families might pool their resources and hire a teacher for their children, but it certainly wasn't a common practice.

Convinced she could no longer ignore the rest of the world, the Dowager Empress declared, "At the time of the founding of our Dynasty, the customs and languages of the two races [Han Chinese and Manchu] were greatly different, and this was in itself adequate reason to prohibit intermarriage. But at the present day, little or no difference exists between them and the time has come to relax the law." She faced the issue of footbinding in this same edict, urging the educated classes to unite in opposing this custom that she felt was inhumane and injurious to the health of young girls.

It was two years before the education commission presented its plans, which was eight volumes in size. Based on the commission's report, the old system of examinations was abolished and a new system of public schools established that was modeled on those in the United States and Japan. This plan was developed primarily for the boys of China, however. Girls were only allowed in the lowest grades.

When the empress was made aware of this, she directed her adopted daughter, the Princess Imperial, to open a school for the daughters of the nobility and top officials. The school was to be housed in the princess's magnificent palace. She knew what universal appeal this concept would hold for the people of China. She further ordered that girls with bound feet would not be admitted to the school. Of course, this eliminated most of the Han Chinese girls. However, the idea was exciting and had modest success with the upper classes in Beijing.

Some years earlier, Prince Su, one of the eight hereditary princes, had established a school for the education of his daughters and the women of his household on the palace grounds. The classes included arithmetic, Japanese language, Chinese language and history, drawing, needlework, music, and calisthenics.

Prince Su's third sister, known as Third Princess, was also deeply interested in Western-style education for girls. She opened a school with more than eighty

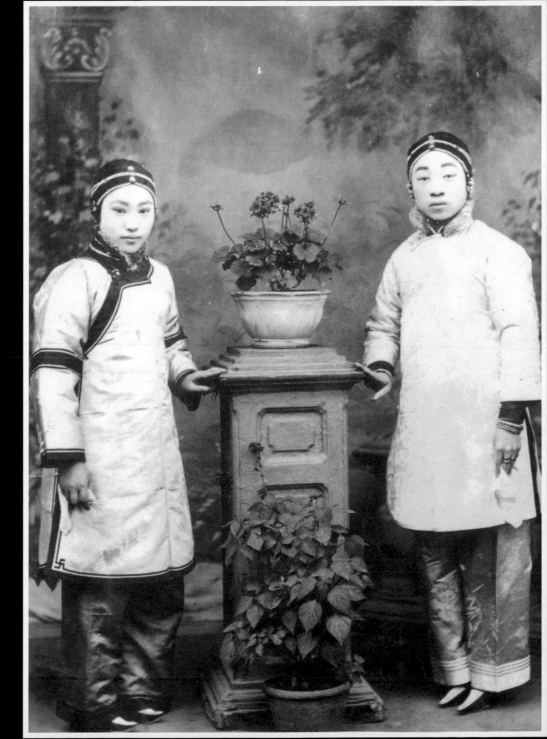

Two fashionable young girls from Shanghai. (From the author's collection)

students from various levels of society. In addition to the hired instructors, the princess herself enjoyed teaching the classes from time to time.

◇ ◇ ◇

After the collapse of the Qing Dynasty in 1912, the newly formed Nationalist government increased pressure to abolish footbinding, and its leader Sun Yat-sen declared that it must end. His orders met with some success, mainly in the cities. In the countryside, however, the old ways are very slow to change and sometimes they carry on indefinitely in secrecy.

In the early 1920s, the Cambridge University-educated poet Hsu Chi Mo wrote: "China is backward in every respect, including women's liberation. In the West they liberate their minds first. We begin with our feet."

By 1928, the Nationalist government had stepped up its anti-footbinding efforts. Among the orders given were that primary school textbooks must contain a chapter dealing with the prohibition of footbinding to try to educate the young. Girls under fifteen were to unbind; unbinding for older women was suggested but not required, since the pain could be so severe; financial rewards were offered for used bindings; and fines were levied against the families of girls with bound feet.

Propaganda aimed at the young was part of the campaign. One popular slogan read: "Yesterday our teacher told everyone, bound foot women are weak and dumb." Another one said, "She washed her bindings on the river bank. Everyone ran away. They smelled. They stank."

In some quarters, the young women didn't need much convincing. By the early 1930s, many younger women in the larger cities were having their own misgivings about their three-inch golden lilies. It wasn't a question of pain or deformity, it was a question of fashion. The latest Chinese gowns had high slits on the sides and were meant to show off a pretty leg, not bindings and leggings on top of lotus shoes. For this type of garment, only Western-style high-heeled shoes would do.

Anti-footbinding movements did show up in some rural areas. For example, in the small village of Ting Xian (Ting Hsien), located about 125 miles south

of Beijing, a Customs Improvement Society was formed to convince their people to abandon some of the more archaic and restrictive traditions. The society, which was chaired by the village chief, sought to eliminate footbinding as well as early marriage and expensive funerals.

A study done in 1929 showed just how effective this homegrown movement had been. There were 1,736 females included in the study. Of the 492 women over age 40 (and therefore born before 1890), 488 had bound feet (98 percent). In the 30 to 39-year-old age group, 94 percent had bound feet. And then there was a dramatic drop, presumably due in large measure to the work of the society: 59 percent for those born between 1905-1910; 19.5 percent for those born between 1910-1915. By 1919, not one girl in the entire area had her feet bound. By 1931, they were able to report that no girls in the village were marrying before they were sixteen, and no girls under sixteen had bound feet. (Gamble 1954)

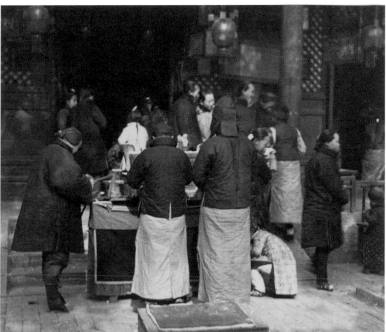

◎◎ Two women (standing far left and far right) offer their prayers for the New Year, c. 1919. (From the Sidney D. Gamble Foundation for China Studies)

These statistics show what could be accomplished when an entire community put its efforts behind a project for change. The village chief alone could not have achieved such results. He needed a cooperative community.

Yunnan Province was one area where binding continued after it had ceased virtually everywhere else in China. A few rural villages kept binding until 1957.

The final sword fell on the practice of footbinding in Taiwan earlier than it did on mainland China. The Japanese seized complete control of Taiwan in 1895, and held the island until the end of World War II, at which point Taiwan was made a province of China. The Japanese found footbinding unattractive, nonproductive, and unhealthy, and set about abolishing the custom. In the beginning, they approached the problem cautiously. They discouraged the binding of young girl's feet, and encouraged older women to unbind. After twenty years of little success, they gave up the subtle approach. In 1915, they issued

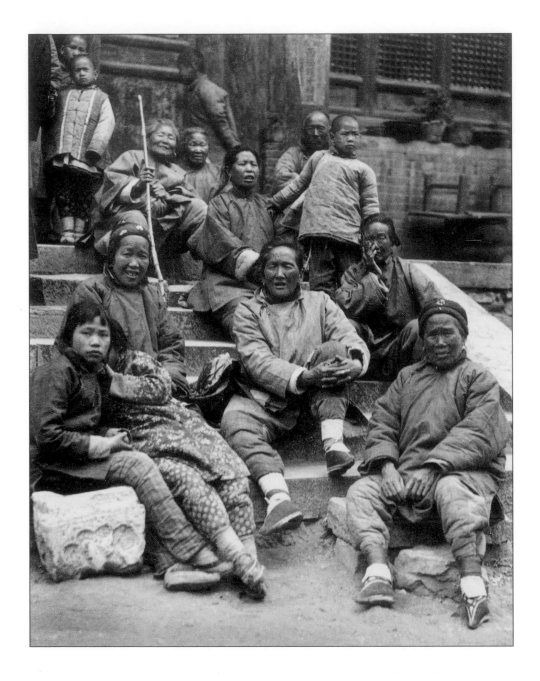

⚇ The three bound-footed pilgrims in the forground have just climbed 6,666 steps to the top of Mt. Taishan, one of the five sacred mountains of China, Shantung Province. (From the Sidney D. Gamble Foundation for China Studies)

official orders banning footbinding and insisted on the unbinding of older women's feet. Detailed registers on each household were maintained, listing names, relationships, the ages of each member, and anything that might prove useful in forcing compliance with the new regulations.

The Japanese never had enough territorial control on mainland China to launch such efforts there. And it was not until the Chinese Communists took over the country in 1949 that the custom of footbinding really came to an end in China. The Communists were not about to tolerate self-inflicted mutilation and the loss of healthy workers for beauty's sake. Their task was to unify and stabilize the country, and footbinding had no place in the scheme.

Once the Communists had control of China, they were in a position to enforce any rules they wanted. Like the Japanese in Taiwan, they kept complete records on every family, and on every family member. And they had brigades of health and welfare officers, women's affairs officials, street cadres, and others who could keep a vigilant eye on all that went on.

Of course, they still had to cope with the problem of those whose feet had already been damaged by binding. One of their solutions was to assign different tasks to the differently abled workers. In mobilizing women for spring planting and cultivation, for instance, "Large Feet" were given the harder work of agricultural production, including land clearance. "Small Feet," which included young boys and old men, as well as women with bound feet, would be charged with simpler chores such as pulling weeds or collecting dung. (Snow 68)

In July 1992, I read a most interesting obituary in the *New York Times*. It was for Deng Ying-chao, the widow of Premier Zhou En-lai. It recounted her early years, and said that in 1919 (she was fifteen at the time), she had joined a group called the Awakening Society which was actively involved in the anti-footbinding movement. What intrigued me most about this was that the leader of this organization was none other than Zhou En-lai himself. In a sense you could say that this renowned leader began his political career working on the abolition of footbinding!

It is perhaps ironic that the fledgling Chinese Communists shared at least one thing in common with the influential foreign diplomats, the well-meaning missionaries, and the last Manchu empress of China. Although each of them had a different motive for doing so, they all worked to bring to an end the thousand-year-old custom of binding women's feet.

157

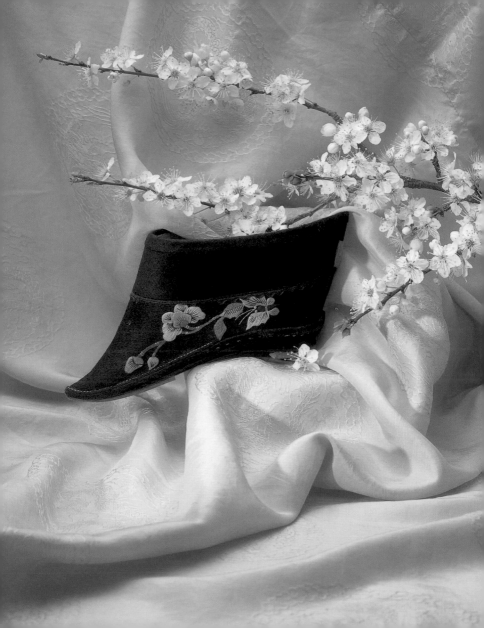

ONE DOOR CLOSES, ANOTHER DOOR OPENS

Those little red lotus slippers I bought that rainy day in Scotland have led me down a very long trail, a trail that I've followed to many distant parts of the world. In the beginning the shoes were just an amusement, a new dimension in an already very full life. As my quest grew, though, they slowly took over center stage and eventually became the total focus for a second life—the one we can enjoy after the children are grown and we retire from our first career.

My time is now almost completely consumed by searching for new shoes, hunting for resource material, and writing and lecturing on lotus shoes and footbinding. Through all this, I have met hundreds of wonderful people I never would have known but for that first pair of little red shoes. I have met professors from universities as far away as the University Kebangsaan Malaysia, museum directors and curators, Chinese textile collectors from every corner of the world, doctors in San Francisco and Shanghai, podiatrists in Washington D.C. and Philadelphia, librarians from Los Angeles Chinatown to the Harvard-Yenching Library to the New Straits Times Press in Kuala Lumpur, people connected with Chinese opera companies in Taiwan and Hong Kong, antique dealers willing to search for tiny feet on old treasures, retired nuns, archivists No matter how remote a part of the world I might visit today, I am sure I could locate

Opposite: Black silk winter shoe with leather soles on the heel that have been fitted with metal studs for better traction in ice and snow. Length 5¾ inches. (From the author's collection, Larry Kunkel Photography)

someone who was somehow connected, at least indirectly, with those little shoes from Edinburgh.

My research brought me closer to a long-time acquaintance, the late Rudolph Nureyev, who was fascinated with my comparison of footbinding to modern-day ballet. He had planned to contribute his thoughts on the subject to this book before his untimely death.

Legendary architect I. M. Pei, whom I knew when we were both young, came into my life again briefly when I asked him for information about footbinding. "I left China when I was quite young; hence I have little or no recollection of the practice of footbinding in China," he replied. "But," he added, encouragingly, "your forthcoming book on the subject should prove highly interesting, especially to me."

I went to the China Institute in New York in search of Sidney Gamble's wonderful photographs, and this led me to his daughter Catherine Curran, who has grown to be one of my most treasured friends. When she understood what I needed, she had 4,000 of her father's photographs taken out of storage for me. The photos were taken between 1908 and 1932 during several trips Gamble took to China. Through his superb eye and camera lens, I was able to enter the world of my women with tiny feet—I was in their homes, foraging for wood with them, climbing sacred mountains with them, sewing with them, living with them, and dying with them.

I knew that the Sisters of the Maryknoll order of the Catholic Church had operated orphanages and schools throughout China, and I decided to see if I could make contact with any of the sisters who had actually worked there. My quest began on the West Coast at the Los Angeles Diocese headquarters, then back to their New York City headquarters. From there, Rev. Charles T. Huegelmeyer of the Maryknoll Mission archives in Maryknoll, New York, came into the act, and he directed me to the Maryknoll Sisters retirement community in Monrovia, California.

There I met Sister Andre. While she herself had not spent time in any of the order's orphanages or schools in China, one of the other sisters had. And so I was

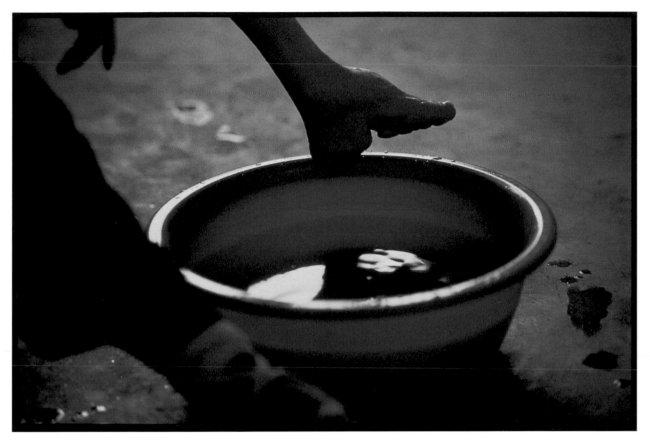

∽ Taken 1993 in a remote village in Yunnan Province, an elderly lady bathes her foot. (Photo by Kazuyoshi Nomachi/Pacific Press Service)

invited to luncheon in Monrovia to meet her—on a day that happened to be my birthday (which was celebrated with all the sisters singing Happy Birthday as a cake with candles was set before me). I met Sister Ignatia McNally who had spent over fifty years in China and had many stories to tell, including the tale of Queenie and her cigarettes.

I also made contact with the Sisters of Providence, and they too shared many stories of their experiences with footbinding in their orphanages and schools in China. One of the Chinese Sisters of Providence who now lives at the headquarters in Indiana described her one-woman rebellion. "I was about eight years old when my elderly grandmother who lived in our house insisted on binding my feet. But when I got about a block away from home, I would sit down in the street and take off my bindings. I wanted to be able to run and play with

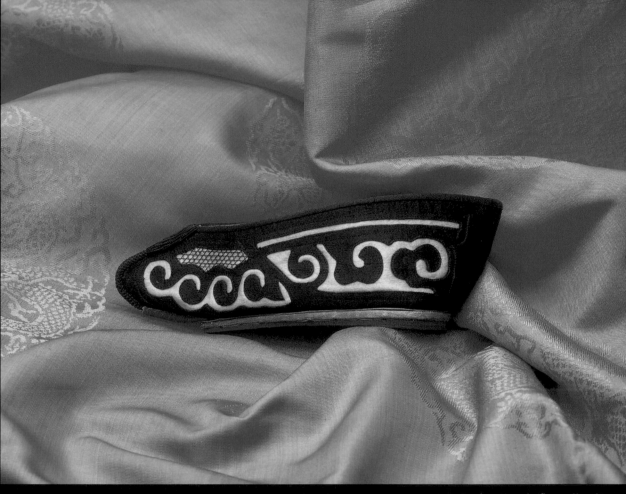

◎◎ Sophisticated flat silk slipper with swirling appliqué, embroidered lattice insets, and a leather sole. Possibly from Hong Kong. Length 6¾ inches. (From the author's collection, Larry Kunkel Photography)

the other children. Then in the evening, on my way home from school, I would put the bindings back on my feet as best I could. My grandmother could not see very well and didn't notice the feet until it was time to wash them at the end of the week."

But the Sister's real release from bound feet came not from her independent spirit but from her father's fear. Once the government outlawed footbinding, he was afraid he would get into trouble for not obeying the law. Her father's wishes were carried out, in spite of her grandmother's very strong protestation that he would be responsible for having a daughter with big feet whom no one would marry.

California history became of special interest to me, as there is a wealth of archival material pertaining to early Chinese immigrants. I found out that many of the hard-working Chinese men who entered the United States between 1882 and 1943, became involved with bound feet in a most surprising way. During that period, the Chinese Exclusion laws were in effect in this country, and new Chinese immigrants could only enter the country legally if they were related to someone who was already a resident.

Many Chinese entered the country illegally by claiming to be part of a family they were not really related to. To prepare for the many questions they would be asked by the U.S. Immigration officials about their "American family," these "paper sons" would spend months studying their false family information before coming to the United States. They needed to know everything—including which women had bound feet and which did not. Incorrect answers could result in immediate deportation.

Just as America had its laws about immigrants entering the United States, China had its own laws about women leaving China. Until 1911, the emigration of women from China was illegal.

The highest class Chinese, the scholars, did not emigrate as a rule, whereas the merchants did. So it was the mercantile class who became the elite in China-towns across the United States and Canada. And most of their wives arrived from China with bound feet. Bound as much by tradition as by the wrappings

around their feet, life didn't change much for these women. Due to the physical restrictions of their golden lilies, they remained as close to home in America as they did in China.

Very few of the so-called "picture brides" who came to the United States to marry single men of the laborer class had bound feet, not surprisingly because most of these men wanted able-bodied helpmates. Photographers in China did a brisk business in those days taking portraits of prospective brides for marriage brokers. A girl's feet would be propped up on a stool, or otherwise prominently displayed, so that her future husband had proof of her ability to work.

Life wasn't easy for any bride in California, no matter what the size of her feet. There is a well-known folk song from the late 19th century that laments this subject:

◎◎ The feet do not regain their natural shape after unbinding, and in some cases, it is simply too painful to dispense with the support from the bandages altogether. (From the Peabody & Essex Museum, Salem, MA)

"If you have a daughter, don't marry her to a Gold Mountain Man.
Out of ten years, he will not be in bed for one.
The spider will spin webs on top of the bedposts,
While the dust fully covers one side of the bed."
> *Chinese American Portraits*
> by Ruthanne Lum McCunn

The wives of poorer men lived in tenements, but they were free to go out and about the town, unlike their wealthier counterparts. Many of these women became quite enterprising in the spirit of their new country. Some became laundresses, shopkeepers, or seamstresses. This usually earned them better treatment by their husbands because they were wage earners. And, of course, most of these women had unbound feet.

Most Westerners thought of bound feet in relation to class, not imagining that the majority of bound-footed women in China were not necessarily of high class nor wealthy. Ironically, in 1895 San Francisco customs detained seven women, accusing them of being illegal entries because their feet were not bound! In fact, women coming illegally into the United States were usually young girls with bound feet who were smuggled in to work as prostitutes or as indentured

@@ Contemporary black leather ox-
ford made for a foot that was once
bound, displayed with an American

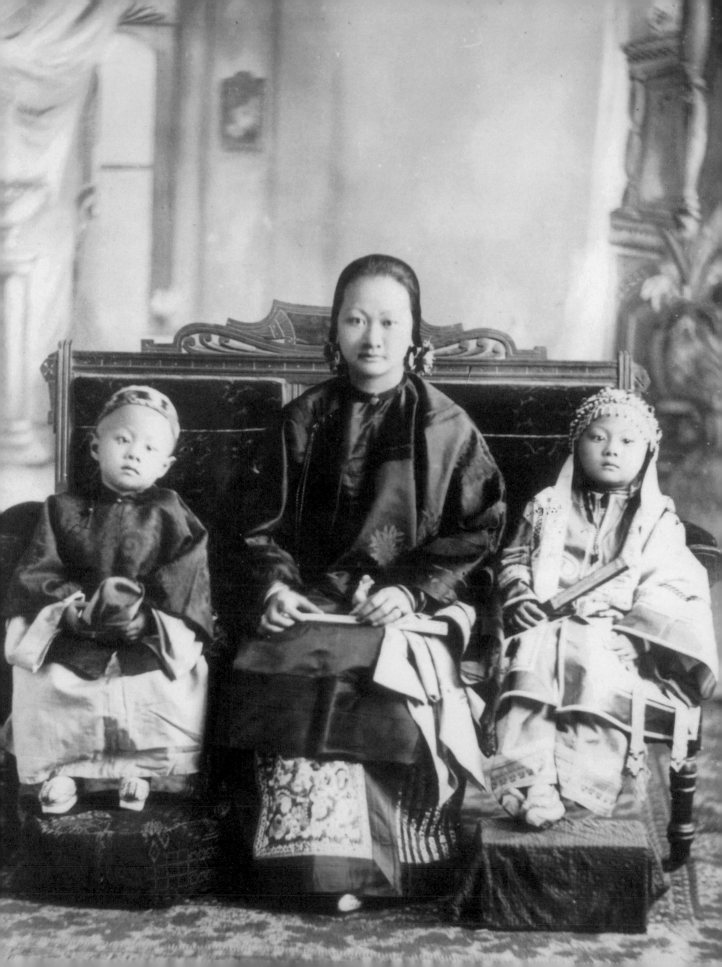

domestic servants called *mui tsai*. Generally, these girls were either kidnapped or bought from poor families in China. Both Chinese and Americans were involved in the smuggling of these girls—their procurement, passage, entry, and final distribution. In 1875, the U.S. Congress passed a bill requiring Chinese women to prove their "virtue" to the Consul in Hong Kong before they would be allowed to emigrate to the United States.

Prostitution in Chinatown was an immensely profitable business for *tongs* in northern California. They guarded the girls closely as they were considered to be valuable property. Young girls with bound feet could be bought for about $50.00 in China and were sold to houses of prostitution for $1,000.00 to $1,500.00. The charge to clients for girls twelve to fifteen years old was generally $1.00 to $1.50. Older girls and women who worked out of shacks in back alleys cost fifty cents—and frequently included a venereal disease free of charge.

Many Caucasian men frequented Chinese houses of prostitution in San Francisco. They didn't necessarily go for sex but often paid just to get a look at a bound foot!

Interestingly, there was very little footbinding in the Hawaiian islands at the end of the 19th century. This can be attributed to the fact that it was mainly Hakka men and women who emigrated to Hawaii to work in the sugar cane fields, and Hakka women never bound their feet. Also, due to a report in 1895 that a Chinese girl died from lockjaw resulting from complications attributed to her bound feet, the Hawaiian missionaries jumped on the anti-footbinding bandwagon, and by the end of 1895, footbinding was a statutory offense in Hawaii.

✦ ✦ ✦

Particularly exciting for me was enlarging my circle of Chinese American friends, and listening to some of their family stories concerning bound feet. One of the most surprising came from the late Pearl Kwok, who is the mother

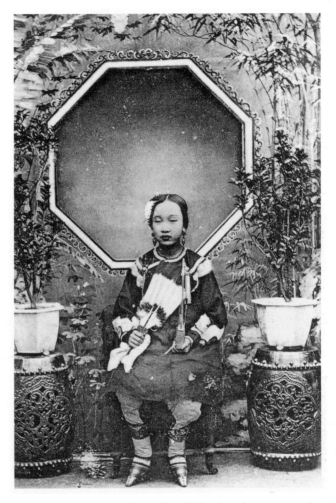

◎◎ *Above:* Following the passage of a Congressional bill in 1875, this young woman would have had to prove her "virtue" to the Counsul of Hong Kong before entering the United States. (From the author's collection)

◎◎ *Opposite:* Women with bound feet could be found in most American Chinatowns. This proud mother lived in Santa Barbara, California. (From the Santa Barbara Historical Society)

of my good friend Munson Kwok. Mrs. Kwok was born in San Francisco, and her feet were never bound. However, her mother, who was also born in San Francisco, *did* have her feet bound—by her mother who had come from Guangzhou with unbound feet. This information was astounding to me. I asked why a woman with unbound feet, living in the United States of America, would bind her own daughter's feet. "They had to keep the girls in," Mrs. Kwok explained. "They didn't go to school. They didn't go out. My grandmother didn't want her to run around town. When my mother, whose feet were bound, married at nineteen, it was to a man she had never seen. She had only seen his photograph."

What Mrs. Kwok remembers most about her mother's bound feet was the pain they caused her all through her life, even though she had unbound them before the arch was broken. "Every night when I came home, she had me help her soak her feet. Then I massaged them with her medicine which smelled like alcohol. The toes were all crumbled up and the nails were very dry and never grew properly. I had to buy her children's Mary Jane shoes because they were wide enough through the toes."

Pearl Kwok's mother wasn't the only family member to have her feet bound. Two other American-born relatives also had bound feet.

The well-known Chinese American actress Beulah Kwoh told me about her mother's bound feet. Her mother came from a family of landed gentry, and all the girls in her family had their feet bound. She was in her thirties when the family came to the United States in 1918, and she had unbound her feet. Beulah also remembers mainly how much pain her mother suffered from the once-bound feet. "And it is so hard to find her shoes! We found some old-fashioned shoes at Montgomery Ward or Sears Roebuck in Stockton that were a bit comfortable. She had to have shoes with ties on them and very blunt toes. Mother used a lot of cotton between her toes to try to comfort them so they didn't rub against each other. The toes did come out fairly straight again, finally, years after unbinding. In her younger days she worked in a cannery in Stockton, standing all day. Her feet hurt so when she came home at night. My father, who was of course Chinese,

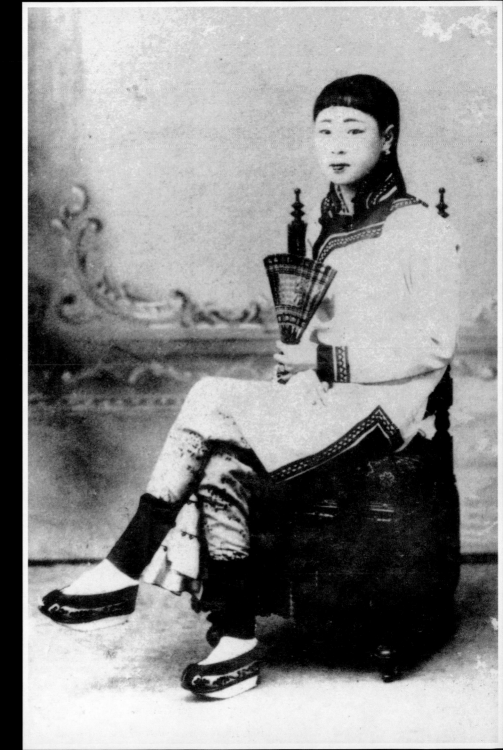

prospective bride for a Chinese
orking in California. Note her
hantly displayed unbound feet.
the author's collection)

◎◎ Centenarian Zhong Le Shi and her daughter Chong Hsia Wen in Los Angeles, California. (Photo by the author)

used to jump up and down and say, 'These Chinese are really crazy to bind their women's feet. It was ridiculous!'"

I have talked to a number of women who had actually had their feet bound. Most of these women had released the bindings some years ago, and the majority of them admitted that unbinding was a very painful procedure. Bones could not be restored to their original form. And the years of bound distortion affected the veins in the feet, so bleeding was a constant problem when the feet were let out. For some, the circulation problems of advanced age added to the pain. Many simply could not cope with the pain of unbinding in older age, and left their feet bound.

Mrs. Archibald Little addressed the topic in her book *In the Land of the Blue Gown:*

Many people ask whether it is possible for women to unbind. It is not only possible, but many women have done so, and can not only walk now, but declare they are free from suffering. It is, however, obvious that their feet cannot regain their natural shape, and probably it is even, in some cases, impossible to dispense with the bandages. . . . In all cases unbinding is a painful process, requiring much care. Cotton wool has to be pushed under the toes; massage is generally resorted to; and not uncommonly, the woman has to lie in bed for some days. But I have seen many women who have unbound at forty, and one even at sixty.

One phase of unbinding that the proper Mrs. Little did not discuss was the wide use of human urine in treating feet that were being released from bondage. It was said that soaking the feet in urine when the bandages were removed would soothe the pain and help the resultant bleeding. The bandages were generally reapplied, but much more loosely, and the feet would be totally released at night. As several women mentioned earlier, it was common to insert cotton between the toes and the bottom of the foot to try to straighten out the toes.

◇ ◇ ◇

Thanks to my good friend Dolores Wong, I recently had the pleasure of interviewing (through interpreters) 101-year-old Zhong Le Shi, who lives in a fine retirement home in the heart of Los Angeles Chinatown. The delightful

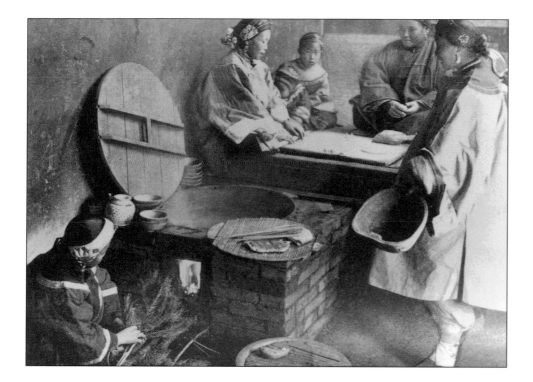

∾ Zhong Le Shi prepared her family's meals in a kitchen similar to this one. (From the author's collection)

centenarian was all dressed up for her interview when she and her daughter Chong Hsia Wen greeted us. She had made a special velvet turban-like hat for the occasion and pinned a pearl and gold pin jauntily on one side. Over her blue jacket and black pants, a bright red satin brocade vest added a festive note. As a final touch, she wore a pair of children's fleece-lined red felt booties on her tiny feet.

Mrs. Zhong was born in 1895 in a tiny village in Sichuan Province. She remembered distinctly having her feet bound at the age of three. When asked why at such a young age, she thought momentarily, then replied, "People in my village were very old-fashioned. They were so backward they started binding earlier than they did in other places."

She laughed merrily at this point, and her daughter asked her why. "I was remembering how surprised everyone was when I still played ball and kicked the ball and won after my feet were bound," she replied. "And I still climbed mountains and worked the fields."

◉◉ *Above and Opposite:* Photos taken by the author in May 1997, in Yunnan and Quizhuo Provinces.

Her marriage was arranged when she was very young, but she never met her husband until the day they were married, in 1913, just after her eighteenth birthday. She said no matter what he was like, she would have had to go with him, but added that he was a fine man. She gave birth to ten children unaided by any medical assistance of any sort. Typical of child mortality statistics of the time, only four children survived.

Life was hard for them in their distant village. She had invalid in-laws to care for as well as her own children. She would arise before daybreak and feed her family. Then she'd put her children into a big basket, and she and her husband would head for the fields where they worked until sundown. After they returned home, she was still faced with preparing the evening meal and doing all the other household work. All this she accomplished on four-inch bound feet.

Their basic crops were rice and yams, but there were some famine years when the fields yielded nothing. When I asked her how they survived, she said, "We rubbed roots into paste and mixed it with grasses and water."

It was during one of these famine years that she sent her daughter to live with an uncle in Taiwan, knowing that this would give the girl a chance for a better life. Chong Hsia Wen eventually emigrated to America. When Mrs. Zhong was eighty, her daughter brought her out of China to Los Angeles.

I asked her if her tiny feet had ever been a problem in this country. She said no, then held up one little foot, decked out in its red bootie, and asked if I wanted to see her foot. Without waiting for an answer, she reached down and pulled off the bootie, revealing a tight white sock covered with red, yellow, green, and blue dinosaurs. From embroidered silken slippers to dinosaur-printed socks in one lifetime!

I had never actually seen a foot that had been bound, and neither had my Chinese American friends or the interpreters who had accompanied me, even

172

though all their mothers and grandmothers had had bound feet. As the colorful sock was pulled off, an ankle appeared looking like a bone covered with skin. But much to my surprise, the foot itself was nothing like the grotesque specimens I had seen in photographs. The skin was smooth, shiny, and pink, indicating a good blood supply without circulation problems. It was well shaped, as a proper lotus foot should be. However, the desired crevice was very subtle and not nearly as deep as would historically be desired.

Looking at the foot, one had to conclude that starting the binding at such a young age made it possible to mold the foot into the desired shape without it appearing totally deformed. Mrs. Zhong turned her foot proudly from side to side, aided by her daughter, laughing happily as her audience nodded their appreciation.

❖ ❖ ❖

I have had many encounters of quite a different sort since my first trip to China in 1975. Because I was more knowledgeable about the Chinese people, their history, and their customs, the older women I saw on subsequent visits were no longer exotic oddities to me. They literally brought the past to life for me in a way that no amount of reading possibly could. I felt that I was on intimate terms with them—that, somehow, I understood them.

My hope on subsequent trips was to meet some of the women with diminutive feet, and I went prepared with photographs of my most beautifully embroidered lotus slippers. The first opportunity came in Tienanmen Square in Beijing. A woman with feet encased in tiny black suede shoes with little laces up the front was sitting on a sidewalk with her family, under the shade

of a tall tree. I sat down next to her, fanning myself with some papers I was carrying—trying to appear casual, though my heart was pounding wildly with excitement.

There I sat with my size 10-B feet in white Reeboks inches away from a woman with real live lotus feet. And we were surreptitiously eyeing each other's shoes! After a respectable interlude, I pulled out a picture of my grand-daughter posing with Mickey Mouse at Disneyland and showed it to the woman's grandson who was now standing in front of me staring. The picture was quickly passed around to the other members of the group, including my lady with the lotus feet.

I had rehearsed this scene a hundred times in my imagination, and the excitement of playing it out was like an opening night at the Metropolitan Opera. Next came photos of my daughter and her husband, my home on the beach in Santa Barbara, my dog—it had been choreographed in advance.

The crowd around me now was at least one hundred strong and everyone was passing the photographs around with great interest. Next came the finale. I pulled out a photo of a lotus shoe. I showed it to a female relative, possibly her daughter-in-law, standing nearby, and with sign language asked if it was all right to let the old woman see it. They nodded yes, so I passed it to her. She sat staring at the photo in bewilderment, then slowly I sensed the excitement rising in the little body as she realized what it was. She looked up at me with a wide toothless grin and pointed first to the photo, then to me. Yes, I nodded, they were my shoes. Then out came the rest of the photos which she devoured with her eyes and passed around to share with the ever-growing audience.

The drama ended with her speaking to a man I presumed to be her son who pointed to my size 10 feet. He held up his camera and pointed from his mother

to me. She wanted a photograph of us together, because of my big feet I think. The crowd dispersed after pictures were taken. My new friends nodded good-bye, the grandson pulled his baseball cap on backwards, and they all set off down the shaded side of Tienanmen Square. The young people waved a Western good-bye to me as they all looked back. My special friend just turned around and stared at me. But at the end of the block, before turning the corner and disappearing out of sight, she too waved good-bye. I had a little trouble seeing that, as my eyes were filled with tears.

❖ ❖ ❖

In Nanjing I became friendly with a charming, brilliant young businesswoman who spoke very good English. In the course of a conversation one day, I asked her if her grandmother had had bound feet. "Yes she does," came the reply. That change of tense sent my expectations soaring!

"Do you ever see her?" I asked hopefully.

"Yes. She lives with us."

"What has she told you about her feet? How old was she when they were bound? Who did the binding? Did a footbinder come to her house? Had she ever tried to unbind them herself when she was still a girl? Did the pain ever really go away? How old was she when she unbound her feet? Had she unbound completely? Or had she left them partially bound? Has she had any medical problems attributable to the binding?" The questions came pouring out.

"Oh, none of us has ever talked about her feet. In fact, I seldom talk to my granny," my friend said.

"Would you do me a great favor and just ask her one question tonight. Would you ask her at what age they first bound her feet?"

The next day my friend reported that her grandmother had been bound at the age of four because she came from a noble family. "Was she upset when you asked about her feet?" I inquired.

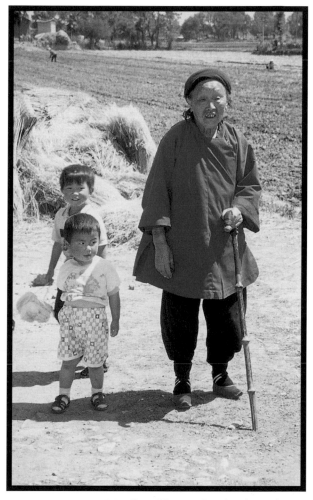

∽ *Above:* Photo taken by the author in May 1997, in Yunnan Province.
∽ *Opposite:* The author and her first personal contact with a woman who had had her feet bound, Tienanmen Square, Beijing, 1996.

175

⊚⊚ Photo taken by the author in
May 1997, in Yunnan Province.

"No, she was very excited. She said no one in the family had once asked her
about them. Then she took me into her room and showed me her secret—a
beautiful pair of little shoes all covered in pearls. They were her burial shoes she
had made before Liberation [1949] and she had them hidden away ever since."

Having opened a line of communication between grandmother and grand-
daughter, I asked my friend one more favor. Since I was leaving for home the
next day, would she ask her grandmother the questions on a list I had prepared
the night before and write to me with her answers?

Several months later, I received a long letter from her, which I've included in
its entirety. There couldn't be a more fitting ending to my story of the three-
inch golden lotus.

Dearest Beverley,

I must ask your pardon for this letter which comes to you so late. Three months ago my dear grandmother who was very old as you know, passed away. This made me very sad. But thanks be to God, with your encouragement and the needs to answer your letter, I tried to talk to her more. Before I met you, I only knew that my granny was the daughter of the old past royal family. She belonged to the elegant gardens, the high-surrounded walls, the over-elaborate family regulations. She smiled, never showing her teeth. She never spoke loudly, never cursed her naughty grandchildren, even (when) we played amusing trick to hide her stick which she always walked with.

She has gone now, ended the old day, with the beautiful pearl burial shoes. I am very sorry I cannot take a photo of that. Because of the old tradition, we could not take any photo during the burial ceremony to prevent the soul of the dead rise to leave.

Sitting on her sick bed, I asked a lot of questions of the old days, especially the bound feet. She showed me her bare bound feet. She only did it once during all of her life. They were very strange I think, so soft and white. I dare not to touch them. They looked like the ice cream ball nearly thawed. But really they were ugly by no size and style. Granny also said that. She told me that in the past men only admired their colorful embroidery shoes, not the foot itself. Of course, they had never seen it.

Granny had bound feet at the age of four. She still remembered the right day. An elder woman servant came to her room, while her own mother was outside murmuring the Buddhist scriptures, worshipping the Goddess of Mercy. Maybe the mother knew how it was suffered and not have the heart to watch her small daughter writhing with pain.

The servant got a hen, opened the chest and put (Granny's) small feet in the still-warmed body for awhile. Then she began to wrap the feet with a long girdle. After that day, she was forced to walk on bits of broken glass and porcelain. Quite painful and bleeding. She cried every day and begged to her mother to stop. But absolutely no way. Scar was there, both on foot and in heart!

After she grew up, she was very proud of her bound feet, especially when she was engaged with a well-known scholar, my grandfather, and became a patriarch of an old and big family. Granny could read and write. She was good at painting and sewing and embroider. The novel *The Dream of a Red Mansion* was her favorite after liberation in 1949. I think this novel helped her back to the old days.

Talking with my dearest granny I realized that we are leaving from the old days so long and we really do not know we are losing something. Even some part of them are the great heritages of civilization from our forefathers and our past. It's a pity. You know, when I showed her the color photos of your bound shoes you left me, I noticed her eyes were full of tears.

REFERENCES

Astor, Brooke. 1980. *Footprints, An Autobiography.* New York: Doubleday & Co.

Bainbridge, Lucy. 1920. *Jewels from the Orient.* New York: Fleming H. Revell Co.

Berg, Eugene E., M. D. 1995. "Chinese Footbinding." *Radiology Review—Orthopaedic Nursing.* 14, no. 5 (September/October):66-67.

Byron, John. 1987. *Portrait of a Chinese Paradise: Erotica and Sexual Customs of the Late Qing Period.* London: Quartet Books.

Chung, Young Yang. 1979. *The Art of Oriental Embroidery: History, Aesthetics and Techniques.* New York: Charles Scribner's Sons.

Cohen, Alvin P. "Chinese Cones III." *Asian Languages & Literature,* 10, no. 3. University of Massachusetts. Newsletter.

Crane, Louise. 1926. *China in Sign and Symbol.* Shanghai: Kelly & Walsh, Ltd.

Fielde, Adele M. 1890. *Pagoda Shadows: Studies from Life in China.* Sixth ed. Boston: W. G. Corthell.

Gamble, Sidney D. and Burgess, Stewart. 1921. *Peking, A Social Survey.* New York: George H. Doran Co.

Gamble, Sydney D. 1954. *Ting Hsien: A North China Rural Community.* Stanford: Stanford University Press.

Giles, Herbert A., trans. 1880. *Strange Stories from a Chinese Studio.* London: Thomas

Hong Kong Museum of Art. 1995. *Heavens' Embroidered Cloths—1,000 Years of Chinese Textiles.* Catalog

Hsu, Immanuel C. Y. 1983. *The Rise of Modern China.* New York: Oxford University Press.

Hyde, Nina. 1984. "Silk, The Queen of Textiles." *National Geographic* 165 (January).

Little, Mrs. Archibald [Alicia]. 1901. *Intimate China.* Philadelphia: J. B. Lippincott Co.; London: Hutchinson & Co.

Snow, Edgar. 1968. *Red Star Over China.* New York: Bantam.

Watson, Burton, ed. and trans. 1984. *Columbia Book of Chinese Poetry: From Early Times to the Thirteenth Century.* New York: Columbia University Press.

Wolf, Sister Ann Colette. 1990. *Sisters of Providence—Mission to the Chinese.* Indiana: St. Mary's-in-the-Woods.

Yuan, L. Z. 1947. "Through a Moon Gate." *Shanghai Evening Post & Mercury.* (February-December). Newspaper columns.

Yutang, Lin. 1935. *My Country and My People.* New York: John Day & Reynal & Hitchcock.

BIBLIOGRAPHY

Allen, Steve. *Explaining China.* New York: Crown Publishing Group, 1980.

Alley, Rewi. *Peking Opera.* Peking: New World Press, 1957.

Alsop, Gulielma F. *My Chinese Childhood.* Boston: Little Brown & Co., 1918.

Arlington, L. C. *The Chinese Drama.* Shanghai: Kelly & Walsh Ltd. 1930.

Basil, George C. *Test Tubes and Dragon Scales.* Chicago: John C. Winston Co., 1940.

Benn, Rachel R., M. D. *Ping-Kua: A Girl of Cathay.* Boston: Tudor Press, 1912. Women's Foreign Missionary Society, Methodist Episcopal Church.

Beurdeley, Michael with Kristofer Schipper, Chang Fu-Jui, and Jacques Pimpaneau. *Chinese Erotic Art.* Hong Kong: Chartwell Books, 1969.

Bird, Isabella. *The Yangtze Valley and Beyond.* Boston: Beacon Press, 1985.

Bland, J. O. P. and Backhouse, E. *China Under the Dowager Empress.* London: William Heineman, 1911.

Bredon, Juliet and Mitrophanow, Igor. *The Moon Year: A Record of Chinese Customs and Festivals.* New York: Paragon Book Reprint Corp., 1966.

Browne, G. Waldo. *The New America and the Far East.* Boston: Colonial Press, 1907.

Bryan, William Jennings. *The Old World and Its Ways.* St. Louis: Thompson Publishing Co., 1907.

Bunge, Frederica M. and Shinn, Rinn-Sup, eds. *China: A Country Study.* U.S. Government Printing Office, 1981.

Burgess, Alan. *The Small Woman.* New York: E. F. Dutton & Co., Inc., 1957.

Burkhart, V. R. *Chinese Creeds and Customs.* Hong Kong: Yee Tin Tong Printing Press Ltd., 1982.

Burton, Margaret E. *Women Workers of the Orient.* The Women's Press, 1919. Published by the Central Committee of the United Study of Foreign Missions.

Carl, Katharine A. *With the Empress Dowager of China.* London: Eveleigh Nash, 1906.

Central Academy of Ethnology and the People's Art Publishing Company, eds. *Costumes of the Minority Peoples of China.* Beijing: Binobi Publishing Co. Ltd., 1980.

Chang, Jung. *Wild Swans: Three Daughters of China.* New York: Simon & Schuster; London: Harper Collins, 1991.

Ch'en, Jerome. *China in the West.* Bloomington, Indiana: Indiana University Press, 1979.

Cheng Mauchao. *The Origin of Chinese Deities.* Beijing: Foreign Languages Press, 1995.

Chew, M. B. K. "Chinese Bound Foot." *Radiography* 39 (February 1973): 39-42.

China for Women. New York: Feminist Press at the City University of New York, 1995.

Chou, Eric. *The Dragon and the Phoenix: Love, Sex and the Chinese.* London: Michael Joseph Ltd., 1971.

Christie, Anthony. *Chinese Mythology.* Middlesex, England: Hamlyn Publishing Group, Ltd., 1968.

Constant, Samuel Victor. *Calls, Sounds, & Merchandise of the Peking Street Peddlers.* Peking: The Camel Bell. Thesis. No date.

Cooper, Elizabeth. *The Love Letters of a Chinese Lady.* Edinburgh/ London: T. N. Foulis, 1919.

Couling, Samuel. *The Encyclopaedia Sinica.* Shanghai: Kelly & Walsh Ltd., 1964.

Cross, Elisabeth. *Wise Daughters from Foreign Lands.* London: Pandora, 1989.

d'Argence, Rene-Yvon Lefebvre, ed. *Treasures from the Shanghai Museum: 6,000 Years of Chinese Art,* 1983, 1984. Catalog for exhibitions in the United States.

Deering, Mabel Craft. "Ho for the Soo Chow Ho." *National Geographic* 51 (June 1996).

di Franco, Toni L. *Chinese Clothing & Theatrical Costumes.* San Joaquin County Historical Museum, 1981. Catalog.

Dobie, Charles Caldwell. *San Francisco: A Pageant.* New York/ London: D. Appleton-Century Co., 1933.

Doolittle, Rev. Justus. *Social Life of the Chinese.* London: Sampson Low, Son, and Marston, 1868.

Douglas, Robert K. *China.* London: G. P. Putnam's Sons, 1901.

Du Halde, Father J. B., S. J. *Cotton and Silk Making in Manchu China.* New York: Rizzoli International Publications, 1980.

Chinese School-Teacher and Her Pupils. H63

Durdin, Tillman; James Reston; and Seymour Topping. *Report from Red China.* New York: Quadrangle/Time Books, 1971.

Elisseeff, Danielle. *Le Femme au Temps des Empereurs de Chine.* France: Stock/Laurence Pernoud, 1988.

The Exhibition of Archaeological Finds of the People's Republic of China. Royal Ontario Museum, 1974. Catalog.

Fairbank, John King. *China: A New History.* Cambridge: Belknap Press of Harvard University Press, 1994.

Fellman, Sandi. *The Japanese Tattoo.* New York: Abbeville Press, Inc., 1986.

Franck, Harry A. *Wandering in Northern China.* New York: Century Co., 1923.

Gamble, Sydney. "The Disappearance of Foot-binding in Tinghsien." *American Journal of Sociology* 49 (September 1943): 181-83.

Glick, Clarence E. *Sojourners and Settlers.* Honolulu, Hawaii: University of Hawaii Press, 1980.

Glynn, Prudence. *Skin to Skin: Eroticism in Dress.* New York: Oxford University Press, 1982.

Graham, Dorothy. *Through the Moon Door.* New York: J. H. Sears & Co., Inc., 1926.

Gray, Ven. John Henry. *Walks in the City of Canton.* Hong Kong: De Souza & Co., 1875.

Hardy, Rev. E. J. John. *Chinaman at Home.* London: T. Fisher Unwin, 1905.

Headland, Isaac Taylor. *Court Life in China.* New York: Fleming H. Revell Co., 1909.

Hershatter, Gail. *Dangerous Pleasures: Prostitution and Modernity in Twentieth Century Shanghai.* Berkeley: University of California Press, 1997.

Hobaat, Alice Tisdale. *By the City of the Long Sand: A Tale of New China.* New York: Macmillan Co., 1926.

Hosie, Lady. *Portrait of a Chinese Lady.* New York: William Morrow & Co., 1930.

Hosie, Lady. *Two Gentlemen of China.* Philadelphia: J. B. Lippincott Co., 1924.

Hsi, Francis K. *Under the Ancestors Shadow: Chinese Culture & Personality.* England: Routledge & Kegan Paul Ltd., 1949.

Humana, Charles and Wang Wu. *Chinese Sex Secrets: A Look Behind the Screen.* Hong Kong: CFW Publications, Ltd., 1996.

Jing Zhi; Qiu Hao; and Yu Cong. "On China's Stage—Regional Opera." *China Today Magazine.* April-October 1996). Six-part series on Chinese opera.

Knox, Robert. *Great Civilizations—Ancient China.* London: Longman Group Ltd., 1978.

Ko, Dorothy. *Teachers of the Inner Chambers: Women and Culture in 17th Century China.* Stanford: Stanford University Press, 1994.

Koo, Madame Wellington, with Isabelle Taves. *No Feast Lasts Forever.* New York: Quadrangle/ Times Book Co., 1975.

Lai, David Chueyan. *Chinatowns Within Cities in Canada.* Vancouver, B.C.: University of British Columbia Press, 1988.

Lee Ho Yin. "Legends and Deities Out from Behind Bamboo." *Window Magazine* (14 July 1996). Hong Kong.

Lernoux, Penny with Arthur Jones and Robert Ellsberg. *Hearts on Fire: The Story of the Maryknoll Sisters.* Maryknoll, New York: Orbis Books, 1993.

Levy, Howard S. *Chinese Footbinding.* New York: Walton Rawls Publishers, 1966.

Lin Shwu-shin and Chen Kuei-miao. *Chinese Embroidery—Dextrous and Colorful.* Taipei: National Museum of History, 1989.

Lin Yutang. *My Country, My People.* New York: John Day Co., Inc., 1935.

Linking Our Lives. Chinese Historical Society of Southern California, 1984. Stories written by the Chinese American Women of Los Angeles.

Little, Mrs. Archibald [Alicia]. *Round About My Peking Garden.* London: R. Fisher Unwin, 1905.

Little, Mrs. Archibald [Alicia]. *The Land of the Blue Gown.* London: R. Fisher Unwin, 1908.

Liu Heung Shing. "China's Living Relics." *Honolulu Star Bulletin* (10 April 1983.)

Liu Jilin. *Chinese Shadow Puppet Plays.* Beijing: Morning Glory Publishers, 1988.

Luo Chong Qi. *The Cultural History of Chinese Shoes.* Shanghai: Shanghai Scientific & Technical Publishers, 1990.

MacGowan, Rev. J. *Sidelights on Chinese Life.* London: Kegan Paul Tench Trubner & Co. Ltd., 1907.

MacKenzie, Donald A. *Myths of China and Japan.* London: Gresham Publishing Co. Ltd. No date.

Mark, Diane Mei Lin and Chih, Ginger. *A Place Called Chinese America.* Organization of Chinese Americans, 1993.

McCabe, James D., ed. and comp. *A Tour Around the World.* Philadelphia: National Publishing Co., 1879.

McCormick, Elsie. *Audacious Angles on China.* Shanghai: Chinese American Publishing Co., 1922.

McCunn, Ruthanne Lum. *Chinese American Portraits.* San Francisco: Chronicle Books, 1988.

Miklos, Pat. *L'Oeil Du Dragon.* Budapest: Corvina Kiado, 1973.

Morrill Samuel. *Lanterns, Junks & Jade.* New York. Frederick A. Stokes Co., 1926.

Morrison, Hedda. "The Lost Tribes of China." *Arts of Asia* (May-June 1980).

Mottram, M. E., M. D. and Pyle, I. Roger, M. D. "Mandarin Feet." *American Journal of Roentgenology* 118 (1973): 318-319.

National Geographic. Vol.169, No.2, February 1986. "Ndebele People: Pioneers in Their Own Land."

Nomachi, Kazuyoshi. "Red Capitalism in China." *Bart Magazine* (27 September 1993).

Norwich, John Julius. *A Taste for Travel.* New York, 1987

Nourse. Mary A. *A Short History of the Chinese.* New York: New Home Library, 1942

O'Neil, Thomas. "Irian Jaya, Indonesia's Wild Side." *National Geographic* 189 (February 1996).

Okamoto, Kyozo. *Ten Soku Monogatari* (The Story of a Bound Foot). Japan: Toho Shoten, 1963.

Origins and Destinations. Chinese Historical Society of Southern California. Los Angeles: UCLA Asian American Studies Center, 1994. Forty-one essays on Chinese America.

Paine, Sheila. *Embroidered Textiles.* London: Thames and Hudson Co., 1990.

Pan Xiafeng. *The Stagecraft of Peking Opera.* Beijing: New World Press, 1995.

Peill, Arthur D. *The Beloved Physician of Tsang Chou: Life-work and Letters of Dr. Arthur D. Peill.* London: Headley Brothers. No date.

Pollard, S. *In Unknown China.* Philadelphia, Pennsylvania: J.B. Lippincott, Co., 1921.

Powell, Charles A., M. D. *Bound Feet.* Boston: Warren Press, 1938.

Princess Der Ling. *Old Buddha.* New York: Dodd, Mead & Co., 1936.

Pruitt, Ida. *Old Madam Yin: A Memoir of Peking Life 1926-1938.* Stanford: Stanford University Press, 1979.

Pu Yi, Henry. *The Last Manchu: The Autobiography of Henry Pu Yi, Last Emperor of China.* New York: Pocket Books, 1987.

Rau, Santha. *East of Home.* New York: Harpers & Bros., 1950.

Ross, Edward Alsworth. *The Changing Chinese.* New York: Century Co., 1912.

Salisbury, Harrison E. *The New Emperors: China in the Era of Mao & Deng.* Boston: Little, Brown & Co., 1992.

Seagrave, Sterling. *The Soong Dynasty.* New York: Perennial Library, Harper & Row, 1985.

Sewell, William G. *China Through a College Window.* London: Edinburgh House Press, 1937.

Sitwell, Osbert. *Escape with Me! An Oriental Sketch-Book.* Harrison-Hilton Books Inc., 1940.

Smith, Arthur H. *Village Life in China.* New York: Fleming H. Revell Co, 1899.

Smith, Arthur H. *Chinese Characteristics.* New York: Fleming H. Revell Co, 1894.

Soothill, Lucy. *A Passport to China.* London: Hodder and Stoughton, 1931.

Suyin, Han. *The Morning Deluge: Mao Tse Tung & the Chinese Revolution.* Boston: Little, Brown & Co.,1972.

Terrill, Ross. *China in Our Time.* New York: Simon & Schuster, 1992.

Thayer, Mary Van Rensselaer. *Hui-Lan Koo.* New York: Dial Press, 1943.

Thomas, Ian. *Chinese Export Watercolors.* London: Victoria and Albert Museum, 1984.

Thomson, John Stuart. *The Chinese.* Indianapolis: Bobbs-Merrill Co., 1909

Time. March 3, 1997. "The Next China," reported by Jaime A. Flor Cruz and Mia Turner.

Townley, Lady Susan. *My Chinese Notebook.* London: Methuen & Co., 1904.

Townsend, Ralph. *Ways That Are Dark: The Truth About China.* New York: G. P. Putnam's Sons, 1933.

Trasko, Mary. *Heavenly Soles.* New York: Abbeville Press, 1989.

Tseng, Yong-yi. *Chine: Le Theatre.* Paris: Philippe Picquier, 1990.

Upward, Rev. Bernard. *The Sons of Han: Stories of Chinese Life and Mission Work.* London: London Missionary Society, 1908.

Vare, Daniele. *The Last Empress.* Garden City: Doubleday, Dorn & Co. The Literary Guild, 1936.

Veblen, Thorstein. *The Theory of the Leisure Class.* New York: Viking Press, 1931. (Original copyright 1899.)

Vollmer, John. E. *In the Presence of the Dragon Throne.* Royal Ontario Museum, 1977.

Walsh, Very Reverend James A. *Observation in the Orient.* New York: Catholic Foreign Mission Society, 1919.

Walters, Dereck. *Chinese Mythology.* San Francisco, California: Aquarian Press, 1992.

Wang Yarong. *Chinese Folk Embroidery.* London: Thames and Hudson Co., 1986.

Wei, Katherine and Quinn, Terry. *Second Daughter: Growing Up in China.* London: Harvill Press, 1985.

Williams, C. A. S. *Outlines of Chinese Symbolism and Motives.* New York: Dover Publishing, 1976.

Williams, Edward Thomas. *China Yesterday and Today.* New York: Thomas Y. Crowell Co., 1932

Wimsatt, Genevieve. *A Griffin in China.* New York: Funk & Wagnalls Co., 1927.

Wolf, Margery and Witke, Roxanne, ed. *Women in Chinese Society.* Stanford: Stanford University Press, 1975.

Yu Yeuh. *Stories of Old China.* Beijing; Foreign Languages Press, 1958.

Yung, Judy. *Unbound Feet: A Social History of Chinese Women in San Francisco.* Berkeley, California: University of California Press, 1995.

Yutang, Lin. *The Importance of Living.* New York: John Day Co., 1940.

Zhong Xin and Lydia Yang. "Oldest Form of Opera." *Window Magazine* (16 August 1996). Hong Kong.

Zucker, A. E. *The Chinese Theater.* Boston: Little Brown & Co., 1925.

Zung, Cecila S. L. *Secrets of the Chinese Drama.* Shanghai: Kelly & Walsh, Ltd., 1937.

INDEX

✤✤ An old woman whose feet were once bound visits the Forbidden City, Beijing 1984. (Photo by Gordon Wright)